HISTORIC PHOTOS OF
WEST VIRGINIA

TEXT AND CAPTIONS BY GERALD D. SWICK

TURNER
PUBLISHING COMPANY

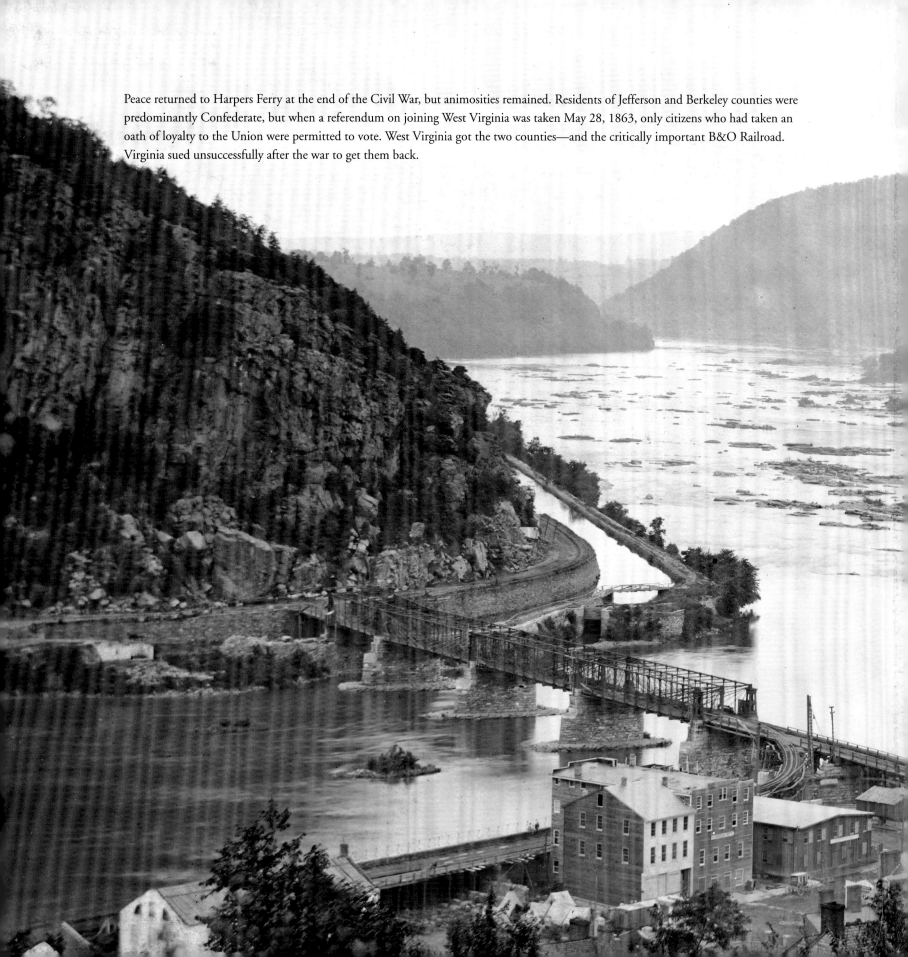

Peace returned to Harpers Ferry at the end of the Civil War, but animosities remained. Residents of Jefferson and Berkeley counties were predominantly Confederate, but when a referendum on joining West Virginia was taken May 28, 1863, only citizens who had taken an oath of loyalty to the Union were permitted to vote. West Virginia got the two counties—and the critically important B&O Railroad. Virginia sued unsuccessfully after the war to get them back.

HISTORIC PHOTOS OF
WEST VIRGINIA

Turner Publishing Company
200 4th Avenue North • Suite 950
Nashville, Tennessee 37219
(615) 255-2665

www.turnerpublishing.com

Historic Photos of West Virginia

Copyright © 2010 Turner Publishing Company

Library of Congress Control Number: 2009939387

ISBN: 978-1-59652-565-8

Printed in China

10 11 12 13 14 15 16 17—0 9 8 7 6 5 4 3 2 1

CONTENTS

Demand for coal oil produced from cannel coal soared in the 1850s, creating the first coal boom in the region. Cannelton, the Fayette County town shown here, was a leading producer. "Cannel" derives from Old English for "candle coal." After the Civil War, petroleum-based kerosene became the main source of illumination, but Cannelton continued cannel coal production into the twentieth century.

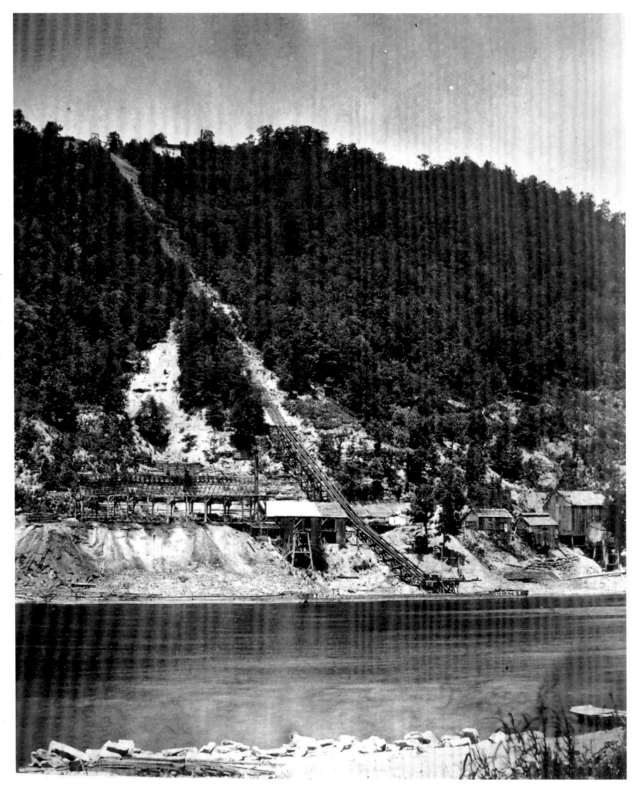

ACKNOWLEDGMENTS

This volume, *Historic Photos of West Virginia,* is the result of the cooperation and efforts of many individuals and organizations. It is with great thanks that we acknowledge the valuable contributions of the following for their generous support:

Vickie Bowden, Belgian-American Heritage Society of West Virginia
David Houchin, Clarksburg-Harrison Public Library
John Piscitelli, Fairmont State University Photo Archives
Library of Congress
Lisle Brown, Marshall University Special Collections
Dr. Keith D. Alexander, Robert C. Byrd Center for Legislative Studies, Shepherd University
West Virginia Humanities Council and the staff and writers of *The West Virginia Encyclopedia,* edited by Ken Sullivan
Debra A. Basham, West Virginia State Archives
Lori Hostuttler, West Virginia and Regional Collection, West Virginia University

Ancella R. Bickley
Sheri, John, and Imogene England
Phyllis and Jim Moore

This book is dedicated to the memory of my parents, Harold and Iona Phillips Swick, and to my brothers and sister, Howard, Clinton, Theron, and Linda, and the memory of their mother, Reinus Wadding Swick.

———

With the exception of touching up imperfections that have accrued over time and cropping where necessary, no changes have been made to the photographs. The focus and clarity of many photographs is limited to the technology and the ability of the photographer at the time they were taken.

PREFACE

There is no such thing as a former West Virginian. Residents may leave the Mountain State, as many have had to do, beginning with the Great Exodus during the Great Coal Depression. But they cling to memories of its magnificent views and friendly people with a tenacity few other states can claim. Even people from elsewhere recognize this. Singer-songwriter Bruce "Utah" Phillips eulogized it in "Green Rolling Hills (of West Virginia)." John Denver sang of the state as "almost heaven" in "Take Me Home, Country Roads."

West Virginians know their state isn't heaven, but they figure it's just down the road from there. Its 55 counties comprise over 24,000 square miles of spectacular, rugged beauty.

The hills have largely defined West Virginia and its people. Coal, oil, gas, and timber extracted from those mountains have been the primary reason for the state's perennial boom-and-bust economy. Creating effective transportation systems in such topography has always been a major consideration. Until the arrival of Interstate highways in the 1970s, many areas were isolated, and some are still well off the beaten path.

In some respects, that has worked to West Virginia's benefit. In towns where rush hour lasts less than 15 minutes, stress is significantly less than in a bustling metropolis. The state has produced many internationally recognized writers, musicians, and other artists; perhaps its calmer pace of life is conducive to artists developing their craft. The state's traditionally isolated communities and history of self-contained coal towns reinforced a strong sense of place that is still present even in the age of Interstates and the Internet.

Besides artists, the state has produced or nurtured noted inventors, ambassadors, and industrialists, along with major players in national politics. Visitors of the 1800s and early 1900s wrote of the great future they saw for West Virginia, and at times that starry future has proven to be a reality. At various times, the state has been a leading producer of coal, steel, lumber, glass, cigars, and even bathroom fixtures.

Tragedy has been a frequent visitor, though. Mining and weather disasters have claimed many lives. Great fires have swept through cities and towns. The extraction industries that created thousands of jobs left scarred hillsides, orange streams, and denuded forests. A 1970 plane crash killed all members of the Marshall University football team and coaching staff.

These tragedies were shared tragedies, felt by everyone in the affected communities and, indeed, by people all across the state, strengthening the bond West Virginians feel with each other.

Then, too, there are all those hillbilly jokes West Virginians have to endure. The Hatfield-McCoy Feud of the 1800s and photographs of deep poverty in the 1930s and the 1950s to 1960s all played a role in creating a hillbilly stereotype. Another annoyance comes from the geographically challenged who don't realize Virginia and West Virginia are separate states. Some World War II pilots even painted "West by Gawd Virginia" on their fighters' noses to make the point. Dealing with these annoyances has also, in its own way, added to West Virginians' camaraderie.

All of this, along with strong family bonds and shared traditions and beliefs, is why so many residents choose to remain through economic ups and downs, and why so many who have had to leave keep the mountains ever in their hearts.

The photos in this book are like the patchwork quilts for which the state is renowned. They capture fragments of history, of great events and daily life that taken together tell the evolving story of a place and its people. It is hoped they will give insight into why West Virginia, like a mother waiting patiently, whispers to its scattered children, "Come home when you can."

—Gerald D. Swick

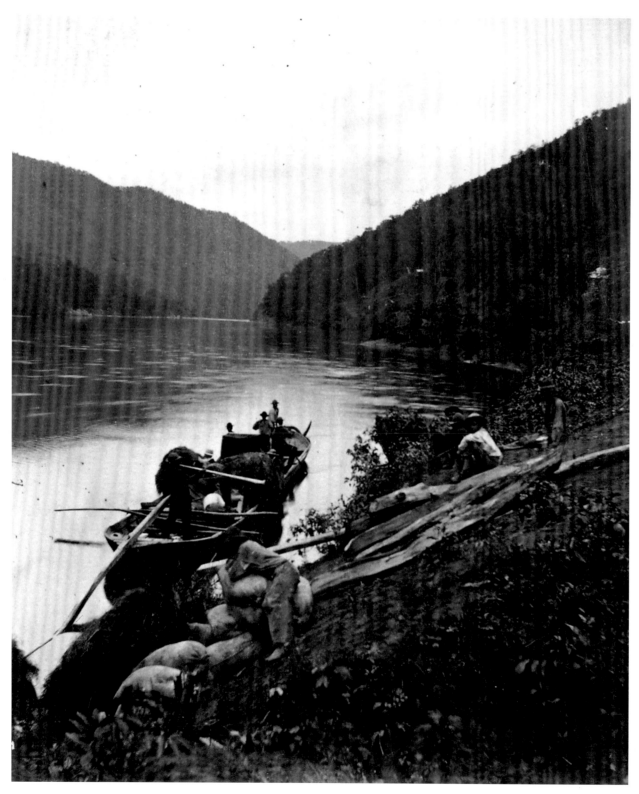

The state's rivers offered a better means of transportation than its roads did, but the amount of goods and passengers was often limited because many rivers could only be traversed by shallow-draft craft like this bateau, the *Tam O' Shanter,* photographed on the New River.

THE WAR CHILD GROWS UP

(1859–1899)

John Brown's attempt to seize the U.S. Arsenal at Harpers Ferry to arm a slave rebellion in October 1859, followed by the election of Abraham Lincoln to the presidency the next year, turned embers of discontent between North and South into open flames of civil war. Virginia passed an ordinance of secession from the Union on April 17, 1861, but on May 13, representatives of western counties met in Wheeling and made the risky decision to keep those counties in the Union.

Article IV, Section 3 of the U.S. Constitution requires the mother state's permission to form a new state. Would admitting Kanawha, as the state was to be called, into the Union be constitutionally acceptable? Those voicing concerns included Abraham Lincoln and Francis H. Pierpont, governor of the Restored Government of Virginia that oversaw the region between 1861 and 1863. The fate of citizens attempting to form a separate, Union-loyal state was as tenuous as that of colonists who had rebelled against Britain in 1776.

Practical considerations prevailed. On June 20, 1863, a thirty-fifth star was added to the U.S. flag. To support the contention that this was a part of Virginia that had never left the Union, the new state was named West Virginia. It was required to amend its constitution in a manner that would prohibit slavery. Even a few counties that had not sought to leave Virginia were grafted onto the new state due to their strategic significance.

The first land battle of the Civil War was fought at Philippi. Some towns in the Eastern Panhandle changed hands over 50 times. The 1863 Jones-Imboden Raid included history's first military action against an oil field.

The new state faced many difficulties, including creating a public education system. Even before war's end, "normal schools" were established to prepare an adequate numbers of teachers. These schools formed the nucleus for the state colleges and universities. The state agricultural college became West Virginia University.

Immigrants were recruited from Europe, first to increase population and investment, then to work in the mines and fledgling factories. Logging, railroading, coal, gas, and oil fed local economies. Tourism grew, despite transportation difficulties in the steep terrain. Out-of-state visitors predicted a bright future for the region. The war child was growing up.

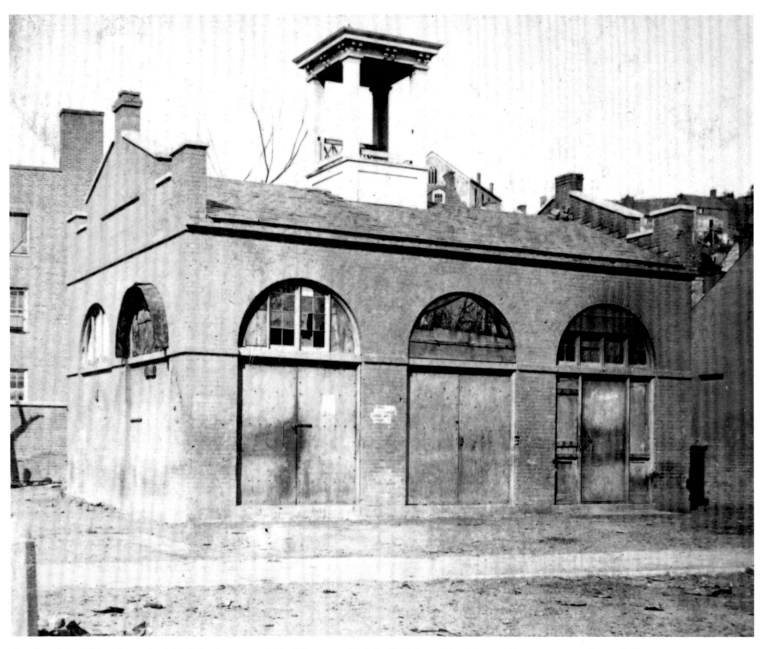

On the night of October 16, 1859, John Brown and his followers seized the U.S. Arsenal at Harpers Ferry to arm a slave rebellion. From the engine house shown here, they traded shots with local militia until U.S. Marines subdued them on the 18th. Brown was hanged for treason against Virginia. Several Northern newspapers and politicians proclaimed him a martyr, reinforcing many white Southerners' fears that the North intended a war of extermination against them.

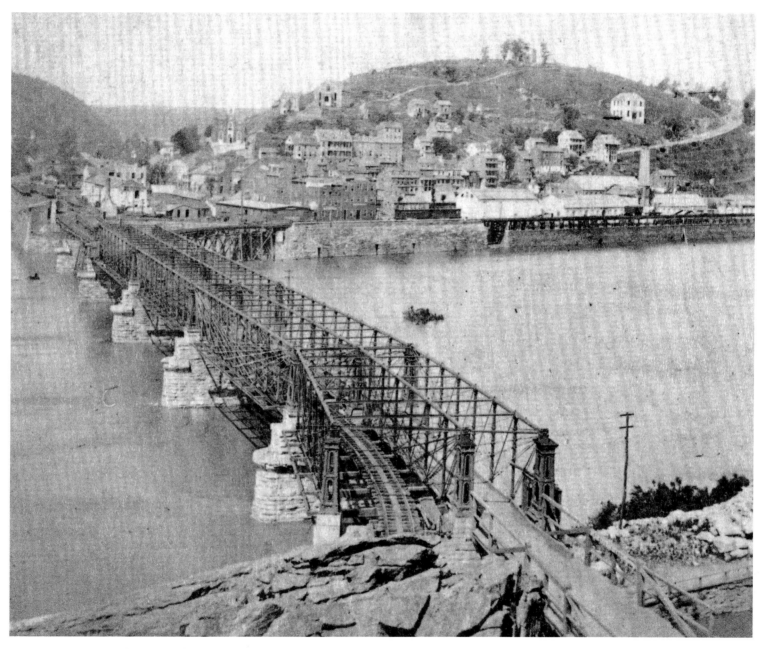

By the spring of 1861, North and South were at war. The U.S. Arsenal at Harpers Ferry had supplied guns to Lewis and Clark and equipped many troops of the Mexican War, but it was destroyed early in the Civil War. The town still remained strategically important. The Baltimore & Ohio Railroad, the only continuous rail line between Washington and the states west of the Ohio, passed through it.

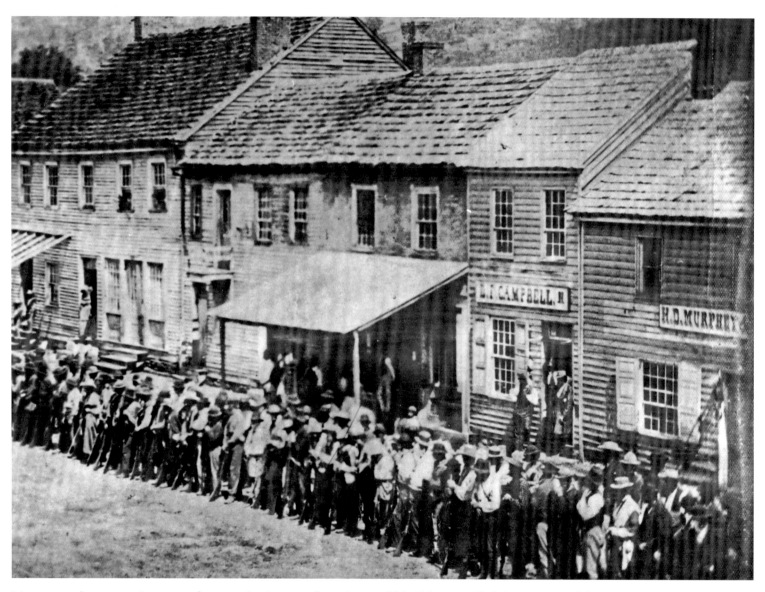

Morgantown became a primary spot for mustering in troops from the state. This 1861 group likely became part of the First West Virginia Infantry. The state raised 17 infantry and seven cavalry regiments, plus an artillery regiment. In 1863, the Jones-Imboden raiders swept through Morgantown before fighting a battle at Fairmont and making history's first military raid against an oil field, at Burning Springs near Elizabeth.

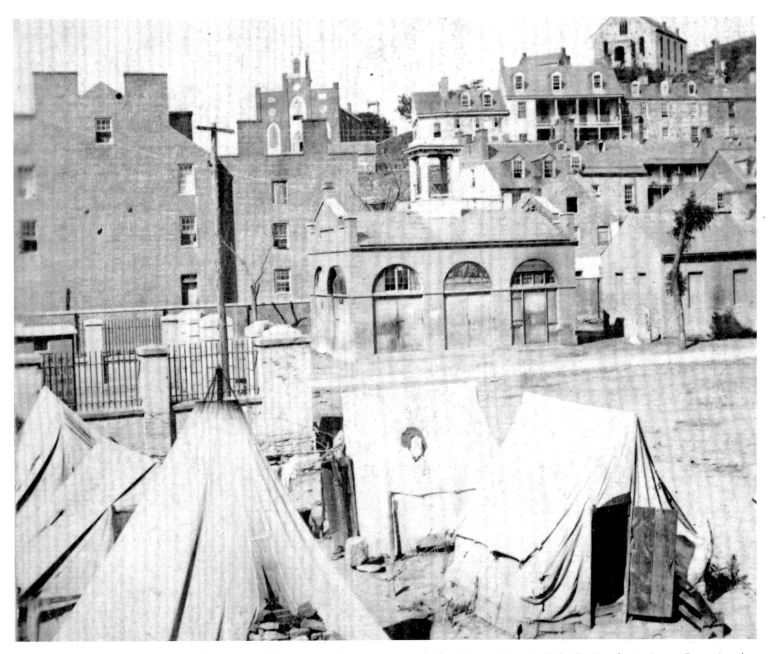

These tents, including a Sibley tent at left foreground, were photographed at Harpers Ferry in 1862. During the Antietam Campaign that September, the Union troops in the town were captured by Confederate forces under Major General Thomas "Stonewall" Jackson, a native of Clarksburg whose military tactics are still studied worldwide. At Harpers Ferry in 1861, he seized six locomotives and had them dragged along dirt roads to present to the Confederacy.

With the war over and statehood secured, the state turned to the business of commerce and attracting new settlers. Steep mountains and rough roads were a barrier to development. In this 1872 photo, a group of teamsters takes a well-earned dinner break at Caldwell's near Lewisburg in Greenbrier County.

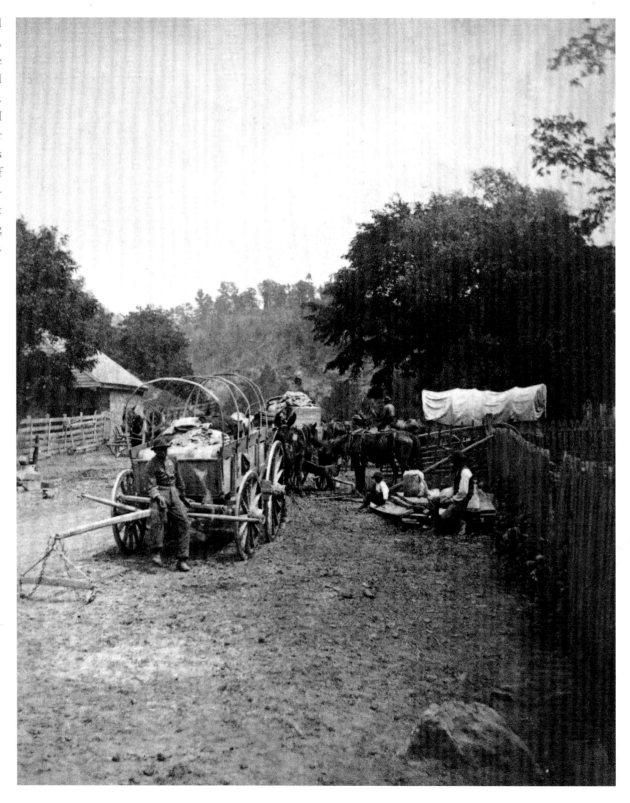

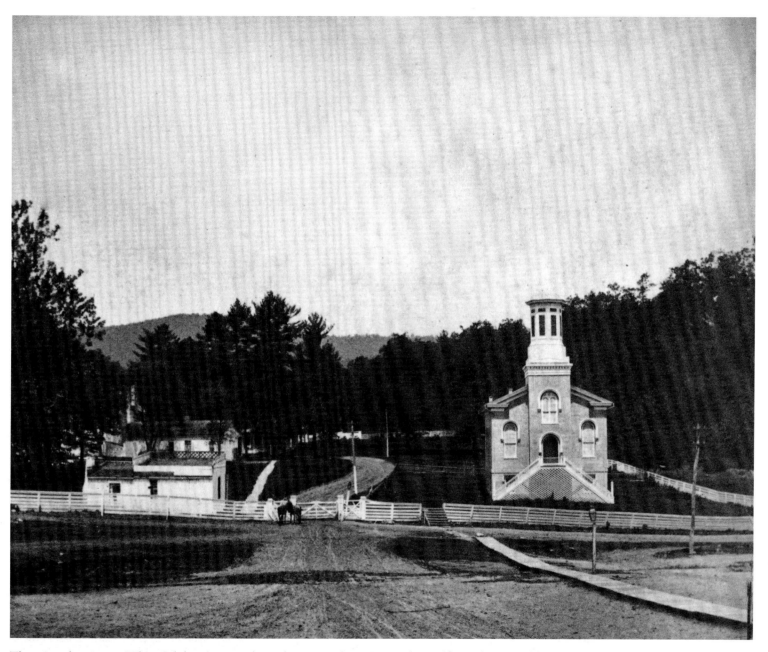

The mineral springs at White Sulphur Springs, shown here around 1872, are rich in sulfate, calcium, and bicarbonate. People of the native tribes considered them healing waters, and visitors were using the springs as a curative by 1778. White Sulphur Springs became one of the preeminent spas of the South. Colonel George S. Patton of Charleston, grandfather of the famed World War II general, won a Confederate victory here in August 1863.

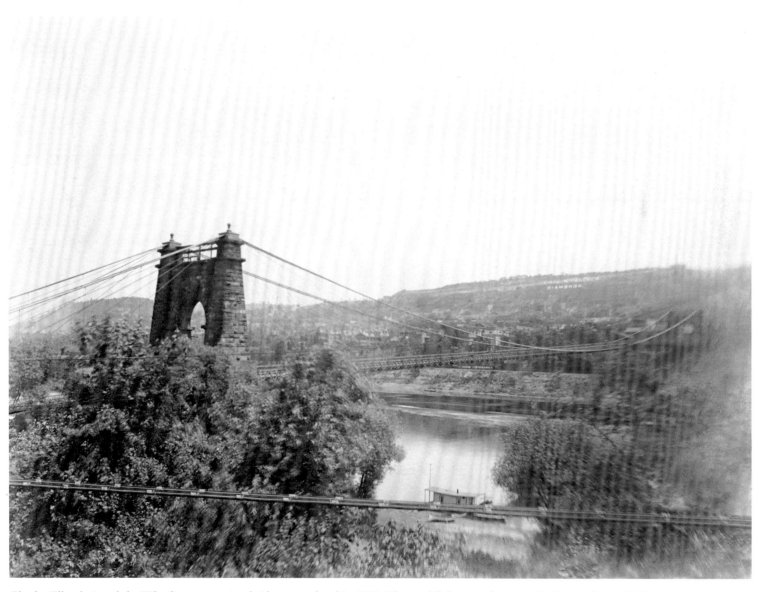

Charles Ellet designed the Wheeling suspension bridge, completed in 1849. The world's longest clear-span bridge until the 1960s, it allowed land transport to cross the Ohio River. It was too low to allow some riverboats' smokestacks to pass under it, resulting in *Pennsylvania vs. Wheeling and Belmont Bridge Company,* the first Supreme Court case concerning bridges obstructing riverboat traffic. The distant sign, in Ohio, advertises Wheeling jeweler Charles Hancher. A clock that was in front of his shop still stands.

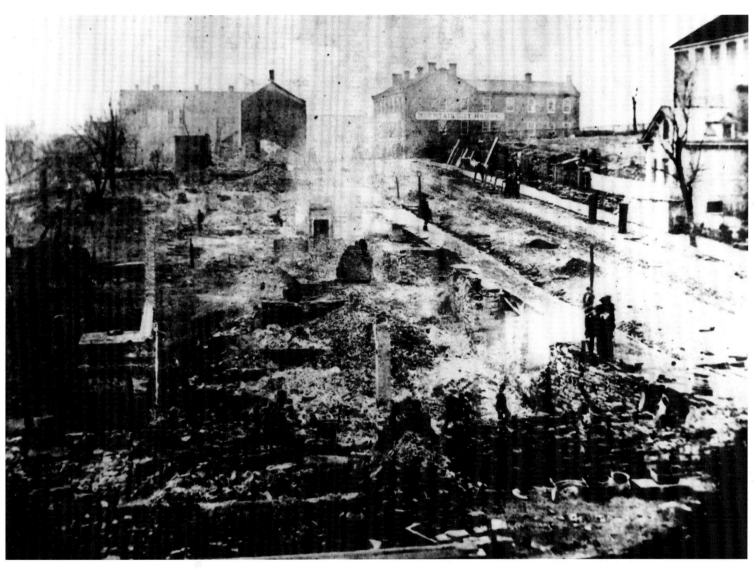

Early on April 2, 1876, a fire began near a saloon in Fairmont. The buildings south of Main (Adams) Street, the area shown here after the fire, were wooden structures built close together and dried by years of wind and weather. The flames spread quickly. Damages totaled nearly $93,000, only some $26,000 of which had been insured. Every city in the state has experienced at least one such conflagration.

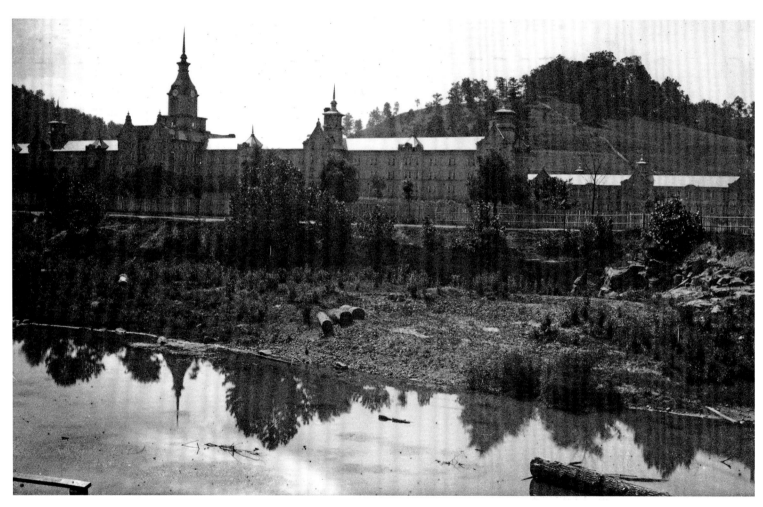

Construction on the Trans-Allegheny Lunatic Asylum in Weston halted in 1861 but resumed in 1862. Renamed the West Virginia Hospital for the Insane in 1863, its first patients entered in October 1864. Six years later, the legislature approved funding for new structures, including a separate building for black patients. The hospital closed in 1994. Attempts are presently underway to find new uses for the two-tenths-mile-long main building shown here.

This photo from around 1885 shows why Davis in Tucker County was once nicknamed Stump Town. Politician and industrialist Henry Gassaway Davis procured the heavily forested land. In 1884, railroad surveyor James Parsons arrived with his wife, and they lived in a boxcar while he laid out the town. By 1893 it had electricity, generated by a plant on Beaver Creek. About a decade later, it boasted 3,000 residents, a hospital, and over 80 businesses.

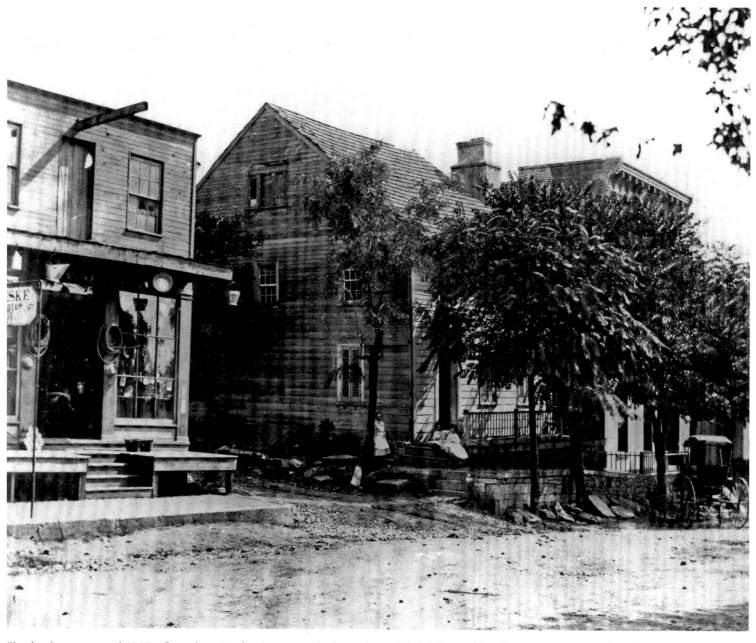

Shepherdstown around 1887 reflects the quiet dignity expected of one of West Virginia's two oldest incorporated towns; the other is Romney. Built near Pack Horse Ford on the Potomac, Shepherdstown has entertained many U.S. presidents. From 1865 to 1871 it was the Jefferson County seat. After losing that position, the town obtained a charter for Shepherd College, a coeducational normal school. Today, Shepherd University is home to the Robert C. Byrd Center for Legislative Studies.

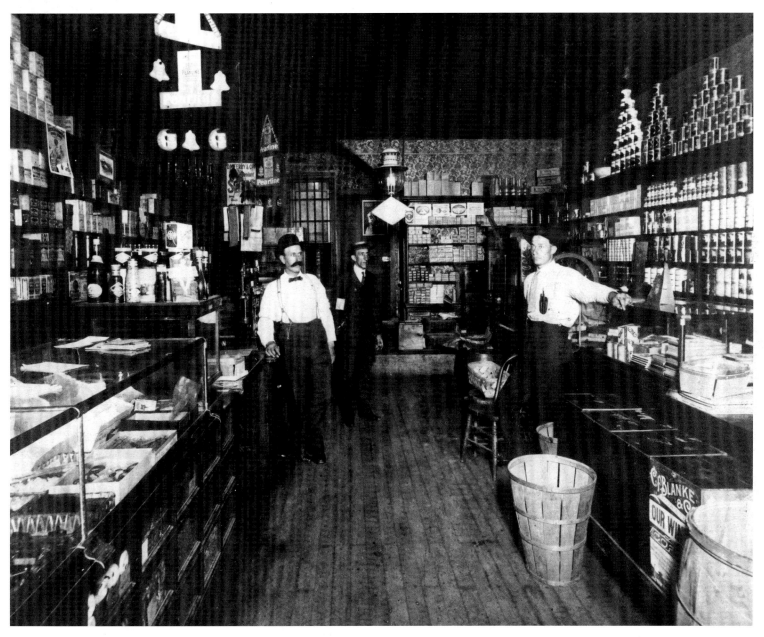

The man sporting the handlebar mustache managed this company store at Montana Mines, a coal camp in Marion County. In the 1880s, coal companies built and owned entire towns. Mine workers were often required to live in company houses and shop at the company store, using company "script" in place of cash. These practices added to the company's financial stability and made it more difficult for miners to go on strike.

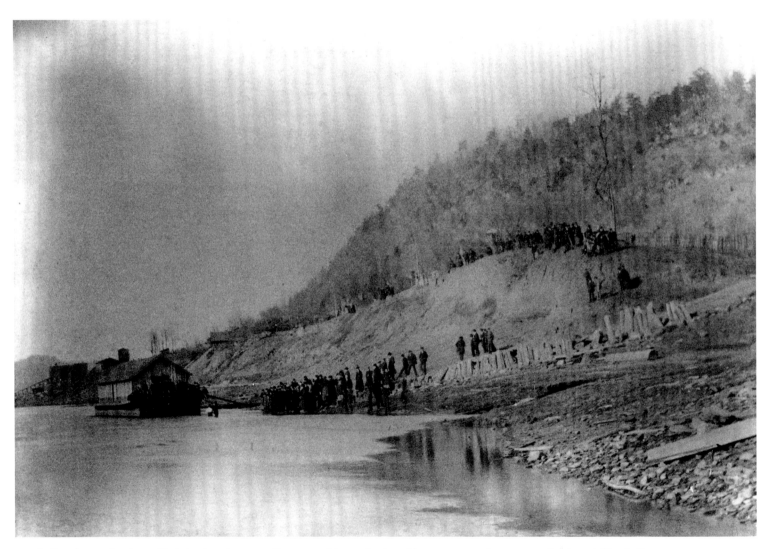

We shall gather at the river: Christian baptisms usually occurred in creeks, but this event around 1880 near Raymond City in Putnam County used the Big Kanawha. The number of participants suggests a revival (camp meeting) was taking place. Revivals were born in the Great Revival or Second Great Awakening, an evangelical movement on the frontiers of the 1820s. They became important spiritual and social elements of community life in West Virginia.

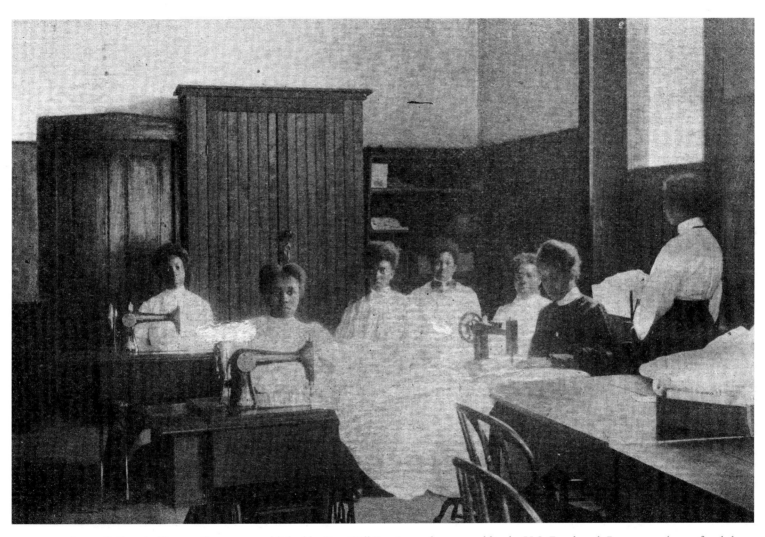

Storer College in Harpers Ferry was established by Free Will Baptists and supported by the U.S. Freedman's Bureau to educate freed slaves from the Shenandoah Valley. Its classes were integrated from its beginning in 1867. Frederick Douglass served on its board. It hosted the 1906 meeting of the Niagara Movement, forerunner of the National Association of the Advancement of Colored People (NAACP). This photo shows a class in sewing and dressmaking.

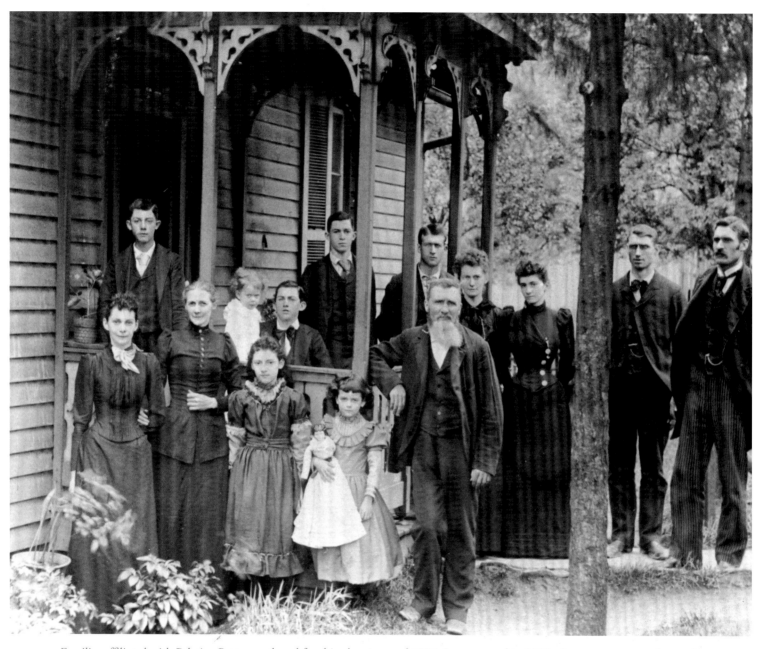

Families affiliated with Palatine Pottery gathered for this photo around 1893. Incorporated in 1877, the company manufactured stoneware, stone piping, and other clay-based products and operated a mercantile store. Palatine was the original name for East Fairmont, reportedly given to it by settlers from the Palatinate States of Germany. For a time it outranked Fairmont in population and number of businesses. It merged with Fairmont and West Fairmont on February 18, 1899.

West Virginia University faculty members display the tools of their particular disciplines, between 1882 and 1884. It opened as the Agricultural College of West Virginia in 1867, charged with emphasizing agriculture and mechanical arts, but its first president, Reverend Alexander Martin, got the name changed to West Virginia University the following year. Initially, many legislators thought its location was too far removed from the rest of the state.

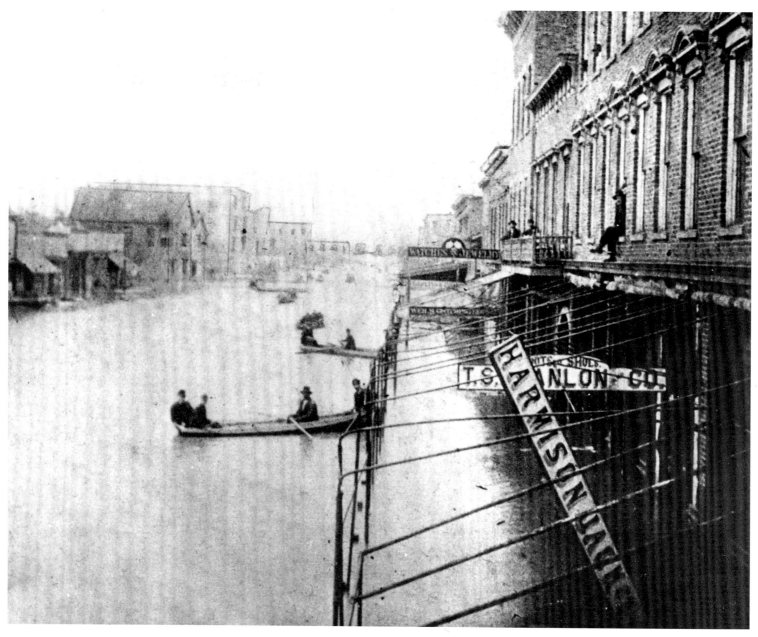

Floods cause most of West Virginia's severe weather damage. February 1884, when this photo was taken in Huntington, brought the most destructive torrents recorded up to that time. At Wheeling, waters crested at an unprecedented 52 feet. Hundreds lost their homes. Four years later a devastating flood wrecked all but one of the bridges in Harrison County. Extensive logging may have exacerbated the problem, permitting rapid runoff during heavy rains.

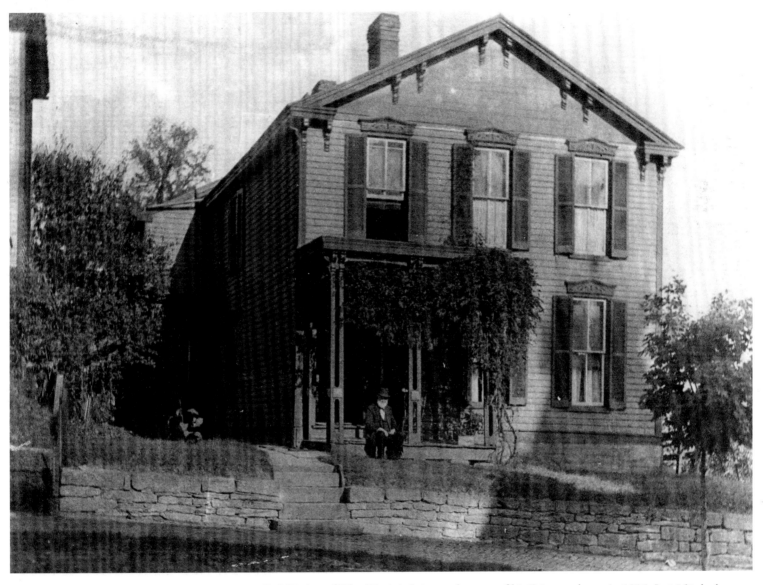

Francis H. Pierpont, sometimes called "Father of West Virginia," sits on the steps of his Fairmont home in 1895. In 1861, he became governor of the Restored Government of Virginia, which oversaw West Virginia until it was admitted to the Union and parts of Eastern Virginia under Union control. During the 1863 Battle of Fairmont, Confederate raiders burned his library in retaliation. He also helped found the West Virginia Historical Society.

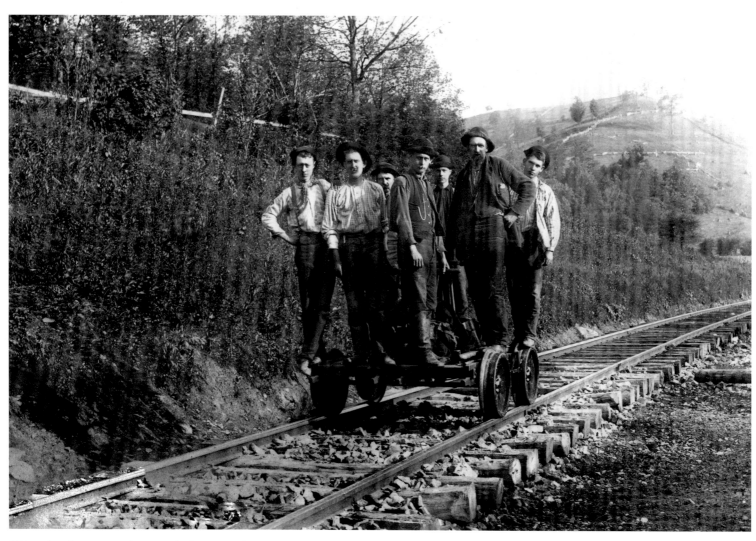

This railroad crew was photographed near Grafton around 1890. Grafton was a child of the B&O Railroad, which arrived in the area in 1852. Chartered in 1856, the town was named for civil engineer John Grafton, who was involved in determining the railroad's path between Baltimore and Wheeling. Many railroad workers were Irish and German immigrants whose arrival marked the first major wave of ethnic immigrants in the state and the first significant numbers of Catholics.

One of these young people sported a WVU beanie while visiting Jackson's Mills outside Weston around 1890. The grist mill behind them and a sawmill beside it belonged to Cummings Jackson. His nephew Thomas, the future Stonewall, grew up here. The gristmill's wheel was horizontal, an unusual feature. After falling into severe disrepair by 1900, the gristmill was restored and still attracts tourists to Stonewall Jackson's Boyhood Homesite today. The name is now Jackson's Mill, singular.

John Koblegard of Denmark and John Ruhl had a produce business in Clarksburg from 1869–1871 before going to Chicago. They returned and opened Ruhl Koblegard & Company Wholesale Grocery in 1880, with additional locations in Weston and Buckhannon. With Peter Koblegard, John's cousin, they organized the wholesale dry goods and notions Koblegard Company. Its building was erected in Clarksburg's Glen Elk section in 1901, around the time this photo was taken.

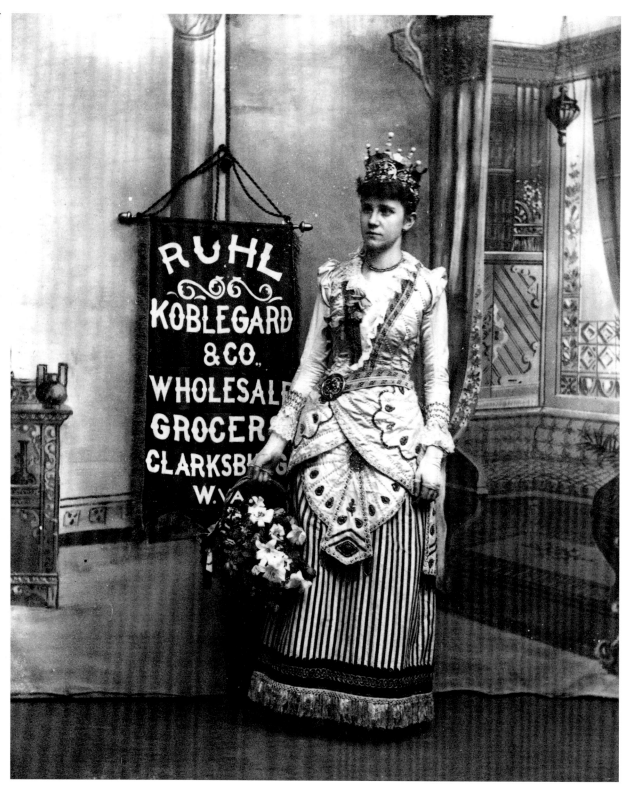

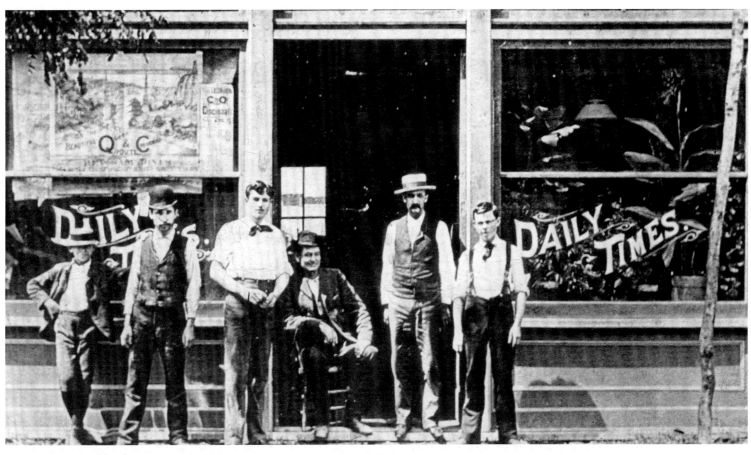

J. R. Dudley of Charleston started Huntington's first daily newspaper, the *Daily Times,* in 1887. It ceased publication early in the twentieth century. This photo of its staff was taken at the *Times* office, 217 10th Street. Huntington's *Herald-Dispatch* began on January 17, 1909, and remains in operation. Many newspapers have come and gone in the state. Two of the more imaginatively named were the *Rattlesnake* in Clarksburg and the *Lubricator* in the oil-field town of Volcano.

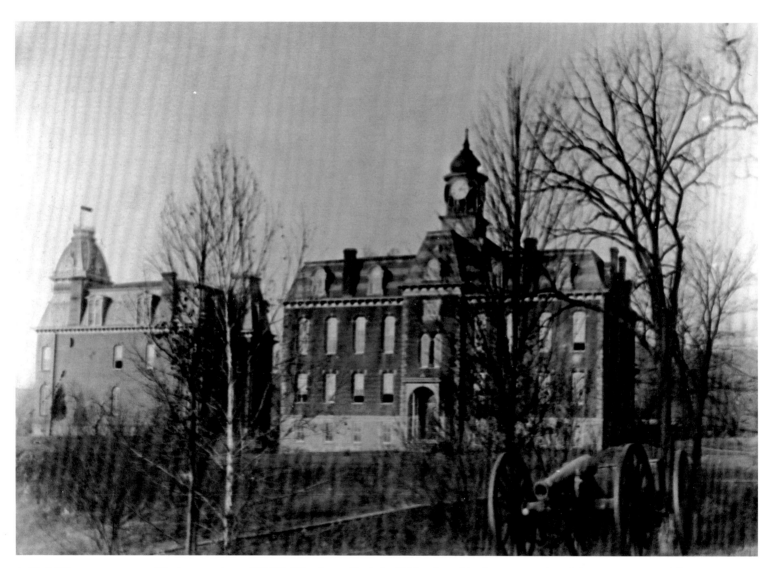

A Civil War–era cannon and limber stood near WVU's Woodburn Circle in 1892, when this picture was taken. Morgantown won rights to the university after state senator William Price of Monongalia County offered the land, buildings, and assets of the Monongalia Academy, including the Woodburn Female Seminary, although the university wouldn't admit women until 1889. During its early years, partisan politics involving lingering Civil War animosities nearly dismantled the college.

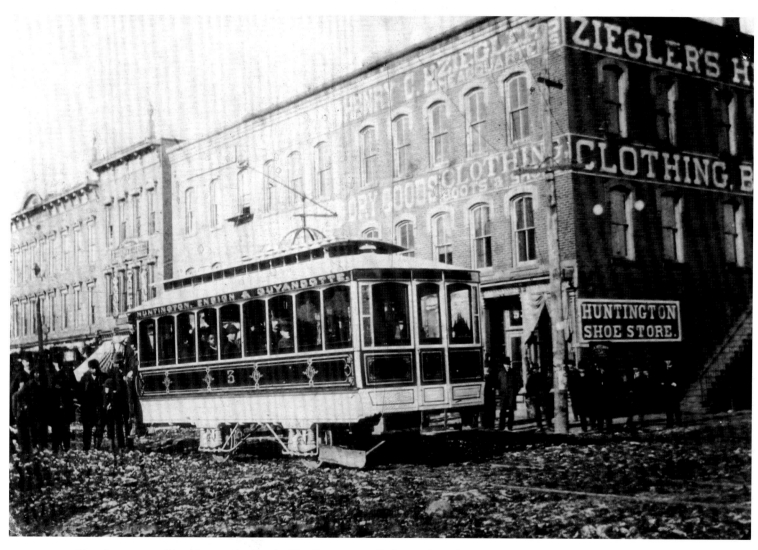

Electric streetcars like this one, the first in Huntington, signaled more than changes in transportation. Transit or traction lines were built between communities, beginning in the late 1800s. The cars required electric lines, and thus, smaller towns along the routes received electricity, which enhanced quality of life and prospects for business development.

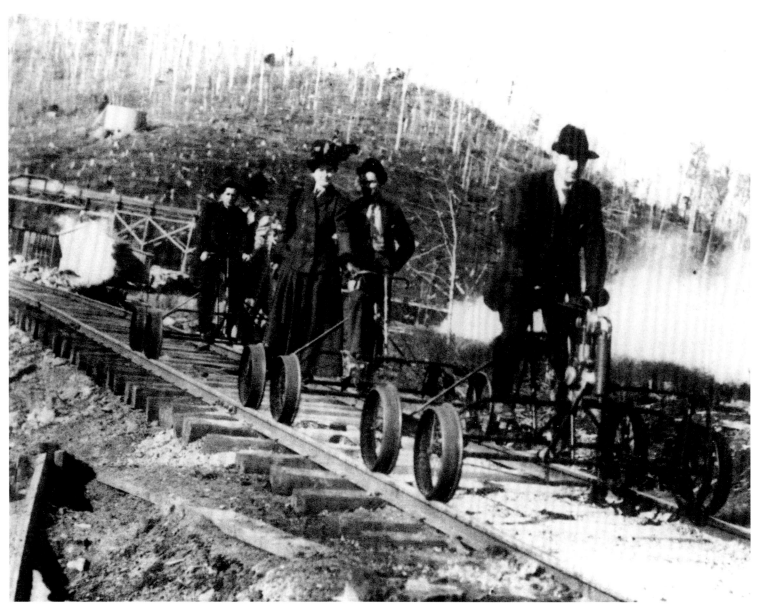

Just going out for a Sunday drive: Vehicles like this speeder were intended to provide transportation for track maintenance crews, but they also gave company officials and physicians a faster means of getting around. They were good for pleasure outings, too, like the one this group is taking on Cheat Mountain.

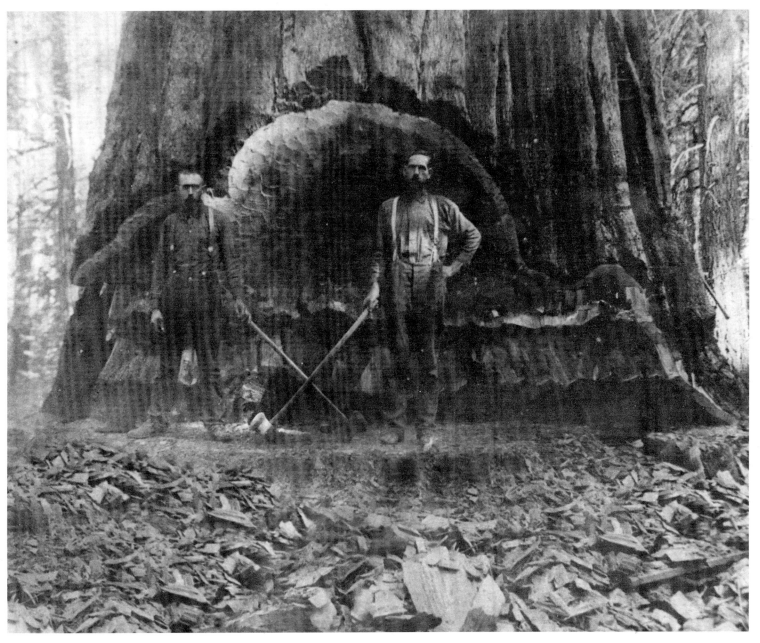

Two loggers stand beside the results of a good day's work. Giant trees like this one were the exception in the Eastern forests, but accounts from the early 1800s tell of felled, hollow trees that a man could ride into on horseback. The caption accompanying this photo says the tree was used in building the *Titanic,* but in fact no American wood was used in constructing that doomed vessel.

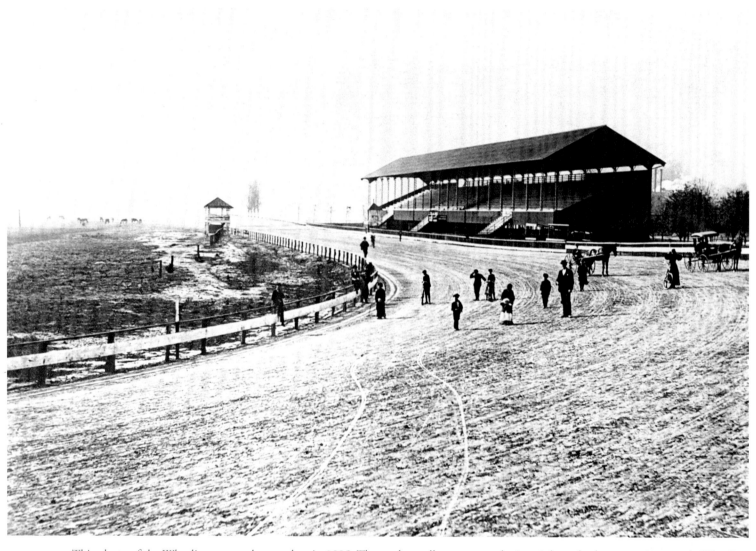

This photo of the Wheeling racetrack was taken in 1895. The track, a roller coaster, a skating rink, and other attractions made Wheeling Island popular in the late 1800s. In September 1924, on a new half-mile track on the island, E. F. "Pop" Geers of Tennessee, perhaps the greatest harness racer of his day, was killed when his horse stepped into a soft spot created by the previous day's rains. Today, Wheeling Downs features greyhound racing.

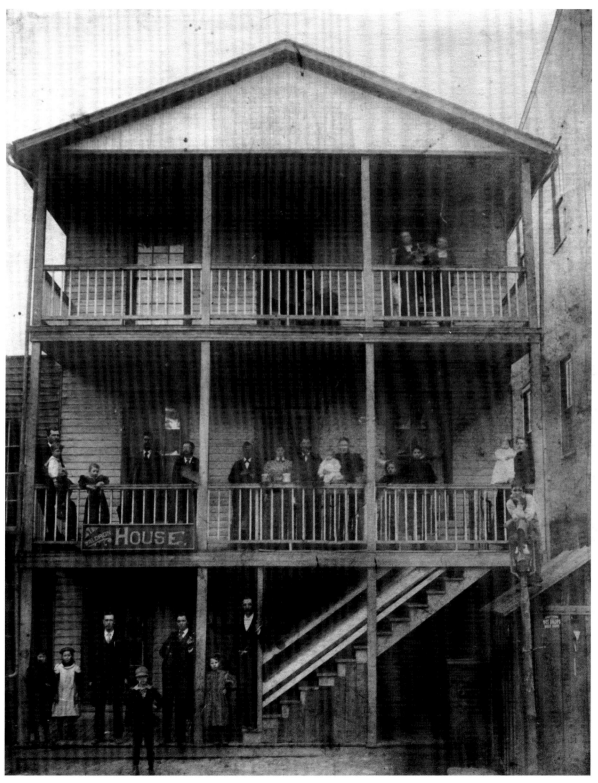

The Waldron Boarding House in Welch wasn't hurting for customers around 1895; the coal town had become an important place in Southern West Virginia. In June 1902, a senatorial convention in Welch split into two factions. Both tried to continue in the same hall, resulting in a brouhaha involving clubs, guns, and knives, according to the *Parkersburg Sentinel*'s account.

The Barlow-Henderson Company Building was considered Huntington's first skyscraper. Located on the northeast corner of 3rd Avenue and 11th Street, it was erected in 1894 and burned shortly after the turn of the century.

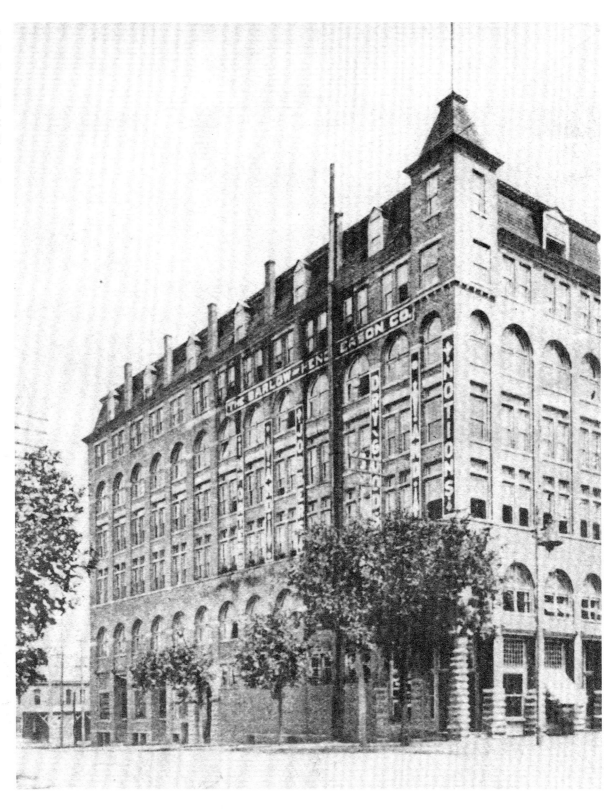

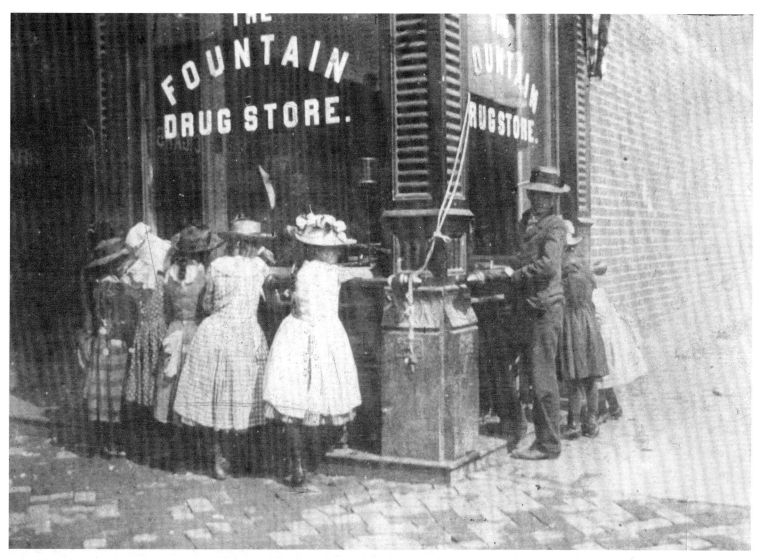

The Fountain Drug Store in Huntington opened in 1898. Owned by William Sampson Vinson, it stood for many years at the northeast corner of 4th Avenue and 9th Street. Vinson was among the organizers of the state pharmaceutical association.

Morgantown turned out in 1899 to celebrate one of its own, Admiral French E. Chadwick, who had been chief of staff of the North Atlantic Fleet during the battle of Santiago in the just-concluded war with Spain. He also served as naval attaché of the American Legation in London and chief of the Naval Intelligence Service. Secretary of the Navy Benjamin Tracey wrote that Chadwick "had a lasting influence upon naval development in this country."

BOTTLES, CIGARS, AND TOILET BOWLS

(1900–1919)

The new century accelerated change in how West Virginians made their living. The 1910 census showed 49.6 percent of the population over the age of 10 was gainfully employed, over four percent more than in 1900. Agriculture, forestry, and animal husbandry accounted for nearly 40 percent of those jobs, and mineral extraction nearly 15 percent. But increasingly, people were leaving farms for work in the manufacturing plants springing up around the state, making everything from glass bottles to cigars to toilet bowls. Oil spewed from a forest of derricks.

Immigration continued to grow. More miners were recruited from Southern and Eastern Europe, Jews fled here from persecution in Russia, and skilled Belgian glassworkers were wooed to the state. Coal assumed a dominant role in West Virginia's fortunes. It made a few people into millionaires and provided a higher standard of living for many than they might have had otherwise. But King Coal demands blood sacrifice on his altar of black gold. American mining deaths occurred at two to four times the European rate. Hundreds of immigrant miners perished when Monongah Mine No. 6 exploded in 1907, the worst mining disaster in U.S. history.

The period 1909–1919 was a time of social change nationally, reflected in everything from permitting direct election of U.S. senators to child labor reform. An international playground movement extolled the virtues of recreation. Three amendments were made to the U.S. Constitution, including prohibition of alcohol sales. West Virginia was ahead of that curve, banning booze six years before the rest of America did.

Anna Jarvis achieved her dream of creating a national holiday to honor mothers. "Good road days" brought out thousands of volunteers to repair the state's atrocious dirt highways.

On Paint Creek, a mine war broke out, signaling the bloody strife that was coming between miners and mine owners. In 1917, America joined the World War in Europe, but some West Virginians, like Weston's Louis Bennett, Jr., didn't wait to go "over there."

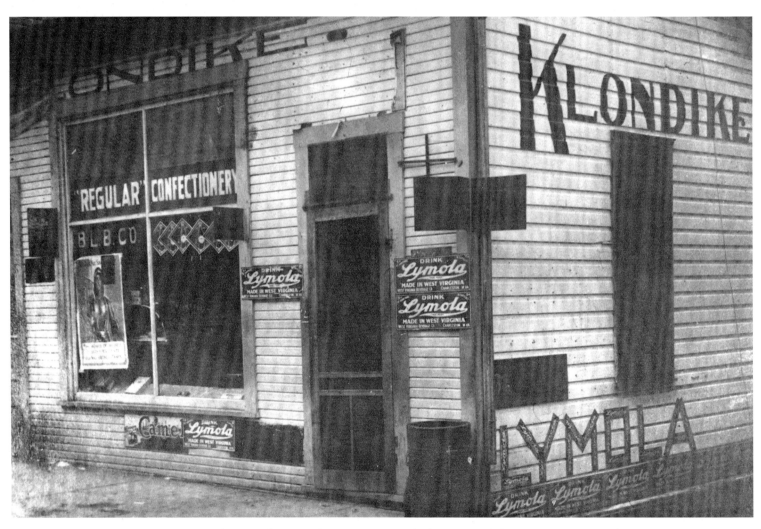

This photo of the Klondike Ice Cream Parlor was taken in Webster Springs near the beginning of the twentieth century. The town was becoming a summer resort, thanks to the arrival of a railroad and the expansion of a grand hotel. Originally Fork Lick, then Addison, Webster Springs has been the name used since 1902. Lymola, "The Pure Cola Drink," was patented by the West Virginia Beverage Company in Charleston.

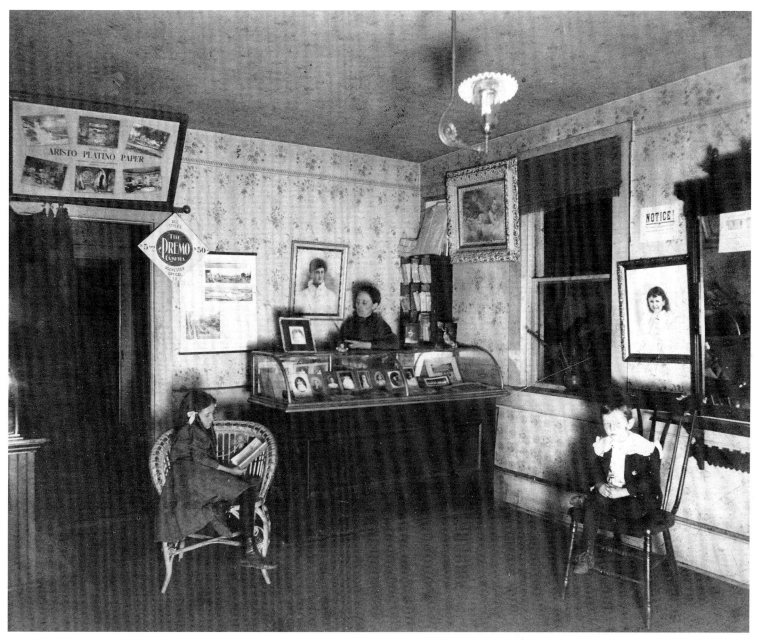

Loar & Company Fine Photographs, studio and wholesaler of photographic supplies, was based in Grafton. This image was taken in their waiting room. W. R. Loar was the first treasurer of the Associated Photographers of West Virginia, which held its first convention in Grafton. Many of the Loar images were donated to the West Virginia and Regional History Collection at West Virginia University.

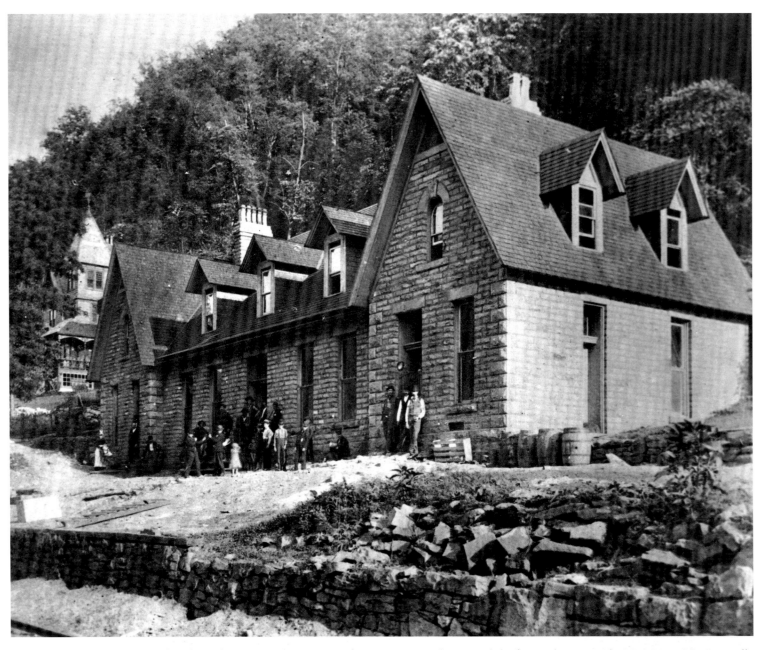

Joseph L. Beury, for whom the Fayette County town of Beury was named, operated the first coal mine on the New River. He reportedly imported stone from Germany to build the house shown in the background, which featured 23 rooms, a swimming pool, stone gardens, and stables. Cost of construction was rumored to be $100,000. Beury died June 2, 1903, and the home later burned. The building in the foreground held Beury's company store and offices.

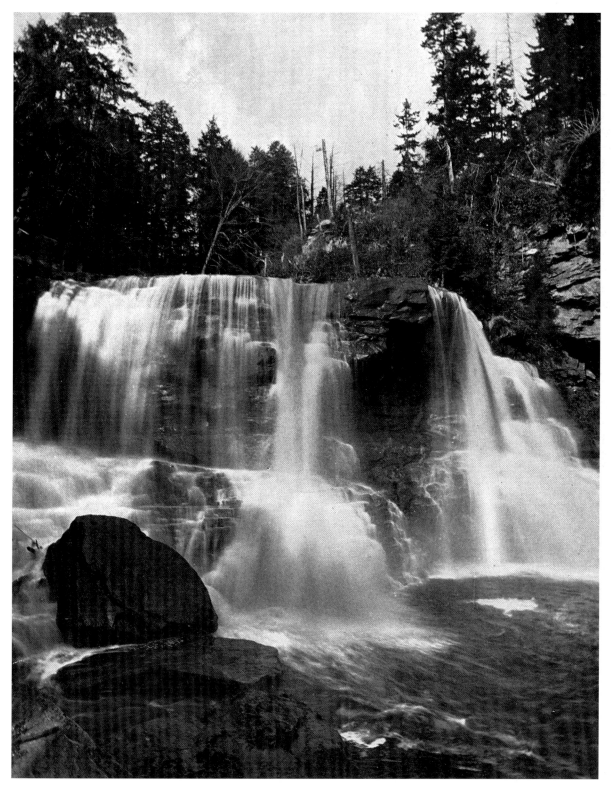

Possibly the most photographed site in the state, Blackwater Falls in Tucker County cascades nearly 60 feet, creating a roar that is heard well before the falls are in view. This photograph was taken in 1901.

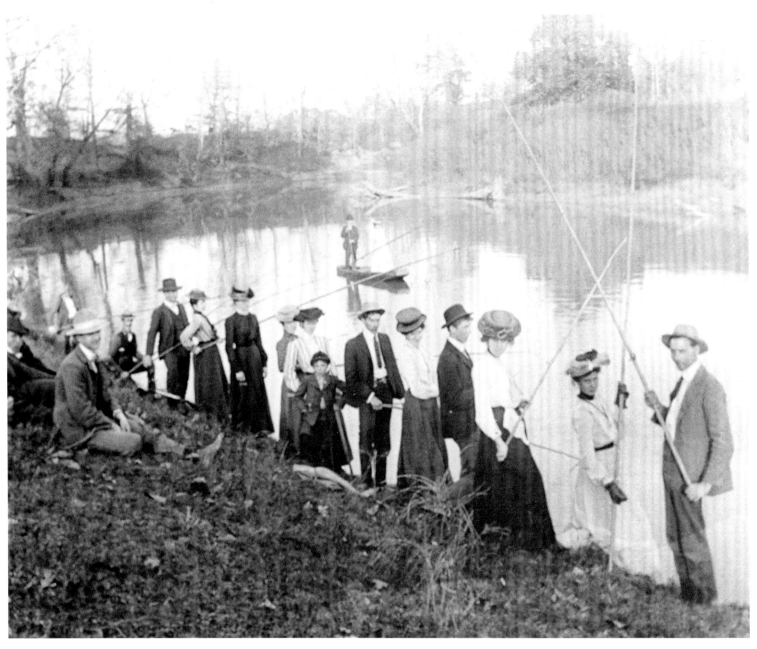

Fishing has always been a popular pastime in the state, which offers anglers everything from small bluegills to muskellunge, from giant catfish to the state fish, the native brook trout. During the 1920s and '30s, streams were stocked with a variety of species delivered in milk cans on specially designed railroad cars.

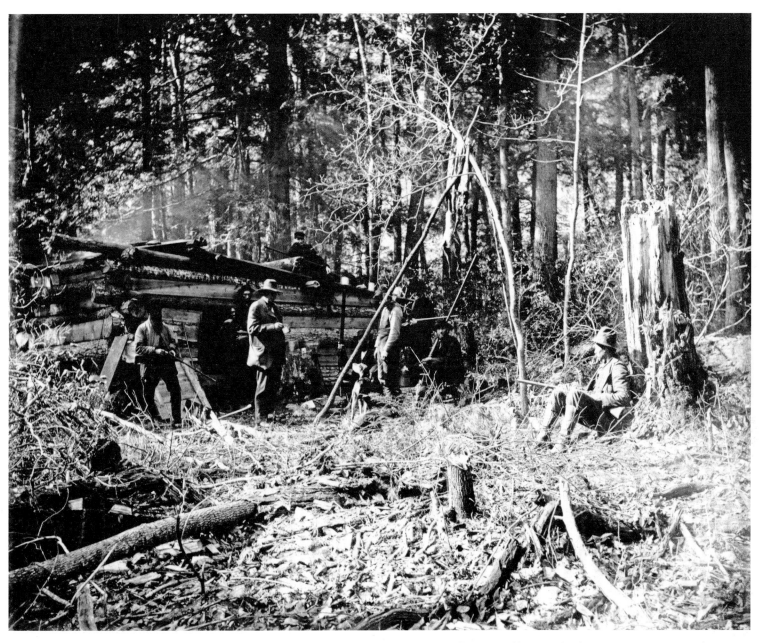

West Virginia's wild, rugged terrain makes it an ideal habitat for many species of game, and hunting has been a mainstay activity here since the days when Shawnee, Delaware, and other tribes hunted deer and bear. This turn-of-the-century hunting party was photographed at their camp before or after the day's expedition. Hunting is on the decline nationally, but West Virginia still attracts 75,000 out-of-state hunters. The sport generates some $300 million annually.

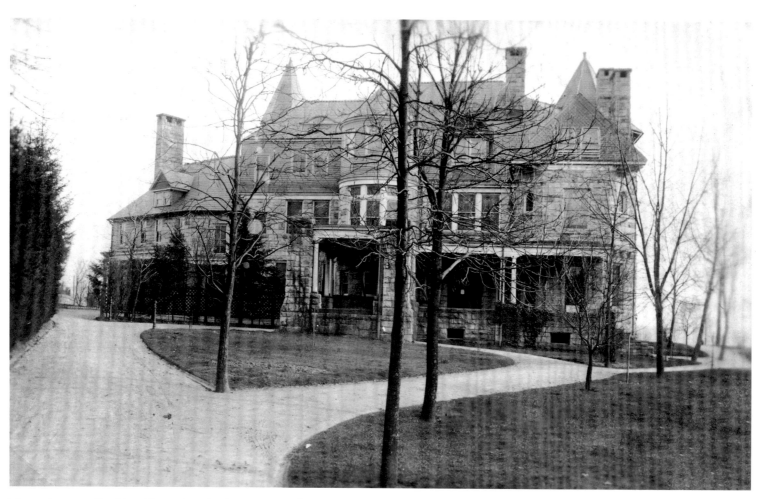

Henry Gassaway Davis' residence Graceland is now part of Davis & Elkins College in Elkins. With only an elementary school education, he made a fortune in land, coal, timber, and railroading. The towns of Davis and Gassaway are named for him. After serving in West Virginia's House and Senate, in 1871 he became the state's first Democratic U.S. senator. In 1904, at age 80, he was the vice-presidential candidate in Alton B. Parker's unsuccessful presidential campaign.

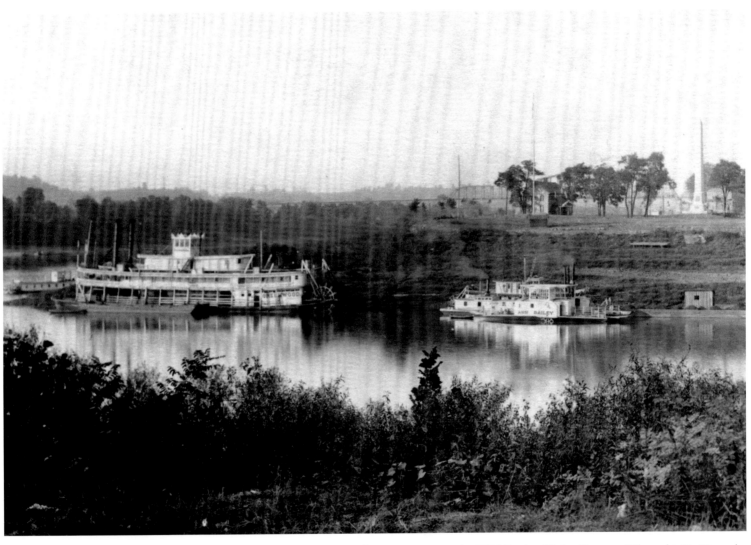

The obelisk beyond the steamboats *Greenwood* and *Ann Bailey* commemorates the 1774 Battle of Point Pleasant. Where the Big Kanawha joins the Ohio River was once Tu-Endie-Wei, "where two rivers meet," a name believed to come from Wyandot Indians. The battle here was the largest between white settlers and Indians east of the Mississippi, with about 1,250 on each side. General Andrew Lewis achieved victory over a force led by Shawnee chief Keich-Tuch-Qua (Cornstalk).

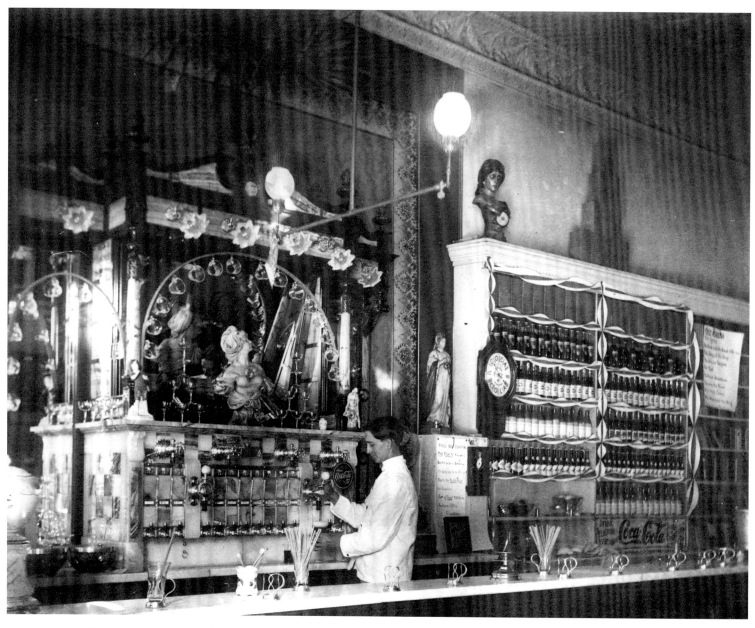

The sign near the soda jerk in this photo of a Morgantown drug-store soda fountain says that anyone who purchased one of the books shown at far right would be entered in a drawing for a trip to "the <u>World's</u> <u>Fair</u> and Exposition." The Louisiana Purchase Exposition World's Fair was held in St. Louis, 1904. Cook-Hayman Memorial Pharmacy Museum at WVU preserves memorabilia from old-time pharmacies like this one.

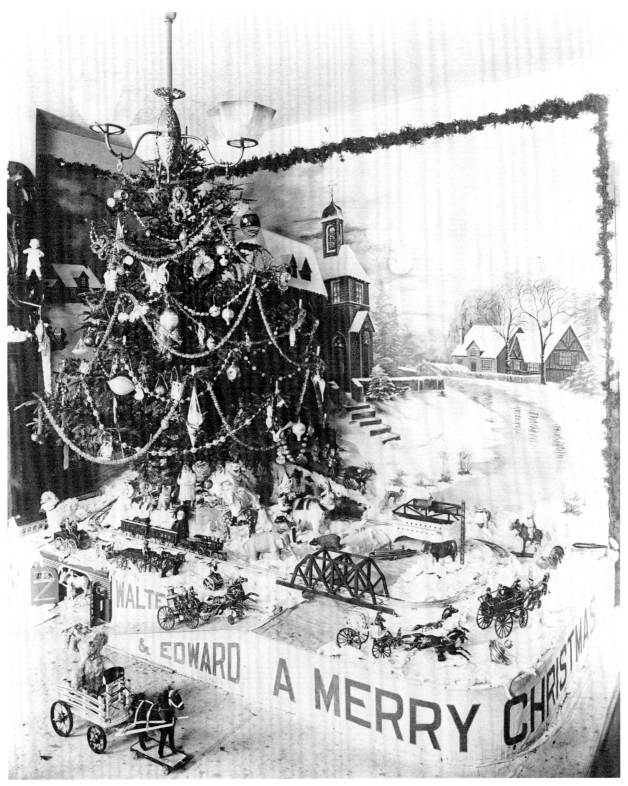

A display in a Wheeling store window, Christmas Day, 1906, reflects changes in Christmas celebrations. Once, dangerous fireworks battles were the highlight of the day in many towns. By the late 1800s, advertisements for "large, handsome, nicely dressed dolls," toy guns, Kodak cameras, and other manufactured goods had become common. Newspapers began tracking retailers' success. The *Intelligencer* in Wheeling reported in 1899 that Christmas sales were up as much as 40 percent.

Fireflies flicker, whip-poor-wills sound their call, a fox barks in the distance, and twilight settles over the land. Quiet scenes like this one along Ten-Mile Creek near Marshville in Harrison County are a big part of why West Virginians feel such strong attachments to their state, wherever life may take them.

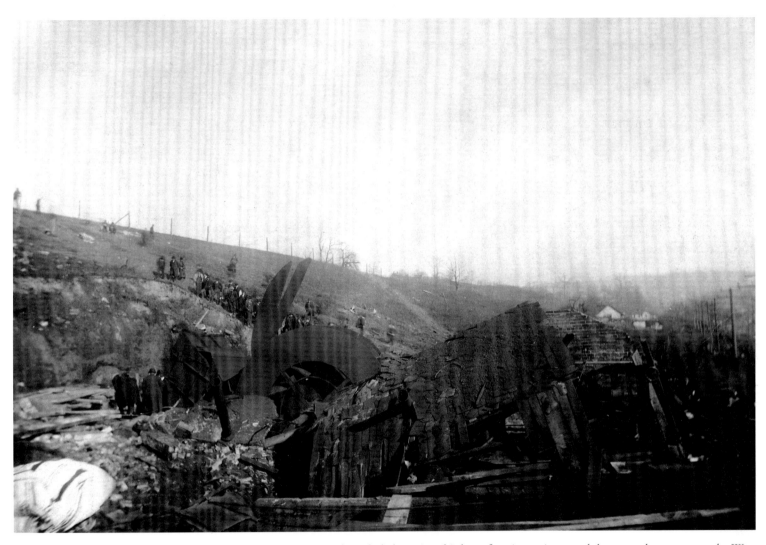

On December 6, 1907, Mine No. 6 at Monongah exploded, tossing this huge fan. A massive portal door was thrown across the West Fork River. It is still the worst mining disaster in U.S. history. The cause is uncertain, but probably one or more runaway mine cars collided in the shaft, setting off sparks that ignited gases and coal dust. Similar incidents had occurred there with less devastating effects in 1894 and 1906.

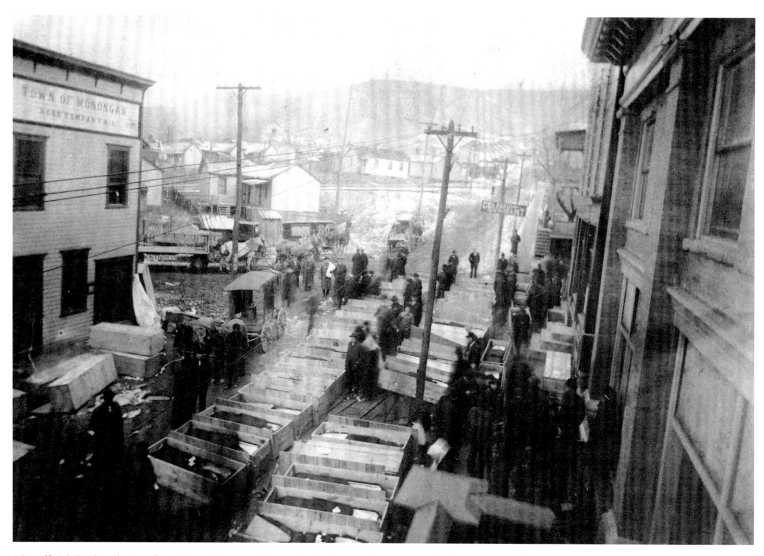

The official death toll given for the 1907 catastrophe was 360 miners and one very unlucky insurance salesman, but because the miners were mostly immigrant laborers who took other family members along to help them dig more coal and receive a larger paycheck, the actual number will never be known. By some reports, over 500 coffins were ordered. The dead were laid out in the streets of Monongah.

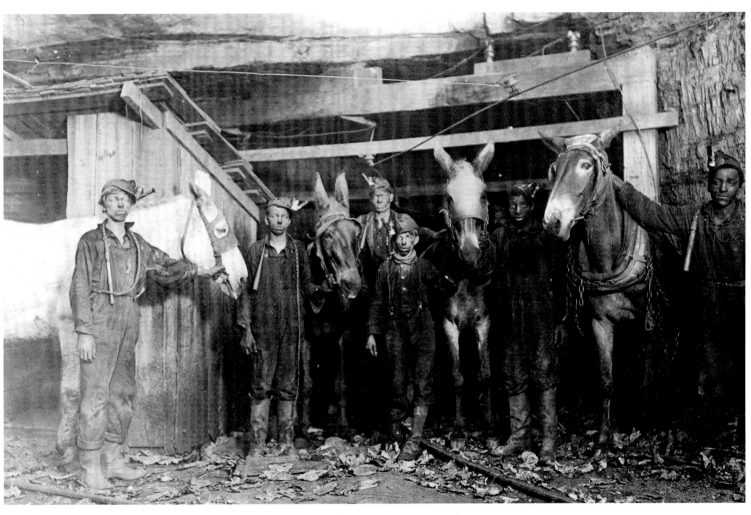

Many mine mules spent virtually their entire lives underground. It would have taken too long to get them from above ground to the work areas. When this 1908 shot was taken at the Brown Mines in Brown, Harrison County, machinery was already slowly replacing mules. *Charleston Daily Mail* reported on March 4, 1914, that a Fayette County mine saved $280 a month by replacing mules with machinery. Some mules were still used into the 1960s.

Young, but not for long: When crusading photographer Lewis Wickes Hine took this photo in September 1908, the coal-dust-covered youngster posing for it had been working for a year as a driver of mule teams that hauled coal in the mines at Brown. His shift was 7:00 A.M. to 5:30 P.M. daily. The lamp on his headgear, known as a wick or teapot lamp, burned oil or tallow fuels that produced an open flame.

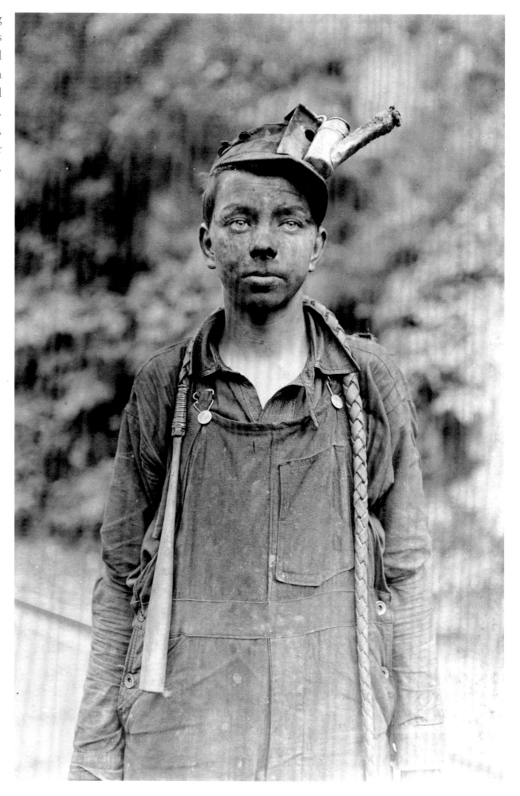

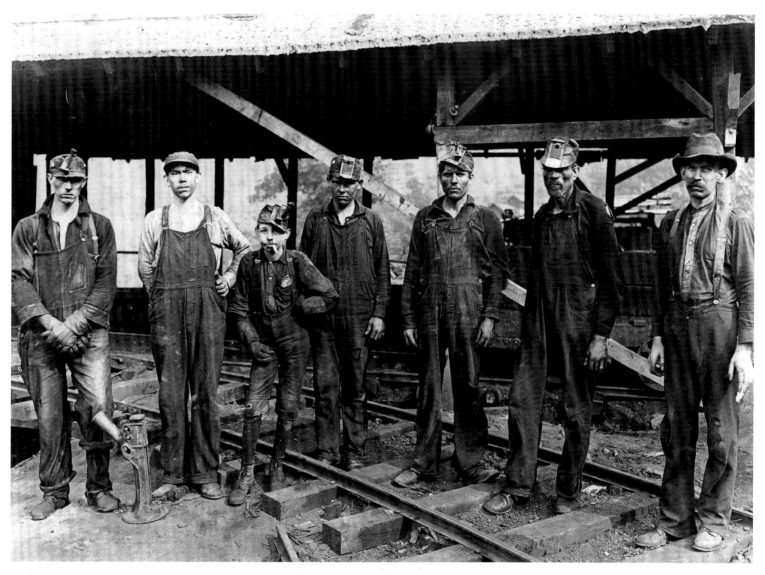

Turkey Knob Mine's tipple crew at Macdonald, south of Oak Hill, posed for this photo in 1908. The small size, slender limbs, and odd angle of the arms of the third man from left suggests he may have suffered infantile paralysis—polio—as a child. The viral disease was once a scourge. Children who developed limb weakness or partial paralysis were sometimes bribed with cigarettes to get them to move despite the pain.

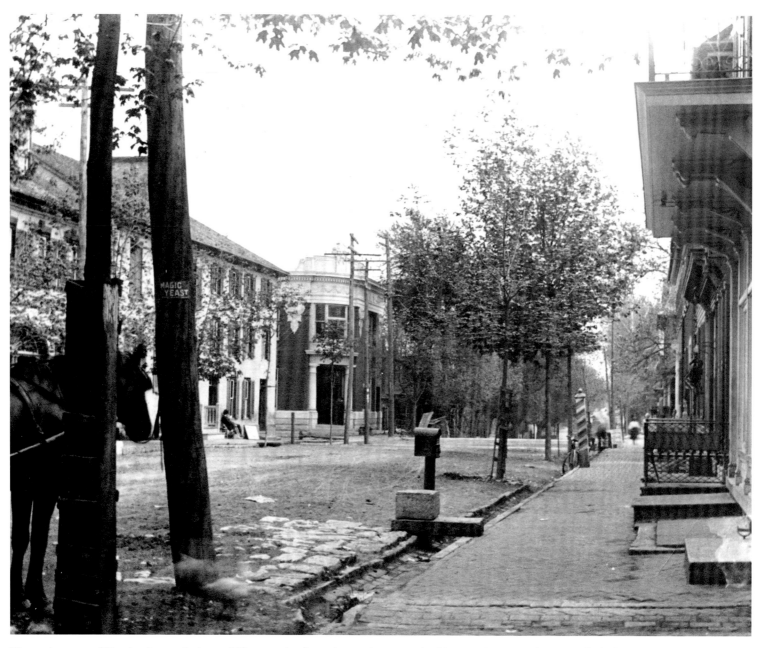

The main street of Shepherdstown isn't too different today from the way it appears in this 1910 image, and tourists flock there on sunny weekends. The building at the far end of the street, just four years old when this picture was taken, would be Shepherdstown's main bank for 69 years. Today it houses an upscale restaurant, the Yellow Brick Bank, a favorite of former First Lady Nancy Reagan.

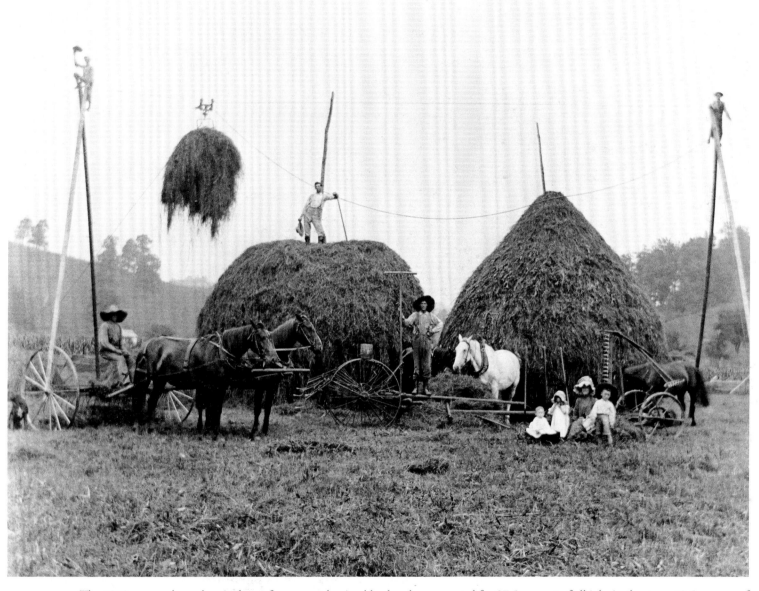

The 1910 census showed agriculture, forestry, and animal husbandry accounted for 37.5 percent of all jobs in the state; 12.5 percent of those workers were women. Federal and state programs attempted to teach farmers and homemakers more efficient methods. In 1913, just five county agents demonstrated more effective techniques to 1,200 farmers. Many older farmers were resistant to change, so Boys and Girls Clubs were established to train young people.

West Virginia's oil industry began shortly after practical uses were found for petroleum in the late 1850s; previously, people drilling in hopes of finding salt cursed the black stuff that often bubbled up from their holes. History's first military action against an oil field occurred May 9, 1863, at Wirt County's Burning Springs. By the early 1900s, forests of oil and gas derricks were sprouting around the state.

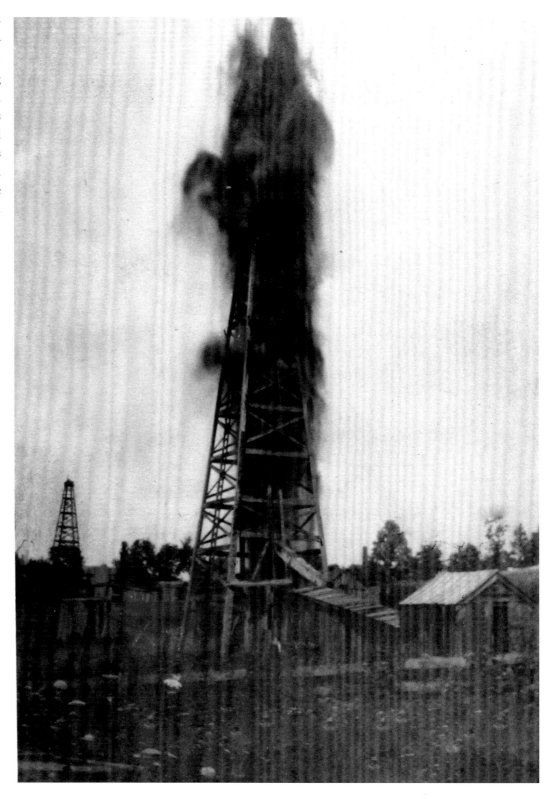

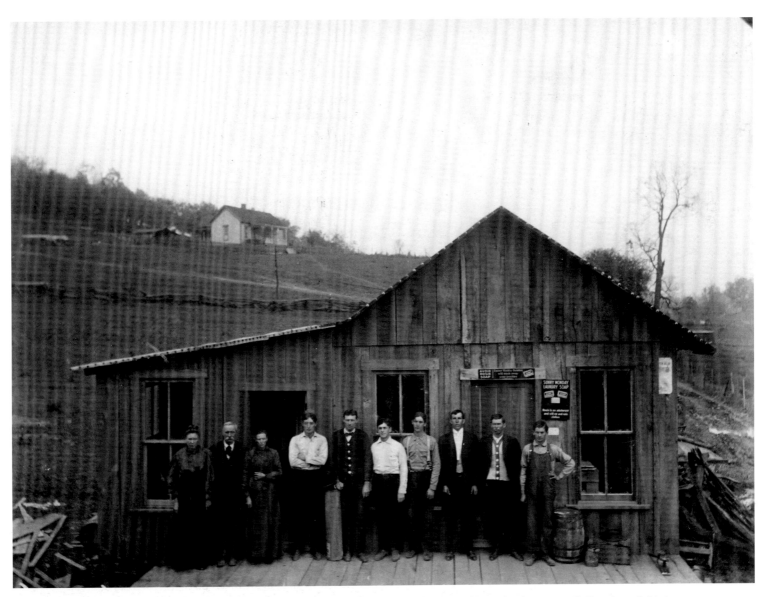

Lambert Brothers store and restaurant at Adamsville near Shinnston was a classic example of how the discovery of oil and gas fields in an area boosted the entire economy. Oil-field workers had to eat and buy sundries. On weekends they wanted to find entertainment and get drunk. A host of small businesses like this one would spring up to fill one or more of those needs.

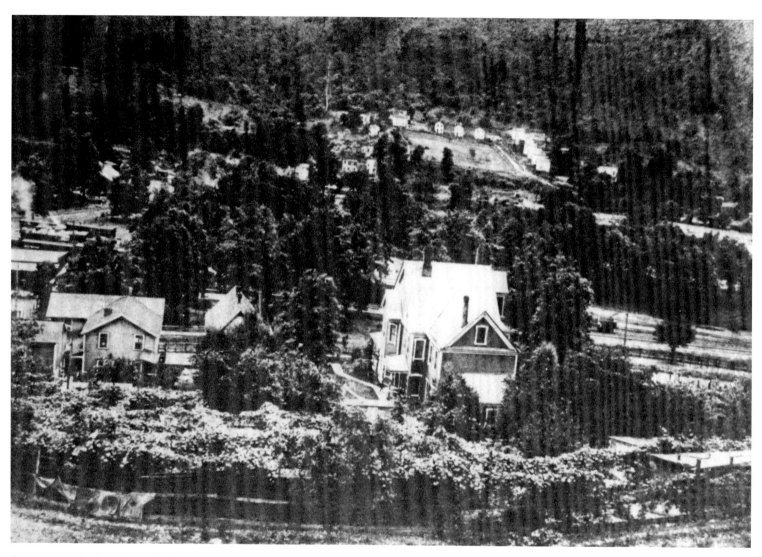

Even among rough-and-tumble logging, oil, and coal camps, Brooklyn Heights was a "Dodge City." Homer Floyd Fansler, in his *History of Tucker County*, claimed he could stand on his front porch and see the locations of nine murders. Charles Darwin Gillespie created the town across the river from Hendricks when Hendricks voted itself dry in January 1901. Gillespie's saloon prospered until statewide prohibition in 1914. Brooklyn Heights was incorporated from 1904 to 1915.

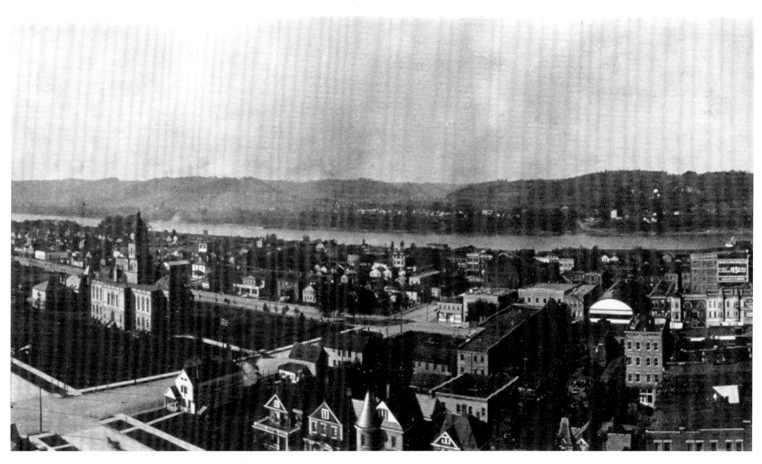

This 1910 panoramic of Huntington shows how the town had prospered in the years since Collis P. Huntington founded it in 1871 as the terminal point of his Chesapeake and Ohio Railway. Its location made for easy transfer of freight or passengers from riverboat to railroad, and it already had the advantage of an established school—Marshall, which began in 1837 in a log church. Collis Huntington also established Newport News, Virginia, and its shipyard.

This barge photographed in 1910 would ferry salt from the Dickinson Salt Works across the Kanawha to C&O rail cars. Long before coal was king, salt was the sultan in West Virginia. Kanawha high-grade red salt had a strong, pungent taste and was excellent for curing meat and butter. It was in great demand from about 1800 to the 1850s. The trade was heavily dependent on slave labor.

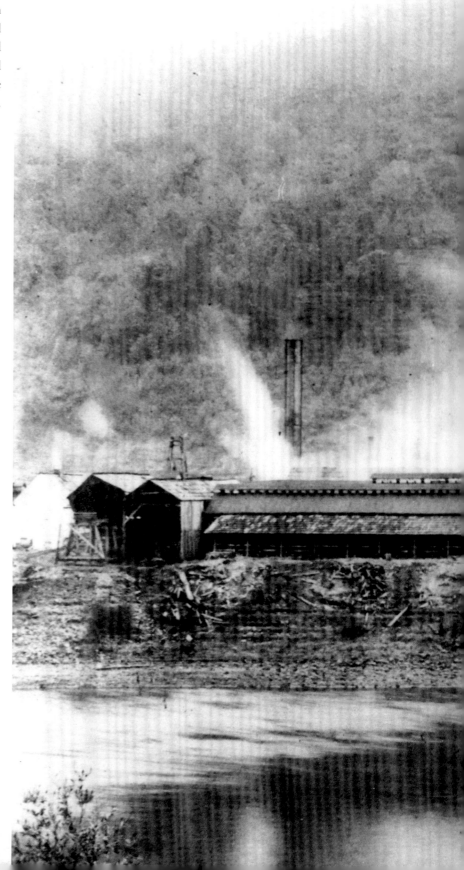

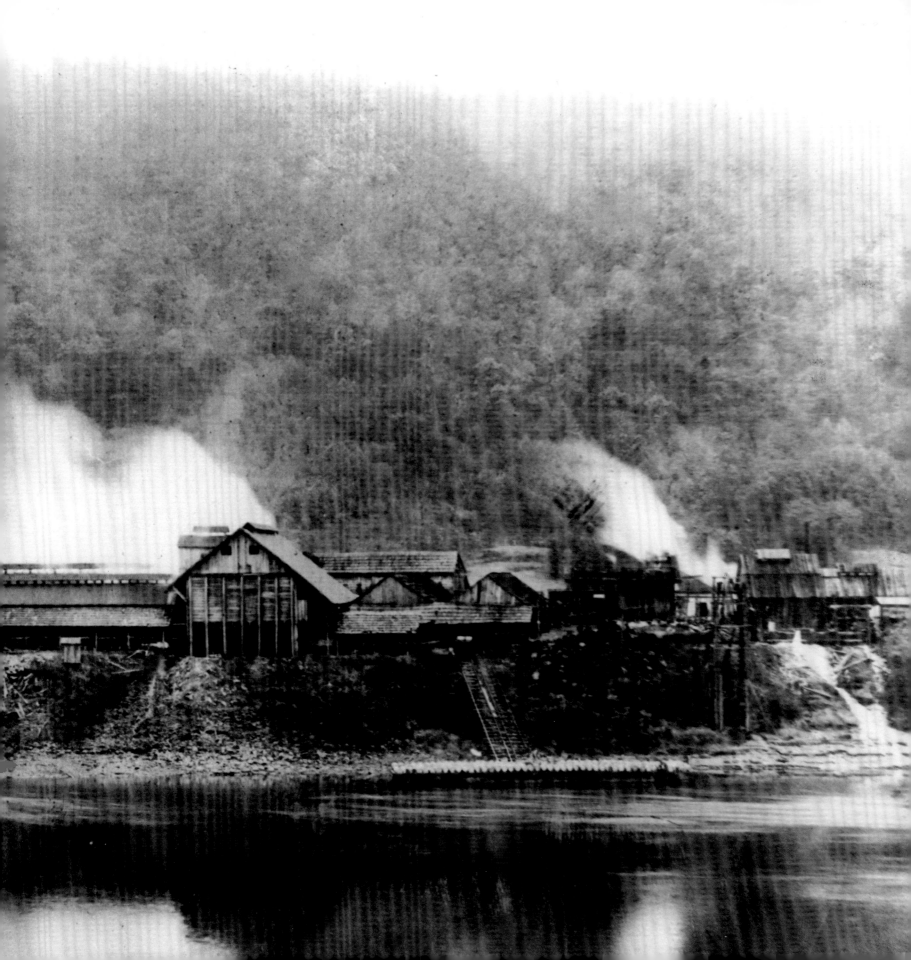

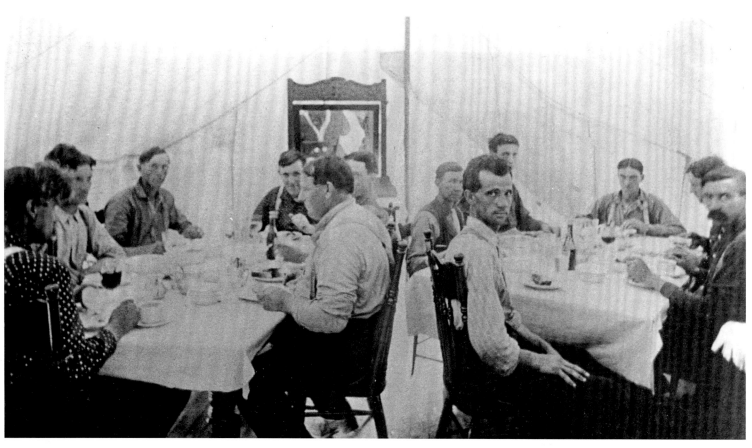

The discovery of oil and gas strained Shinnston's ability to deal with the influx of population; Doak's Dining Tent provided workers at the Mudlick oil field a place to sit down and eat a hot meal. Despite Shinnston's small size, it has influenced the writings of two noted authors, Granville Davisson Hall and Meredith Sue Willis. It grew up around a gristmill Levi Shinn built during the Revolutionary War; his 1778 log home still stands.

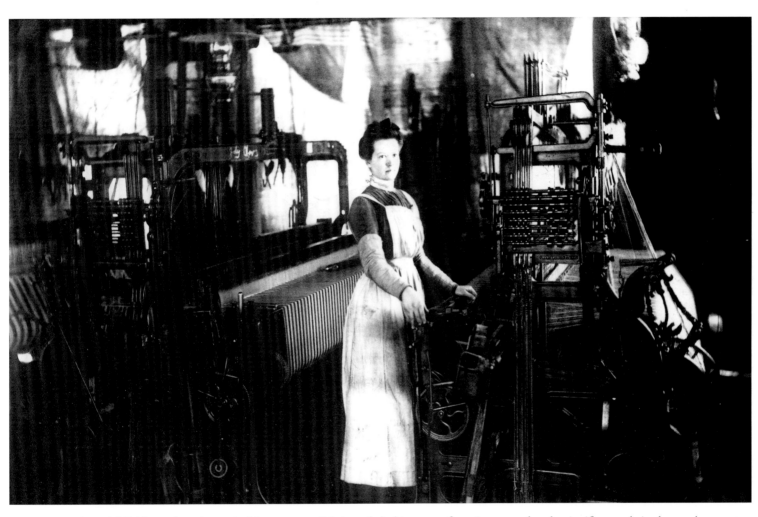

Anna McBride works at looms in Morgantown. Fabric and clothing manufacturing once played a significant role in the state's economy.

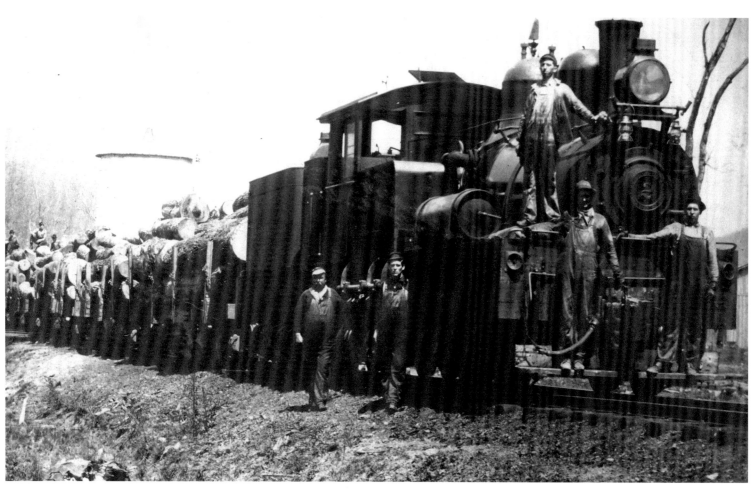

Shay Engine No. 2 of the Meadow River Lumber Company is hauling another load. Thomas and John Raine from Pennsylvania purchased over 100,000 acres of virgin hardwood in Greenbrier County in 1906. They established the town of Rainelle and built the world's largest hardwood mill, with three nine-foot band saws operating inside it. The company provided flooring for New York's Waldorf-Astoria Hotel and, from 1932 until the 1960s, produced millions of shoe heels annually.

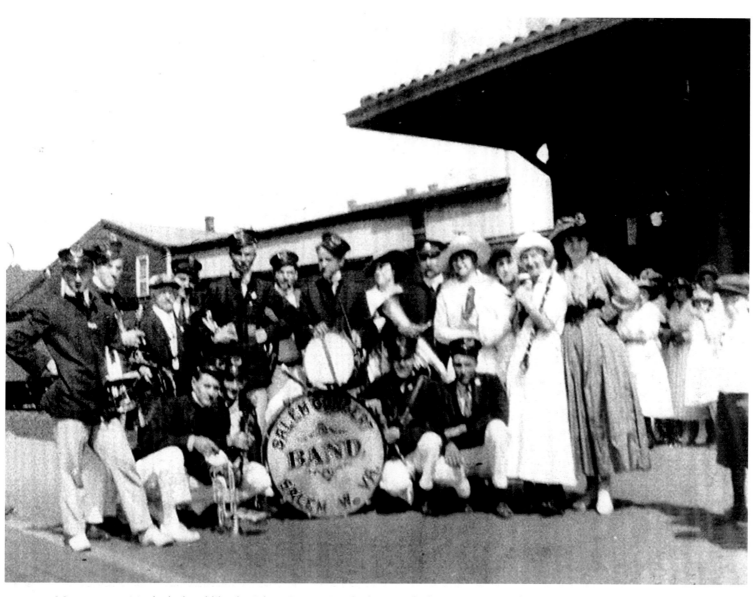

Most communities had a band like the Salem Concert Band, photographed in 1912. Many, if not all, of Salem's band members are believed to have been Belgian. The abundance of clean-burning natural gas drew glass industry to the state, and West Virginia strove to attract skilled Belgian glasscutters. Belgian families required all their children to learn at least one musical instrument. Wherever these immigrants settled, their band frequently became the town's band.

To make bottles and other glassware, skilled workers called gaffers blew into an iron pipe. A mold boy opened and closed a hinged blow-mold as necessary, and a crack-off boy cracked the finished piece from the red-hot pipe. They were called "boys" regardless of age, but factories did employ many youngsters, such as these photographed at Morgantown's Seneca Glass Works. It robbed them of much of their childhood but opened doors to a well-paying trade.

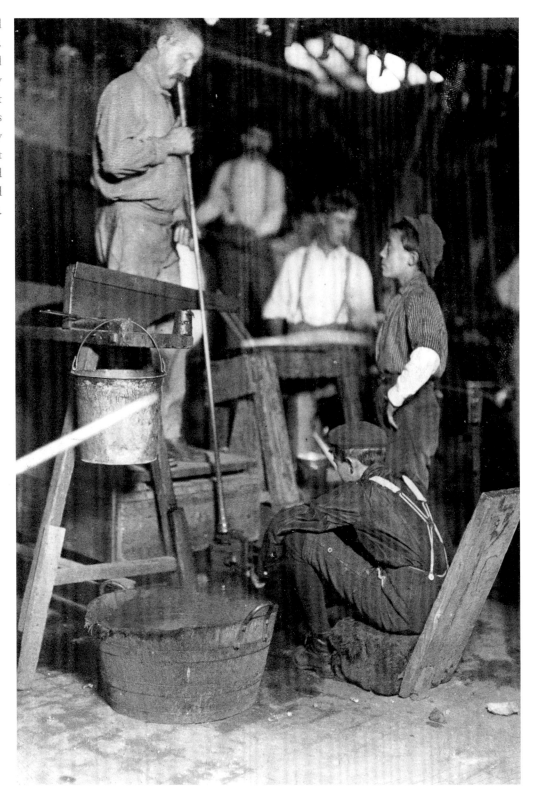

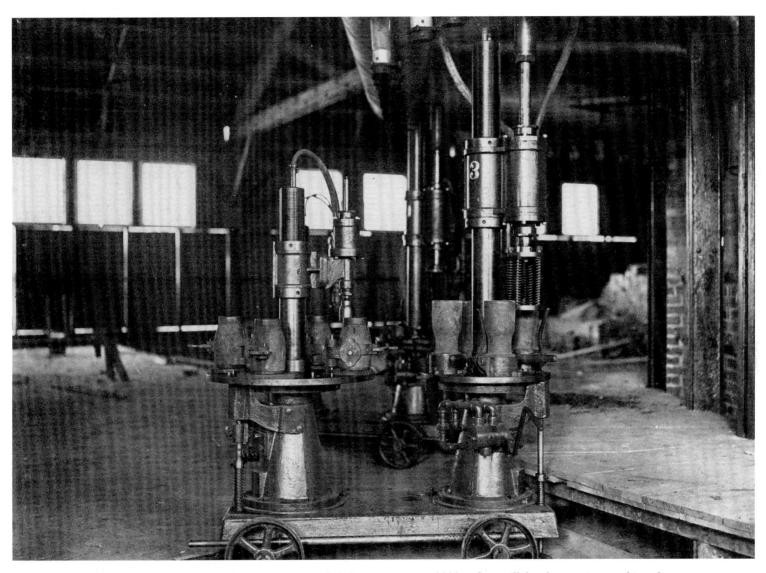

This machine photographed at the Travis Glass Company in Clarksburg in 1908 could blow four milk bottles at a time, making glass craftsmen obsolete. Michael Joseph Owens from Mason County, a former glassmakers' labor leader, designed the Automatic Bottlemaking Machine (ABM) in 1903. One ABM could replace 13–54 skilled glassblowers. It has been called the greatest innovation in glassmaking since the invention of the blowpipe some 2,000 years ago.

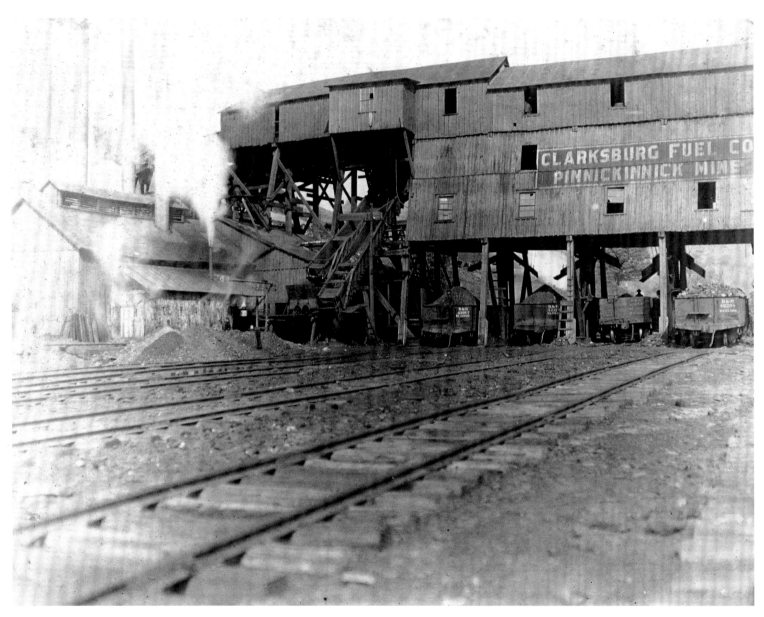

In 1866, the state legislature established the standard measurement for sale of coal at 80 pounds per bushel. Once coal cars were created for rail shipments, large tipples were designed to clean, sort, and pour tons of coal into them. This Clarksburg Fuel Company tipple was in the Pinnickinnick area east of town, near the site of the 1891 Ocean Mines disaster that killed four men. The origin of the word Pinnickinnick is unknown.

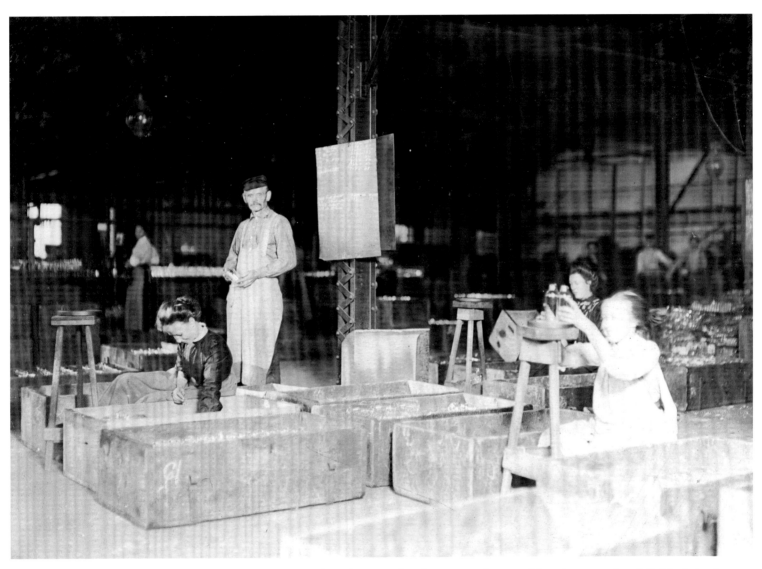

Central Glass Company in Wheeling, like other glass plants, employed women and young girls to inspect and pack finished glass because they were believed to have better eyesight than males and to take more care in packing. West Virginia initiated child labor laws beginning in 1887, but families needed income, so if inspectors came around, youngsters said, "I'm fourteen," the minimum employment age.

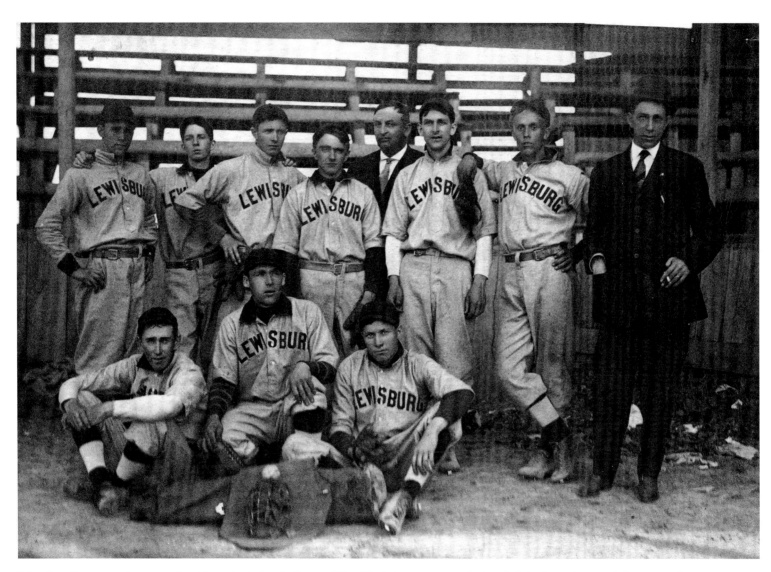

Like virtually every other town, Lewisburg had a baseball team. West Virginians were nuts for baseball in the early twentieth century, but teams often ran afoul of state laws that prohibited professional sports on Sunday. Local constabulary would break up Sunday games and haul the players and coaches into court. Jesse Burkett, Del Gainer, Sad Sam "Toothpick" Jones, and Lewisburg's Pat Friel are a few of the West Virginians who have played in the majors.

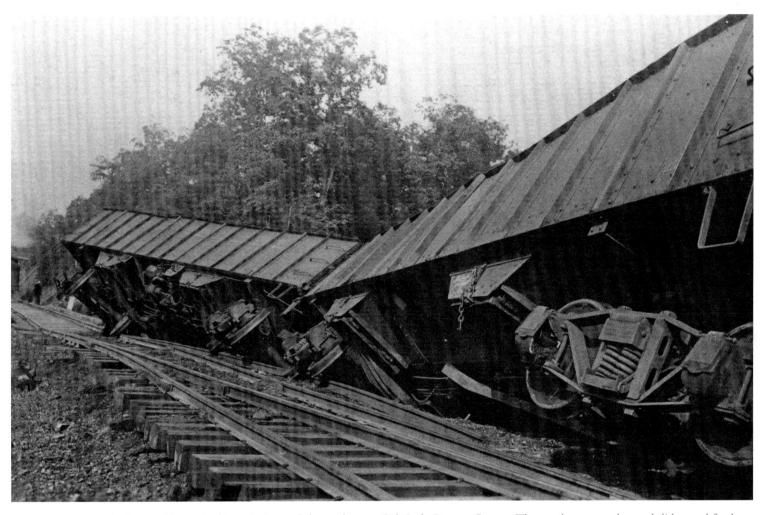

On August 11, 1912, this train jumped the tracks near Oak Park, Preston County. The state's steep grades, rockslides, and fog have always put rail traffic at risk. Perhaps the first accident was April 16, 1853, when two B&O passenger cars toppled 100 feet into the Cheat River. Some accidents inspired ballads like "The Wreck on the C&O," an event east of Hinton in which engineer George Alley gave his life to save his passengers.

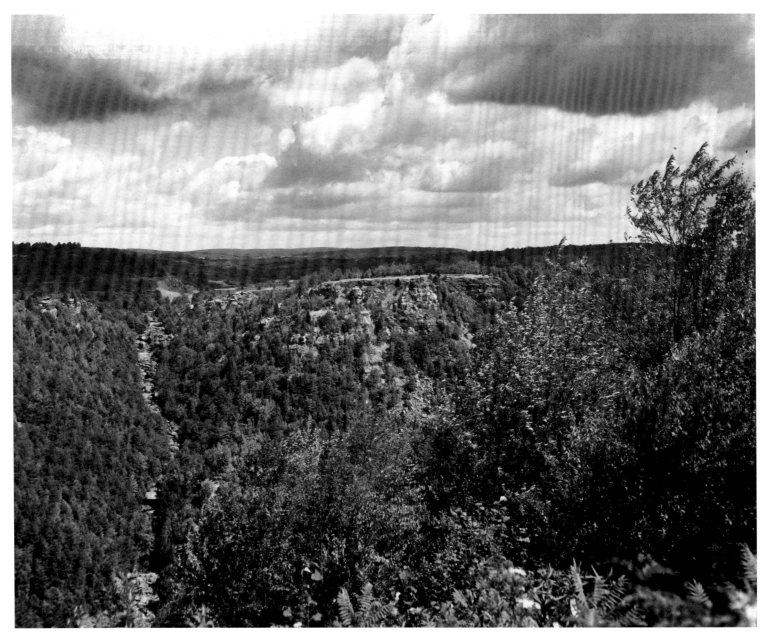

The state's rugged grandeur, seen here near Blackwater Falls, inspired the words of the most popular of West Virginia's three state songs, "The West Virginia Hills." The lyrics were written by Ellen Ruddell King of Glenville or by her husband, Rev. David H. King, or the two collaborated on them. Henry Everett Engle composed its tune and chorus after the *Glenville Crescent* published the lyrics as a poem in 1885.

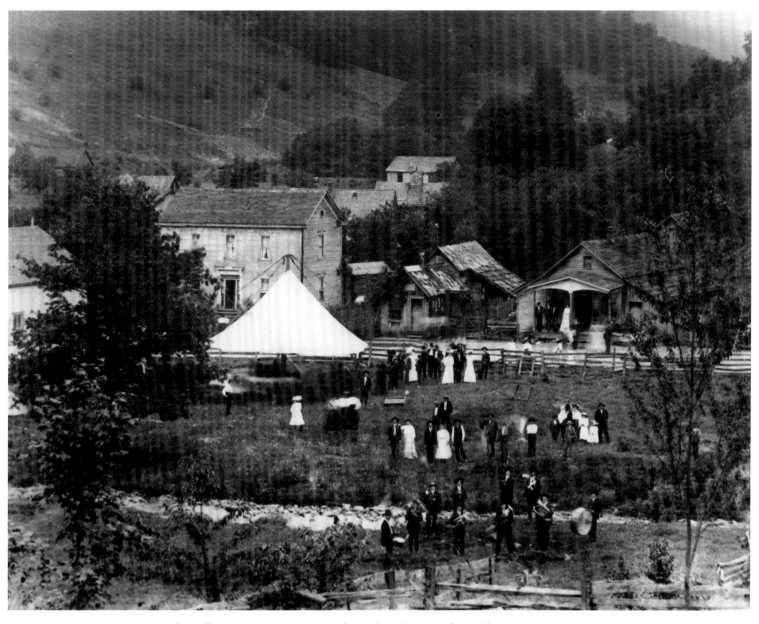

West Virginia's first efforts to attract immigrants focused on the Swiss, favored because they were regarded as a clean, ingenious, and industrious people of good morals. A colony of them settled in Randolph County in 1869, establishing the town of Helvetia, shown here during a celebration around 1910. Its population peaked around 500 at the beginning of the twentieth century; about 100 residents currently live in the picturesque village.

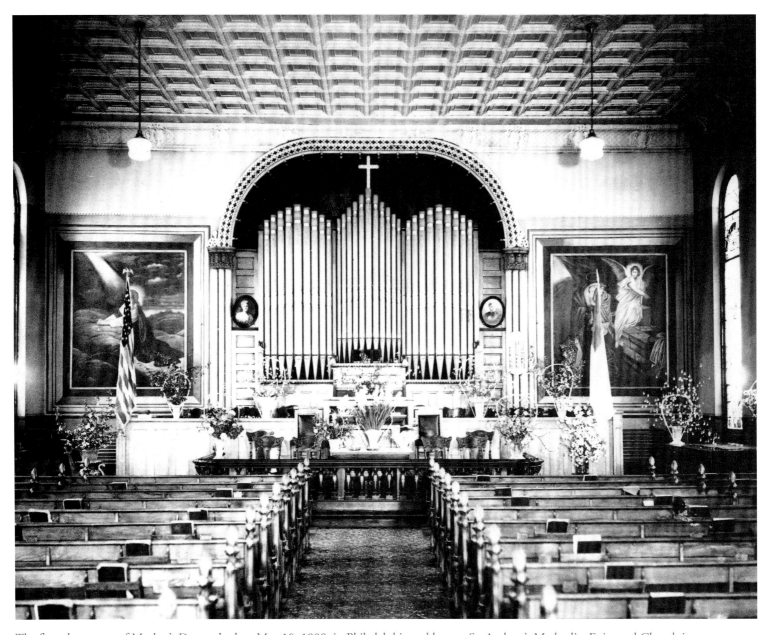

The first observance of Mother's Day took place May 10, 1908, in Philadelphia and here at St. Andrew's Methodist Episcopal Church in Grafton, "The Mothers Day Church." This photo of its interior was taken in 1911, three years before the first national Mother's Day was proclaimed. Anna Jarvis, a native of Webster near Grafton, campaigned for a national holiday to honor all mothers, something that had been a dream of her own mother.

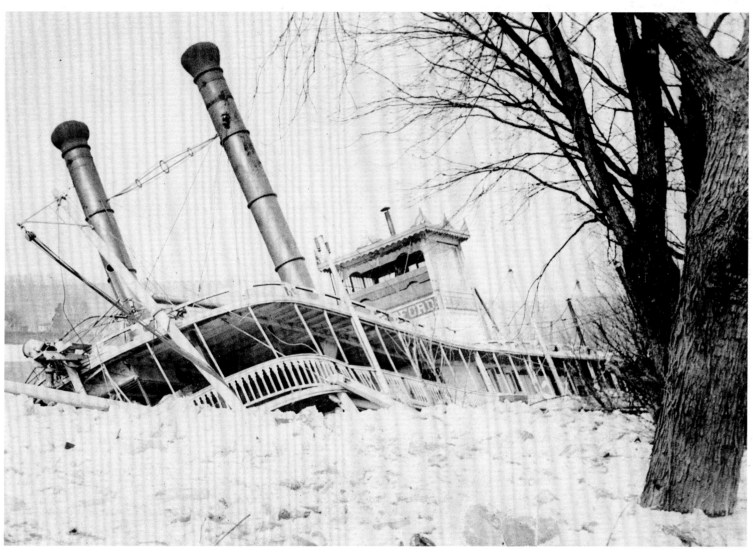

The 149-foot steamboat *H. K. Bedford* wrecked in the ice on the Ohio River near Waverly in February 1912. At times the Ohio was iced over bank to bank. In 1890, Cincinnatian Gordon C. Greene and his wife Mary Becker Greene purchased the boat and began the Greene Line, the company that later owned *Delta Queen*. They sold *H. K. Bedford* to a Wheeling company in 1898.

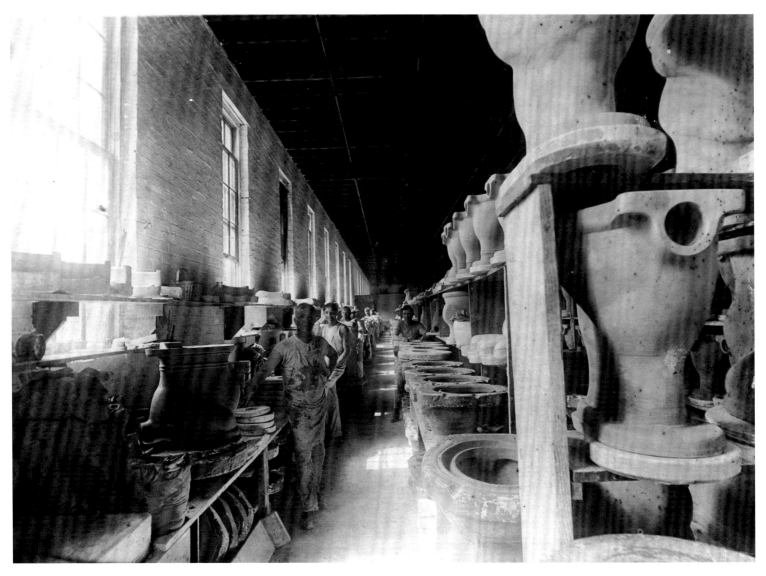

George W. Bowers started Homewood Pottery just outside Mannington in 1904. The name later changed to Bowers Sanitary Pottery. It was one of the largest manufacturers of toilets in the world, capable of producing 200,000 a day. Around 1913, it employed some 250 workers. It closed upon the owner's death in 1943. Bowers also owned Warwick China in Wheeling and S. Bowers Company in Wellsburg.

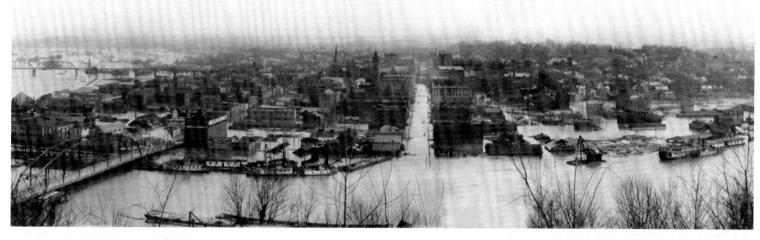

The terrible 1913 flood shown here is one of many that has swamped Parkersburg, built where the Little Kanawha flows into the Ohio. On March 19, 1909, it was even flooded by two million gallons from water storage tanks that burst atop Prospect (Quincy) Hill. The town was home to the state's first governor, Arthur I. Boreman, and the designer of the state's Great Seal, Joseph H. Diss Debar.

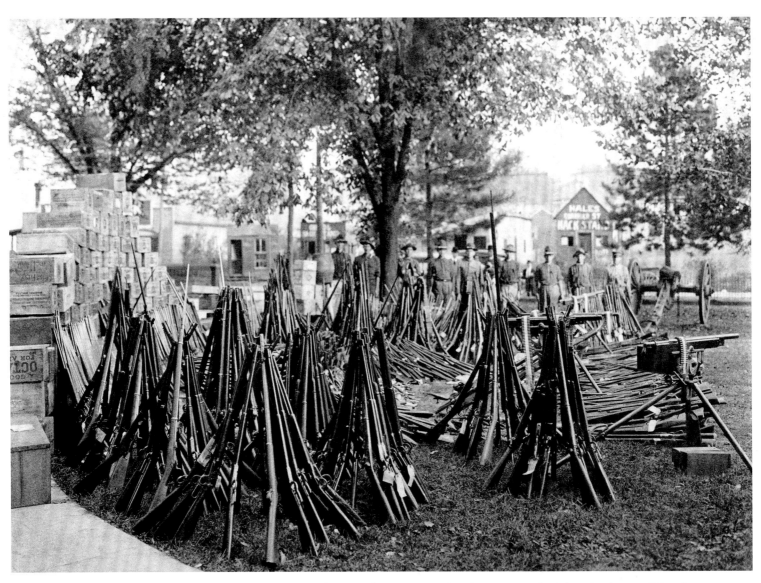

National Guard troops outside the state capitol watch over a collection of weapons seized in the Paint Creek–Cabin Creek Mine War of 1912–1913. A strike that began over wages became a battle for recognition of the United Mine Workers of America (UMWA) union. Mine owners brought in detectives, built machine-gun emplacements, and evicted miners' families from company housing. Miners responded with their own weapons, fighting several pitched battles.

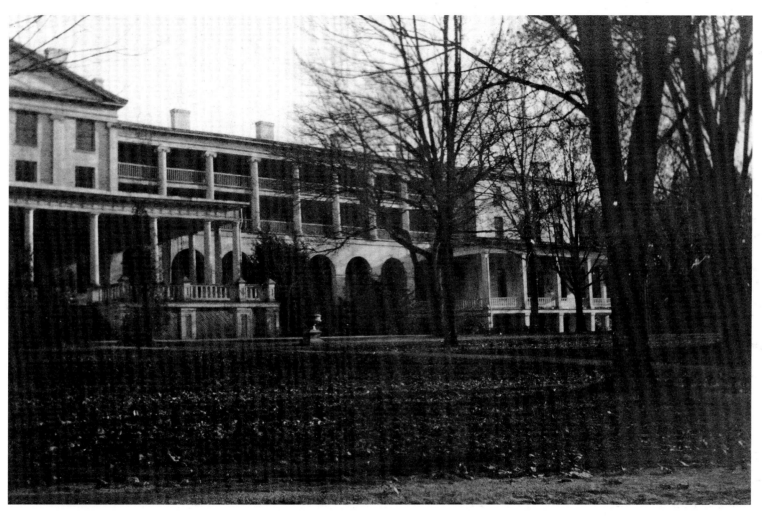

The Greenbrier, the "new hotel" at White Sulphur Springs, was an expansion of the existing resort, which the C&O had purchased in 1910. The railroad added a golf course and other amenities to create a resort extraordinaire and attracted many famous guests. One of its chefs founded the Chef Boyardee company. In the summer of 1933, it was a "hideout in plain sight" for Verne Miller, one of the Kansas City Massacre gunmen.

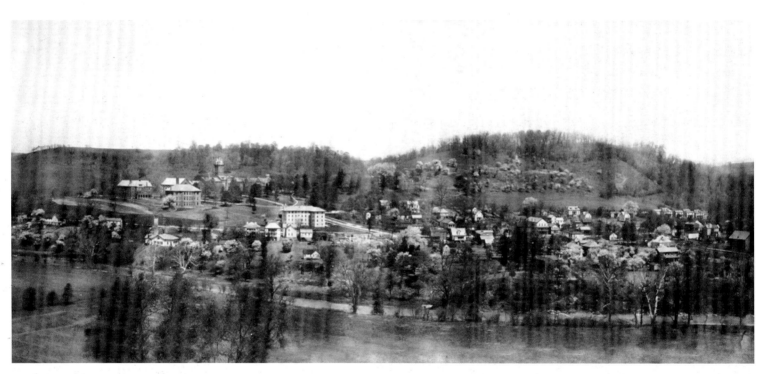

This panoramic taken around 1914 shows Bethany and Bethany College, the state's first four-year, baccalaureate-degree school. The tower of Old Main, a National Historical Landmark, rises on the hill at left. Alexander Campbell, founder of the Christian Church (Disciples of Christ) denomination, obtained a charter for the institution in 1840 when the town was "wild and secluded . . . shut out from the world," as the *Wheeling Intelligencer* described it on March 6, 1866.

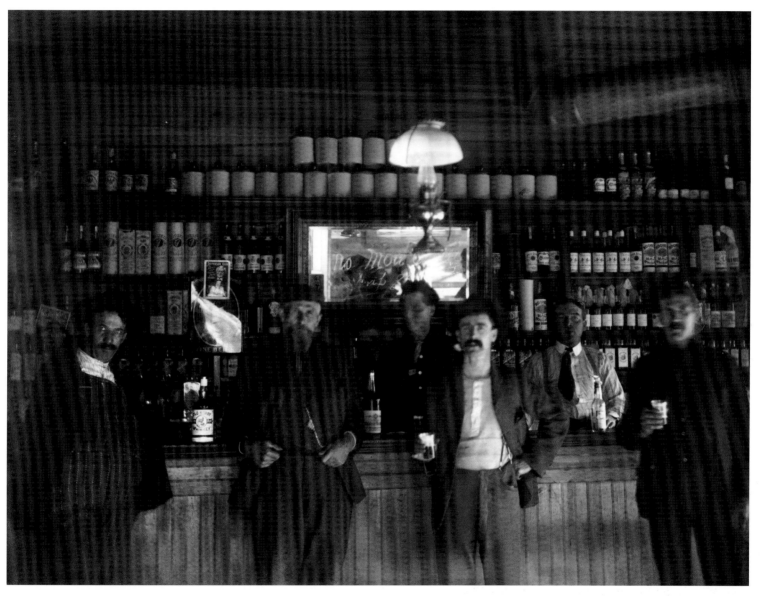

Drink up, boys, it's going to be a long dry spell. Statewide prohibition began at midnight, June 30, 1914, six years before the nation went dry. The days leading up to June 30 saw citizens pushing wheelbarrows full of liquor home. Bootlegging and moonshining flourished, though West Virginia was never among the top 10 states where stills were found. On July 25, 1933, the state voted in favor of repealing national Prohibition.

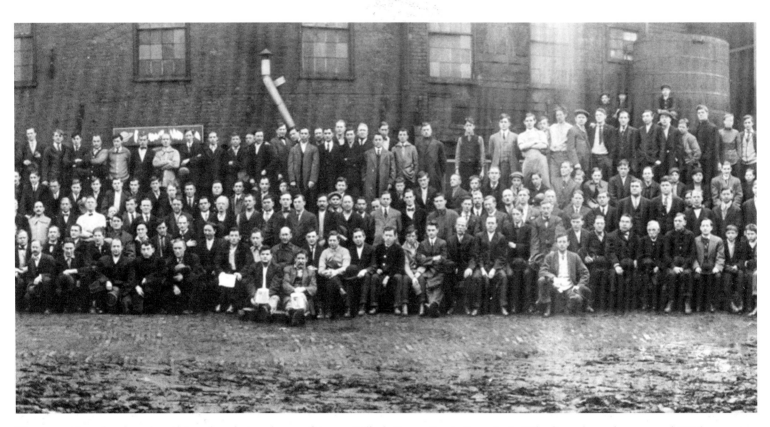

Liquor may have been on the way out, but the employees of August Pollack Crown Stogie Factories in Wheeling, shown here around 1914, kept America puffing. The founder, a German immigrant, started the company named for him in 1871 and established a reputation for fine cigars. His obituary in Wheeling's *Register* newspaper, April 24, 1906, gave him the lion's share of credit for making Wheeling a leading cigar-manufacturing center.

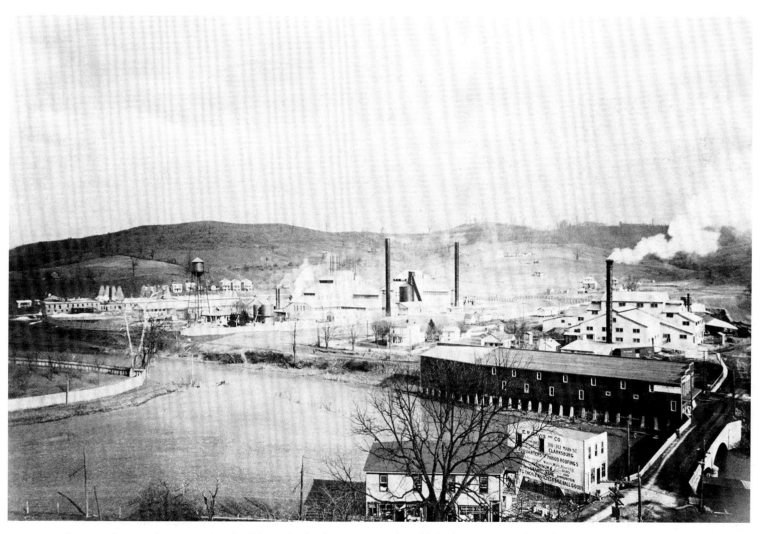

Streetcar lines made commuting feasible, and suburbs grew around established cities. McNichol China, far left, and Pittsburgh Plate Glass were wooed to speed development of the Nutter Fort–Stonewall Park (Stonewood) area outside Clarksburg. The long building just across the bridge became a broom factory that employed blind workers. Norwood Park, left foreground, opened June 15, 1914, on the site of the Central West Virginia Fair. Roosevelt-Wilson High School/Fairgrounds Elementary opened nearby in 1918.

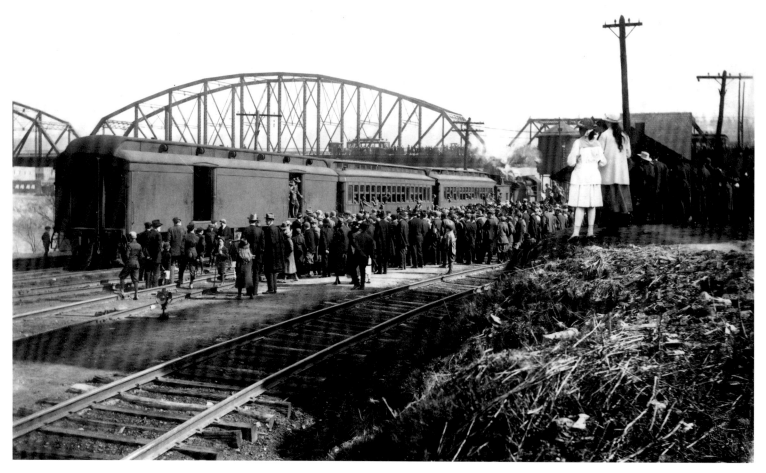

America entered the Great War on April 6, 1917. As in this Morgantown scene, families in towns throughout West Virginia gathered at railroad depots to send 58,000 of their boys "over there." Most never saw combat, but 1,120 were killed in action; dead, wounded, and missing totaled around 5,000. The influenza pandemic that swept through the state in 1918 lifted just in time for towns to explode in celebration at war's end on November 11.

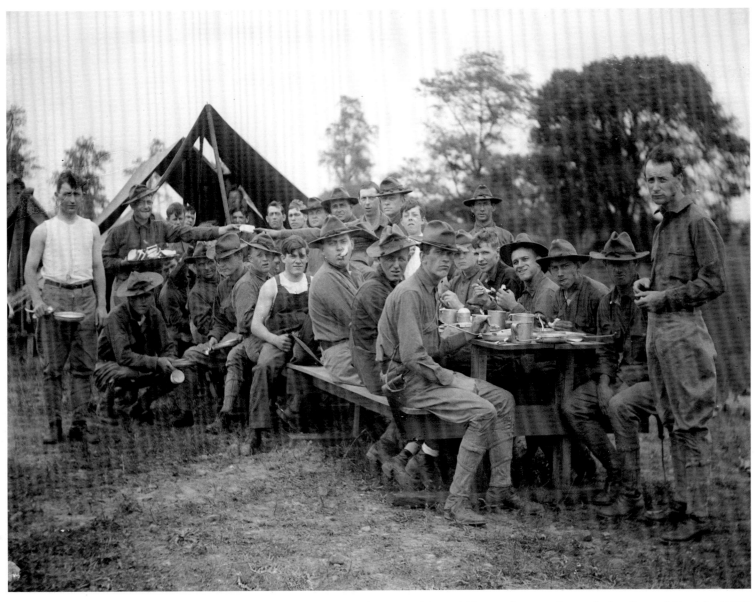

National Guard troops await orders at Harpers Ferry during World War I. The state's two regiments had earlier mobilized for 1898's Spanish-American War and 1916's punitive expedition against Pancho Villa but never saw combat. In World War I, they were reorganized as the 150th and 201st infantry regiments, 38th U.S. Division. West Virginians were in all military branches. Two privates, Felix Hill and Raymond White of Marshall County, won France's highest honor, the Croix de Guerre.

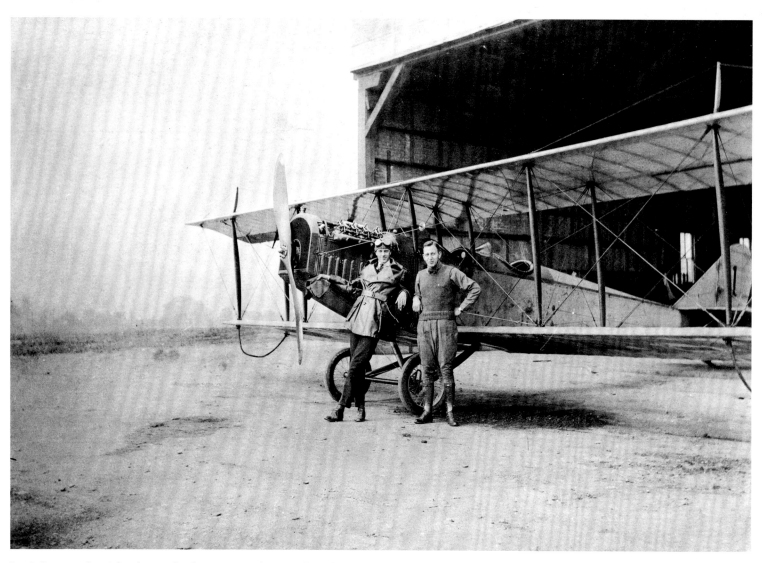

Louis Bennett, Jr., right, departed Yale University for Canada, enlisted in Britain's Royal Air Force, and was in the skies over Europe by July 1918. Credited with downing at least two planes and eight observation balloons, he was shot down August 24 and died in a German field hospital. His boyhood home is now Louis Bennett, Jr., Library in Weston. His mother commemorated his memory with a stained-glass window in Westminster Abbey.

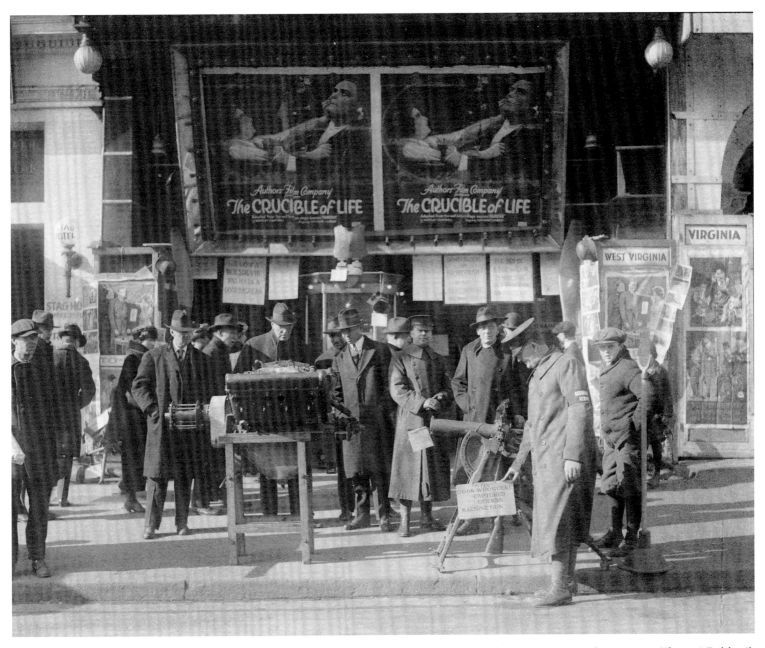

Passersby outside a movie theater beside the Stag Hotel in Sidney, Wayne County, stop to examine captured equipment. The anti-Bolshevik signs below the movie posters reflect concern about a not-so-new bogeyman. Socialist newspapers had been forcibly shut down during the 1912–1913 Mine Wars, and West Virginians were among troops fighting Bolsheviks in the ill-starred North Russia campaign of 1919, the year this photo was taken.

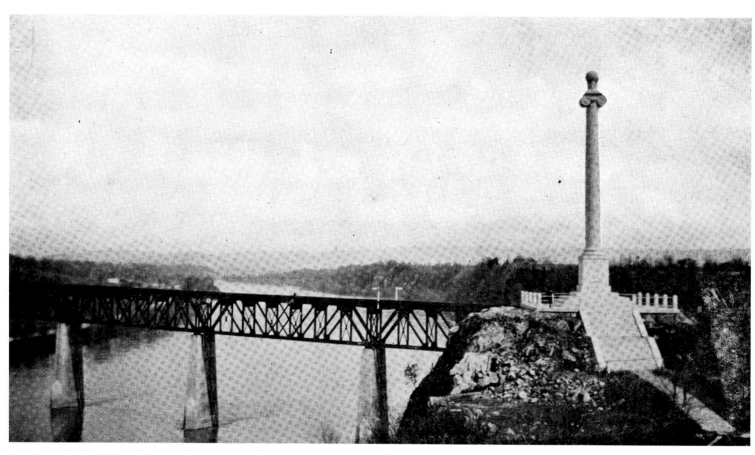

On December 3, 1787, at Shepherdstown on the Potomac, James Rumsey of Maryland demonstrated a steam engine he'd designed that was capable of propelling a boat. This was 20 years before Robert Fulton would win fame as the inventor of the steamboat. Fulton's design was superior, but Rumsey demonstrated the possibilities that day on the Potomac. In 1915, Shepherdstown erected the Rumsey Monument, shown here in June 1919, to commemorate the event.

YELLOW DOG, RED BLOOD, BLACK FRIDAY

(1920–1939)

In the 1920s, many West Virginians saw their standard of living rise, but miners found themselves fighting literally and figuratively against "yellow dog contracts" that prohibited them from organizing labor unions in pursuit of better wages and working conditions. On Blair Mountain, an "army" of armed miners shot it out with law enforcement officials and mine guards. Army Air Corps planes were sent to bomb and strafe miners if necessary, and troops were sent to Blair Mountain.

In education, schools and school districts consolidated. Carter G. Woodson, "the Father of Black History," became a dean at West Virginia State College in Institute.

West Virginia narrowly passed the Women's Suffrage Amendment, the next-to-last state to do so, setting the stage for the showdown in Tennessee that would ultimately allow American women to vote. Women in the town of Reedy won the right to wear pants in public—by one vote—and Friendly elected an all-female government. America's first federal prison for women opened at Alderson.

Politics thrust the state into the national spotlight. In 1922 and 1924, Izetta Jewell Brown of Kingwood tossed her Democratic bonnet into the race for the U.S. Senate. The national Democratic Party chose the brilliant attorney John W. Davis of Clarksburg as their candidate for president.

On Black Friday, October 25, 1929, the stock market crashed, taking with it the fortunes of many mine and factory owners. Banks closed and jobs disappeared during the Great Depression. Mother Nature added to the despair of the 1930s with some of the worst flooding in the state's history.

Photographs of poverty-stricken miners' families in flimsy houses surrounded by junk-strewn yards were seen across the nation, fueling stereotypes about barefoot hillbillies living in shacks precariously perched on hillsides. But New Deal programs like the CCC and WPA brought jobs and built dams, roads, and state parks. National subsistence communities provided state-of-the-art housing.

Pearl S. Buck, born near Hillsboro, received the Nobel Prize in Literature, the first female in America to be awarded the prize in that category. Communities started annual festivals, and rays of hope broke through the economic gloom.

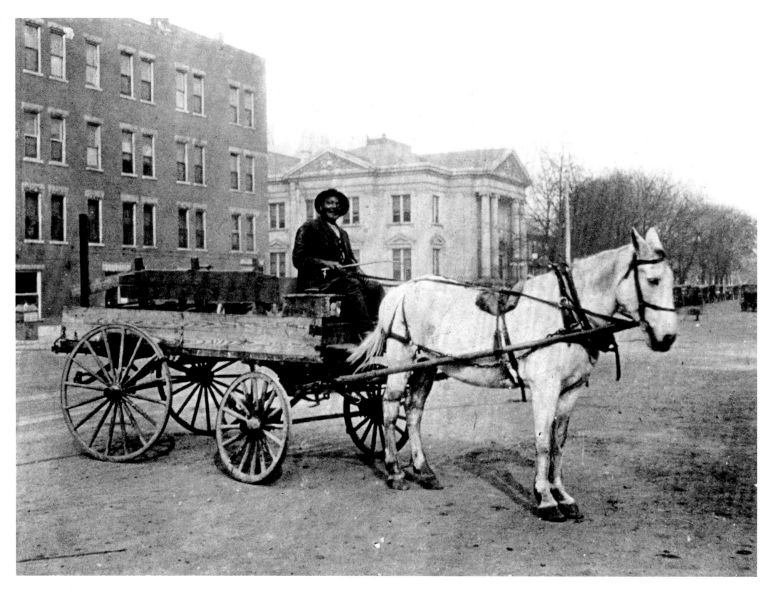

Dan Hill, shown here, reputedly used this horse-drawn wagon as the first taxi in Huntington. It was not uncommon for wagon and carriage owners to hang around railroad depots and haul passengers or freight to locations within a city. The process was modernizing, however; by the 1920s in Fayetteville, the Fayetteville Taxi Company had been organized to provide better service there.

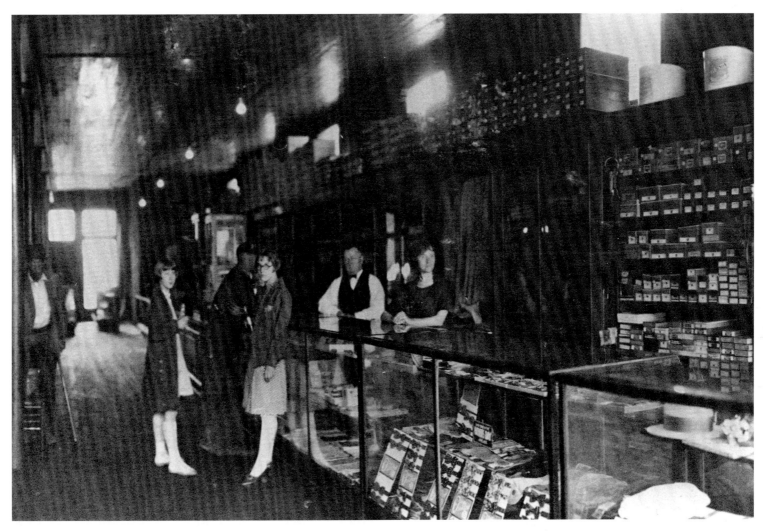

This photo inside an unidentified company store shows a variety of items available, from straw hats and bow ties in the display case to dresses hanging behind the clerks. It also shows the narrow aisle common to many businesses of the time. When someone accustomed only to these close quarters visited a department store or a five-and-dime for the first time, those stores must have seemed gigantic and their stock endless.

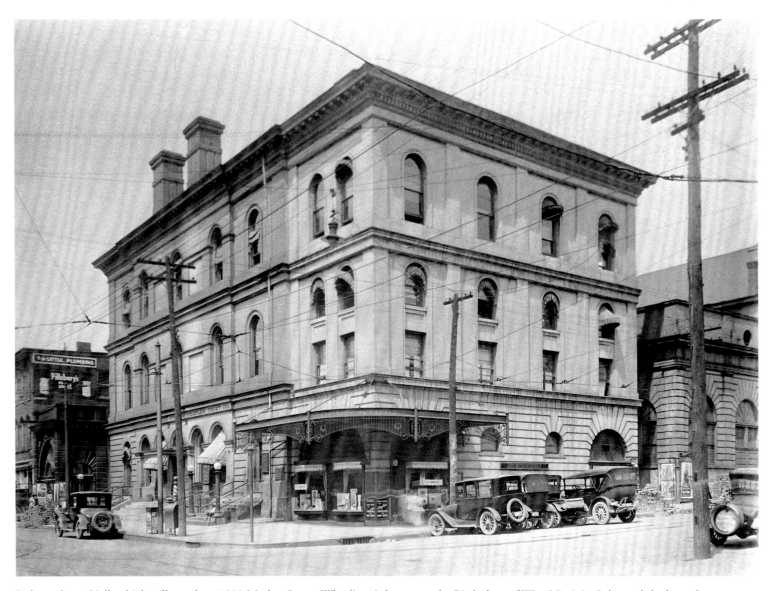

Independence Hall, which still stands at 1528 Market Street, Wheeling, is known as the Birthplace of West Virginia. It housed the heated debates of 1861 regarding whether the western counties should break away and form a state separate from Virginia. After that decision was made, the building became the capitol of the Restored Government of Virginia until 1863.

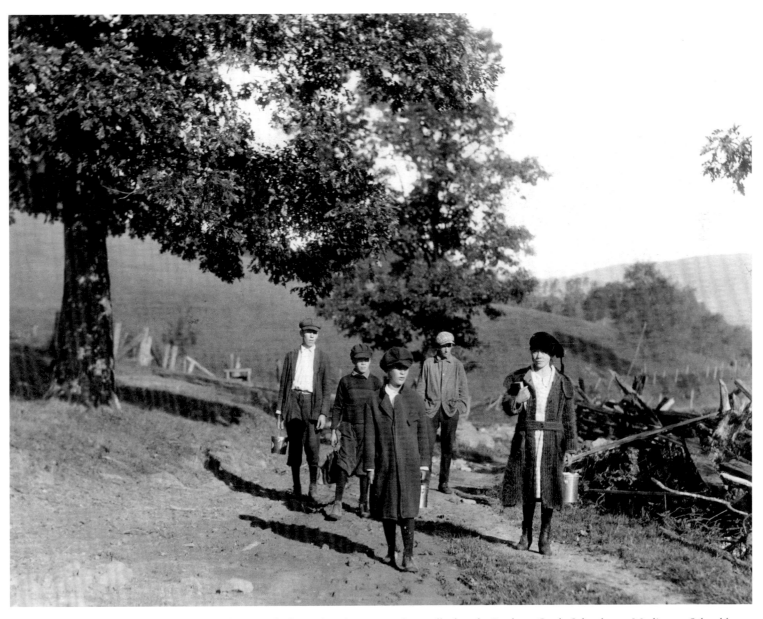

These young scholars were photographed October 6, 1921, as they walked to the Buckeye Grade School near Marlinton. School buses carried students in some areas, but walking two miles or more to school was not uncommon. In winter, if a creek was conveniently close, boys and girls might skate to school. The pails they are carrying held their lunches.

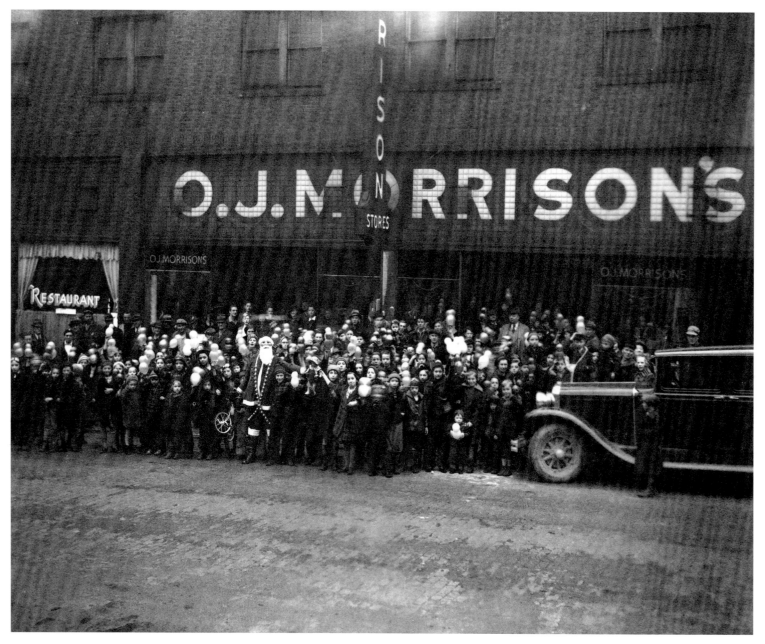

This O. J. Morrison store in Grafton was part of a chain founded by O. J. Morrison in his native Ripley. He personally traveled to large cities and bought discounted clothing to sell at lower prices than his competitors. In 1910, he opened his third store, in Charleston. By the mid-1920s, his chain was one of the state's largest with a million dollars in capital. Wheeling's Stone and Thomas chain was another department store success story.

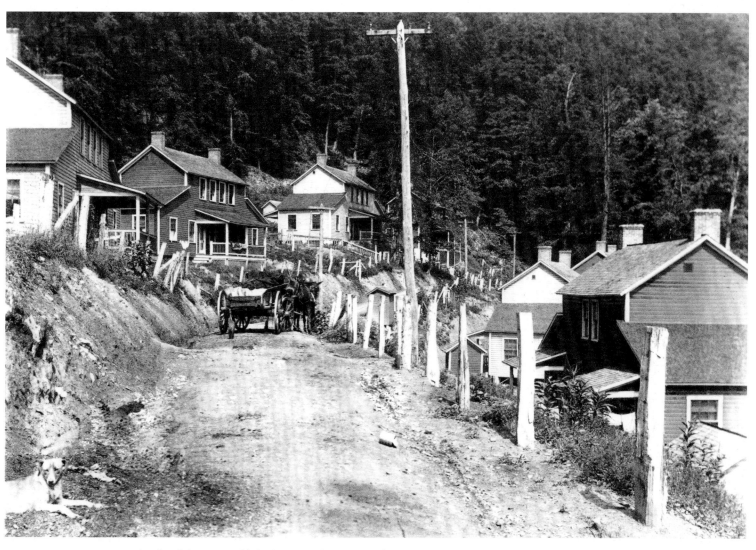

Venus, south of Welch, was established in 1920 by U.S. Coal and Coke, the mining arm of U.S. Steel. Another town called Venus was located in Gilmer County. This photo shows the conditions common to roads in the state. Until the Good Roads Amendment was passed in 1920, the legislature had no power to authorize road building or maintenance. A 1919 slogan favoring the amendment said, "Help Pull West Virginia Out of the Mud."

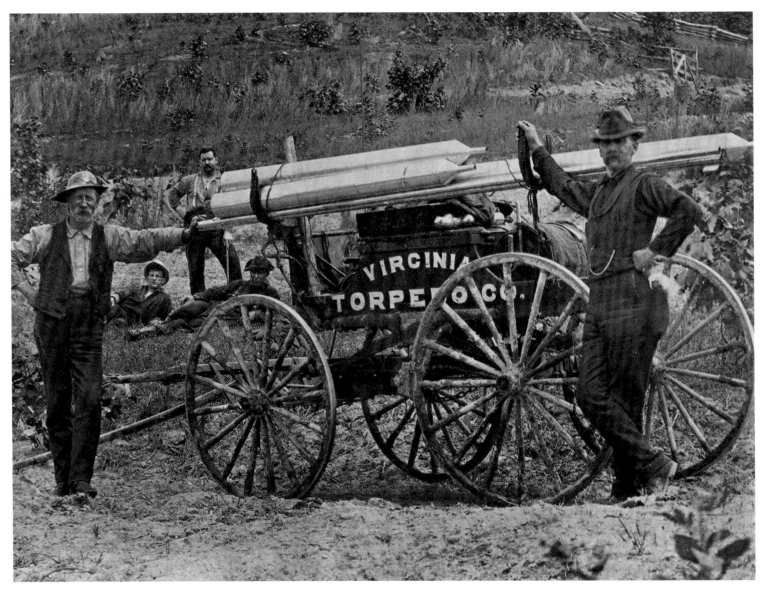

Nitroglycerine torpedoes like these in Harrison County were used to blast oil and gas wells. A resident of that county told of being hired to haul a shipment of nitroglycerine from the railroad depot to a work site in his wagon over rough, rutted roads. Upon arrival, he asked what it was used for. Nitro's properties were explained, and he was asked if he'd like to bring another shipment the next day. He quickly refused.

A worn, dirt road winds past a farmhouse outside Charleston in 1921. The state tried various methods of maintaining its thoroughfares, from toll roads to convict labor. In 1914, Governor H. D. Hatfield called for every community to provide volunteers on May 28 and 29 to work on roads in their counties. An estimated 30,000 volunteers participated, including the governor himself.

Wheeling's Eoff Street Temple was built in 1892 to serve a growing Jewish congregation and remained in service until 1957. The state's first Jewish community was established in Wheeling in the 1840s. In 1873, Kanawha County's Jewish residents made a serious bid to secure America's first rabbinical college for Charleston—although only 10 Jewish families and 15 single, young Jewish men lived in the county.

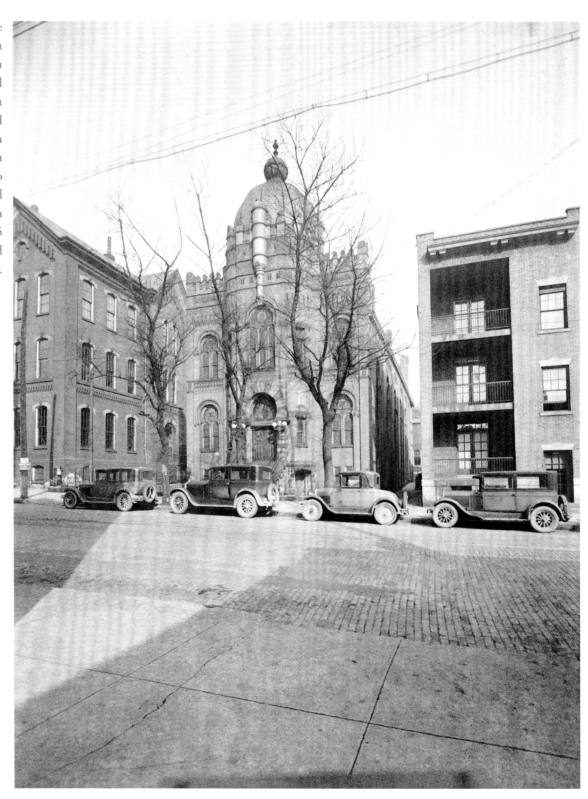

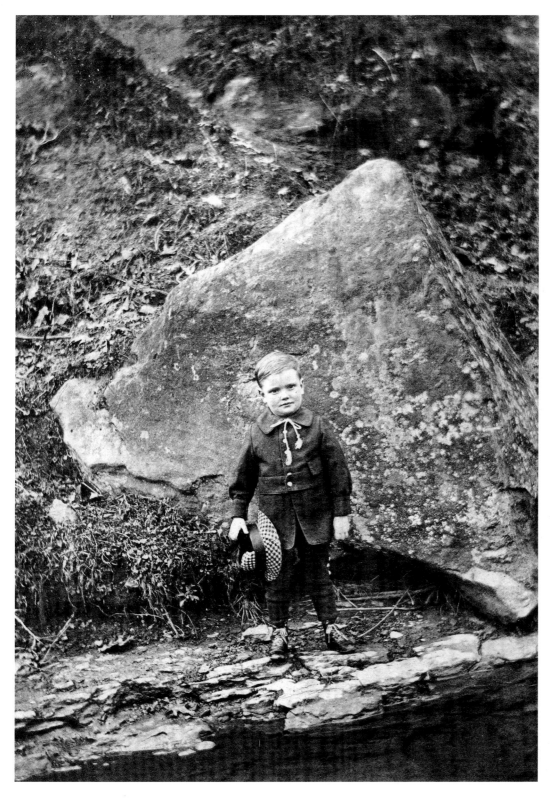

Young Oran Phillips was photographed beside a Wirt County stream close to the time his father, Jacob (Jake), was killed in an oil-field accident in the 1920s. Jacob reportedly had premonitions of death and had his wife wake the children so he could play with them before going to work that day. Such stories are common in West Virginia folklore. Ruth Ann Musick relates some in *The Telltale Lilac Bush and Other West Virginia Ghost Stories.*

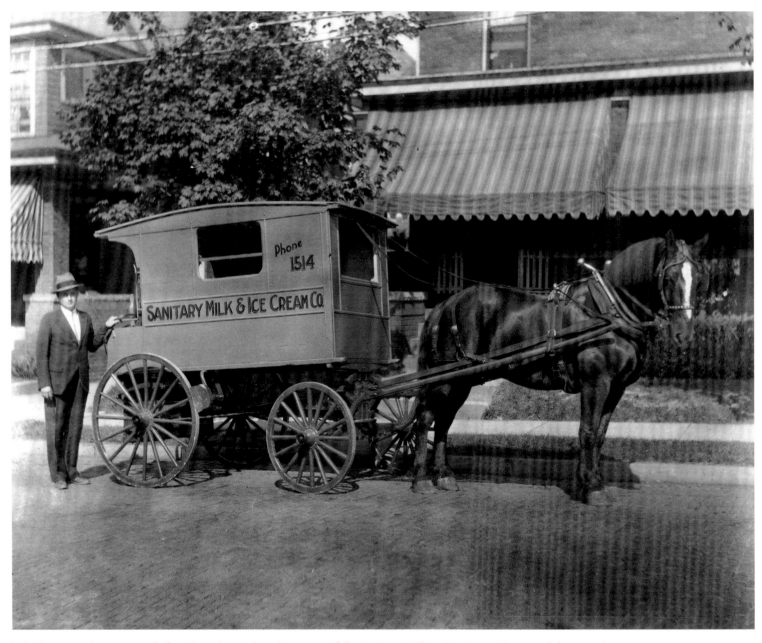

Telephone numbers were only four digits long when this image of the Sanitary Milk & Ice Cream Company's horse and wagon was taken in South Park, one of Morgantown's first suburbs. One of the Sanitary Milk & Ice Cream Company's co-founders, J. D. Anderson, reportedly owned the first mechanical milking equipment in northern West Virginia.

When fog hangs in the hollows and autumn has splashed bright colors across the landscape, West Virginia's hillsides resemble a vast, Impressionist painting. This serene image was captured in Upshur County, where foothills give way to mountains that rise in excess of 3,000 feet.

Dr. Carter G. Woodson, the Father of Black History, was photographed while dean of liberal arts at West Virginia State College. He came to West Virginia as a child, graduated from Frederick Douglass High School in Huntington, and secured his first teaching job in Winona. He authored or co-authored 19 books and founded *Journal of Negro History, Negro History Bulletin,* and Associated Publishers. In 1926 he conceived Negro History Week, which later became Black History Month.

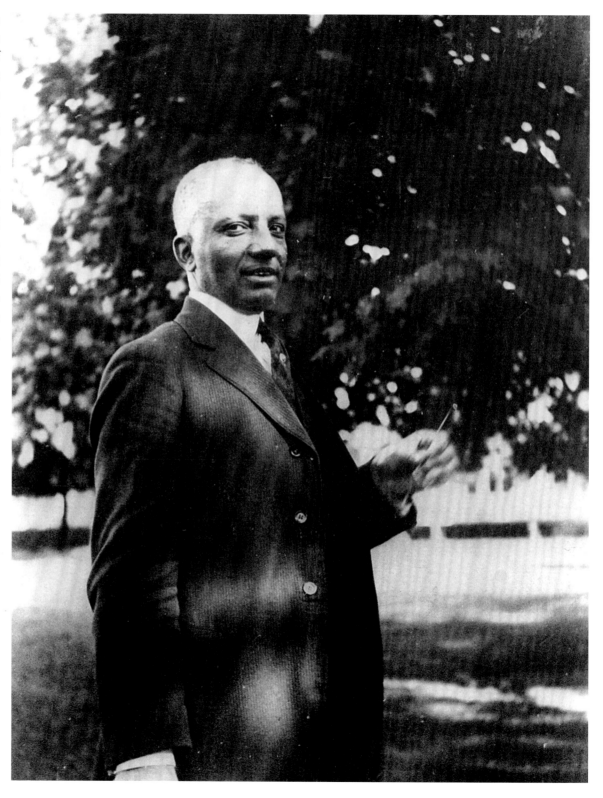

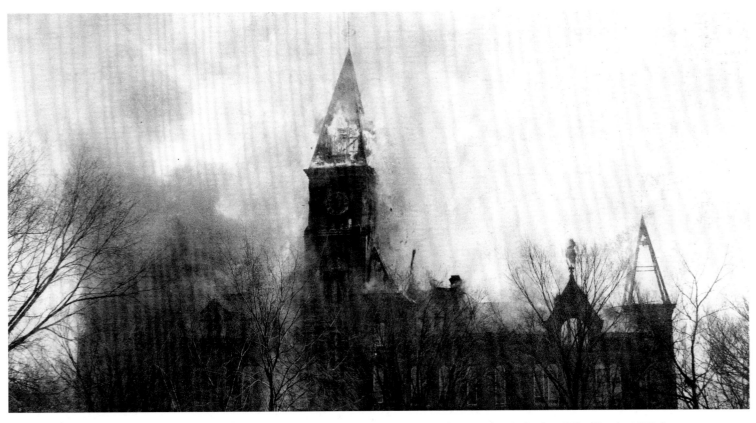

West Virginia's first capital city was Wheeling. Charleston became the capital in 1870. The capital went back to Wheeling in 1875, but voters returned it permanently to Charleston in 1877, and an ornate, Victorian capitol building opened on May 1, 1885. On January 3, 1921, it was destroyed by fire, shown in this image. A "Pasteboard Capitol" erected in 42 working days temporarily replaced it until the new, $10 million capitol was completed in 1932.

Johnny-on-the-spot: Millions of indoor toilets may have been manufactured in Mannington, but the outdoor outhouse was ubiquitous. Plumbing was just a rumor outside of cities and suburbs. Even there, a "Johnny" could be found in many backyards until health laws said otherwise. Today, they have virtually ceased to exist. This pair was photographed behind the Sunset School in Pocahontas County in October 1921. Upon entering, visitors first checked for snakes, wasps' nests, and spiders.

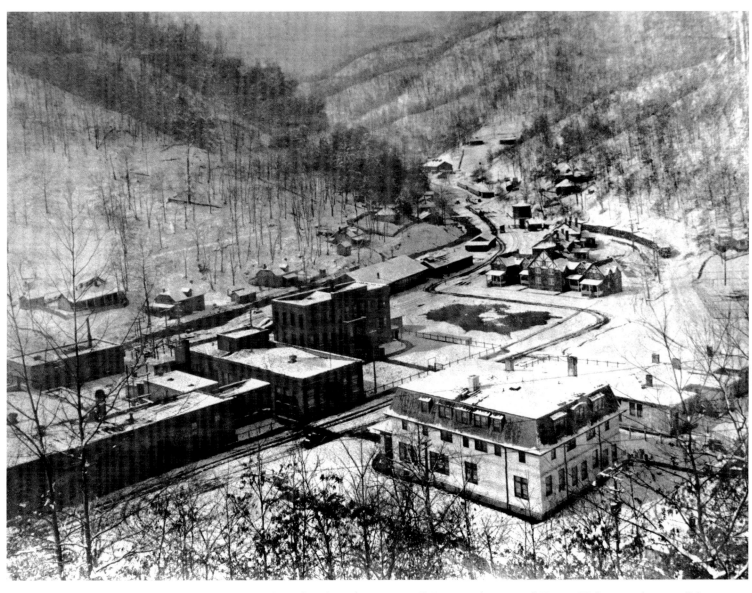

Twenty years after this 1923 photo was taken of Coalwood in McDowell County, a boy named Homer Hickam was born on February 19, 1943. He grew up in Coalwood and made the town famous with his book *Rocket Boys,* later made into the movie *October Sky.* The site was known as Snakeroot when a post office was established in 1869 but became Coalwood around 1900.

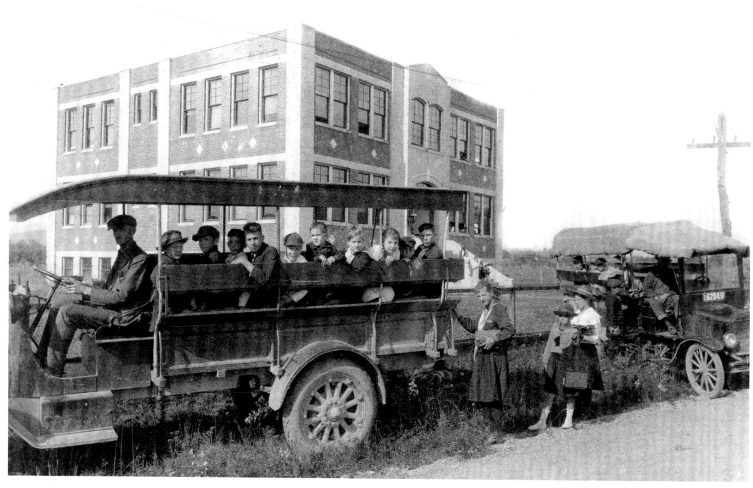

A school bus outside Green Bank Consolidated School in Pocahontas County loads up for its six-mile haul. More than 6,100 schools existed in nearly 400 districts, but by the 1920s, some school consolidation had begun. In the next decade, the Great Depression led to the state adopting the County Unit Plan, which replaced 398 districts with 55—one for each county—combined schools, and cut nearly 1,000 teaching jobs to keep schools open.

Students play outside the Colored School at Pleasant Green, Pocahontas County, in 1921. From its earliest statehood, West Virginia provided education for black students as well as white, but a new constitution in 1872 segregated schools along racial lines. Often, "Negro schools" were open fewer months per year and the teachers were paid less, a practice that was deemed illegal thanks to an 1898 lawsuit brought by Tucker County teacher Carrie Williams.

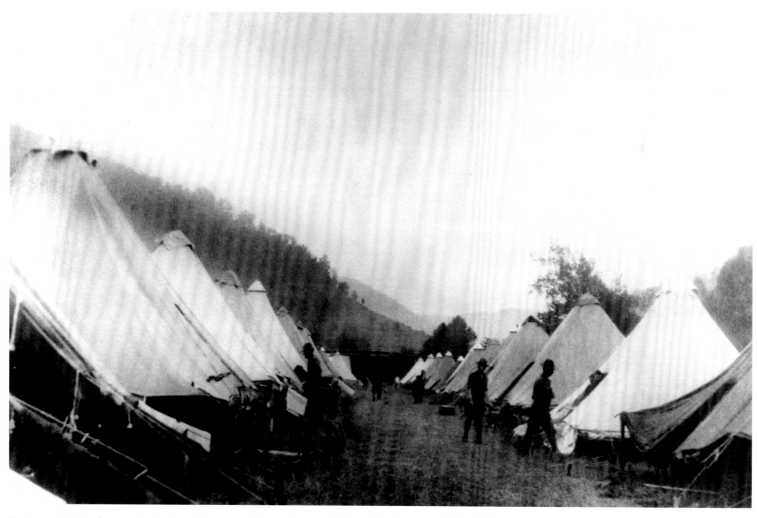

In August 1921, thousands of miners from several counties met in Kanawha County and decided to arm themselves and march to Logan and Mingo counties to free jailed union organizers. Mine operators brought in armed guards, and the two groups clashed at Blair Mountain, the largest battle of the Mine Wars. Army Air Corps planes and federal troops, like these photographed on Blair Mountain on September 21, were sent to quell the fighting.

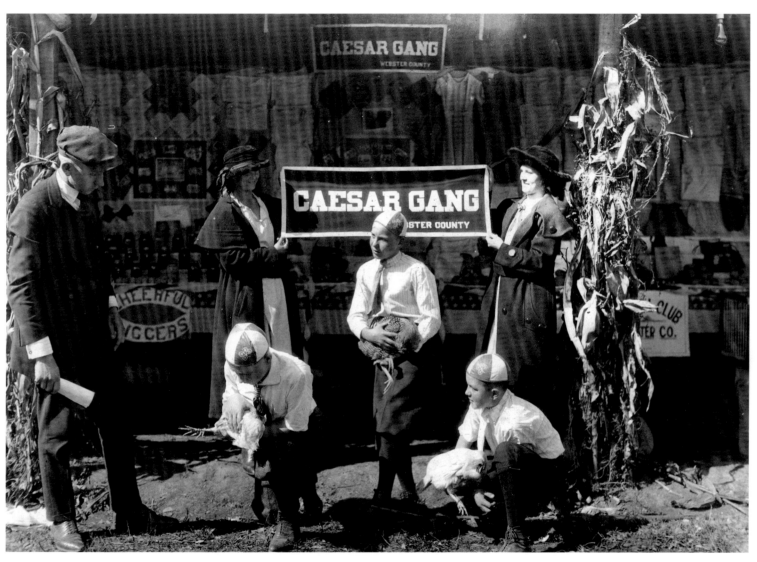

Members of Webster County's Cheerful Diggers 4-H Club demonstrate how to cull chickens for better quality and quantity of product at the State 4-H Fair in Charleston, October 13, 1921. Webster County's 4-H camp, Camp Caesar, opened the following year. Boys' corn clubs and girls' home canning clubs had evolved into the 4-H program, which emphasized "fourfold development" through head, heart, hands, and health.

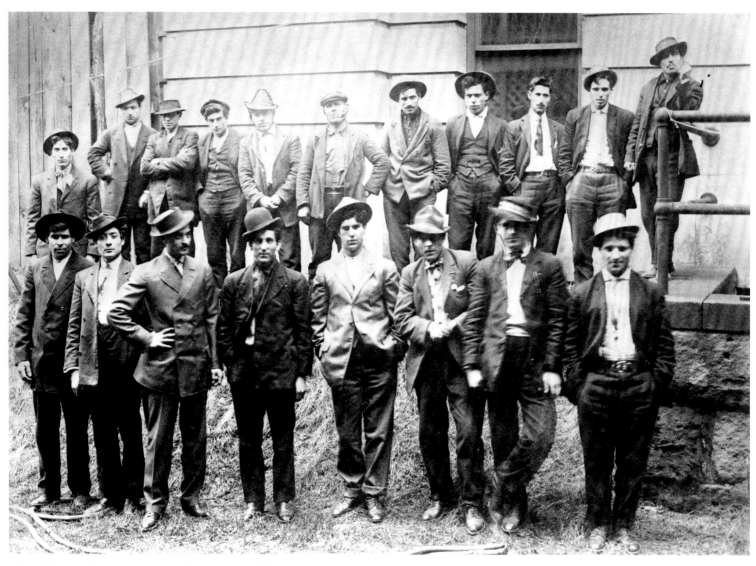

The Black Hand, a Sicilian criminal organization, followed immigrants into the state. The 1920s saw a spate of killings, primarily in Harrison and Marion counties. The most brazen murder, that of Frank Napolitano on February 13, 1922, occurred within view of the top floor of Harrison County's courthouse. Information from immigrants tired of paying extortion money helped police round up the gang members shown in this Fairmont photograph. Three men were convicted and hanged.

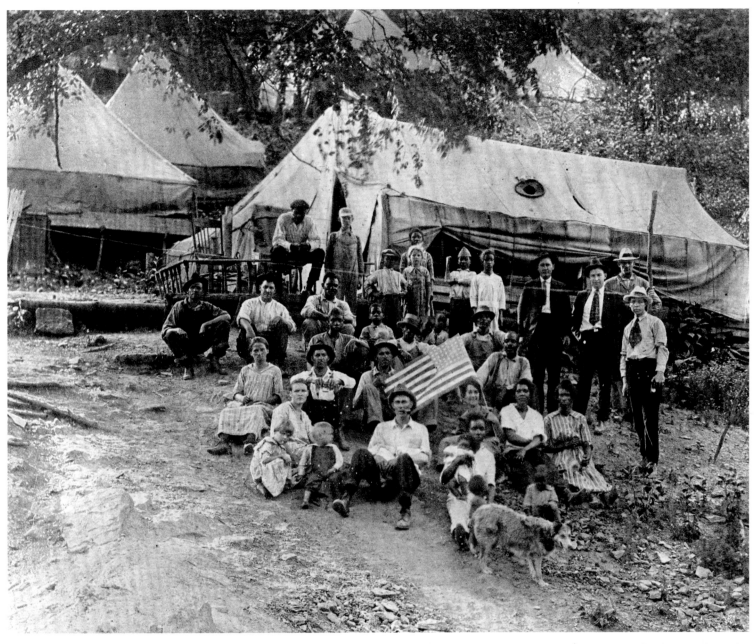

Mine operators fought unionization with "yellow-dog" employment contracts that prohibited union membership. Workers who attempted to unionize were fired and evicted along with their families from company-owned houses. The union sometimes provided temporary housing, but often striking miners and their families had to live in tents, like this group photographed at Lick Creek, south of Hinton, on April 12, 1922.

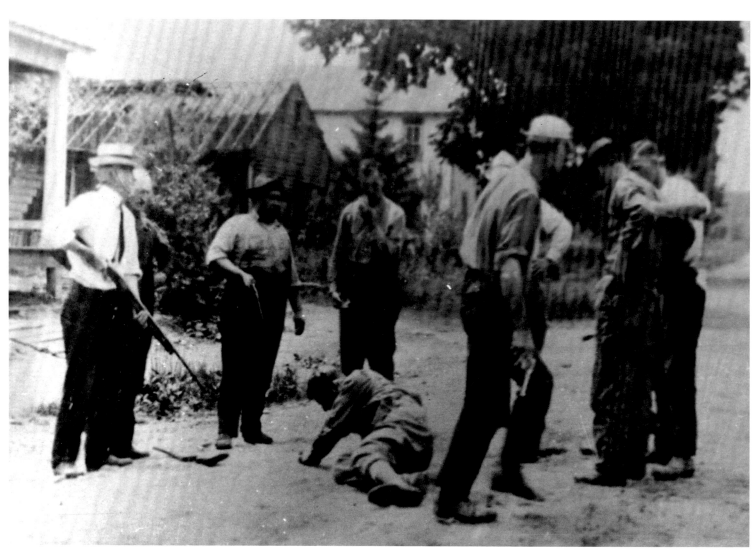

In 1921, four men hitched a ride on a wagon into Bruceton Mills, Preston County. Their questions about Bruceton Bank aroused the driver's suspicions, and he warned a cashier. When the men attempted to rob the bank, a group of armed citizens was waiting. In an exchange of gunfire, one robber was mortally wounded. Reportedly, a bullet he fired snapped the suspenders of the man at the right of this photo.

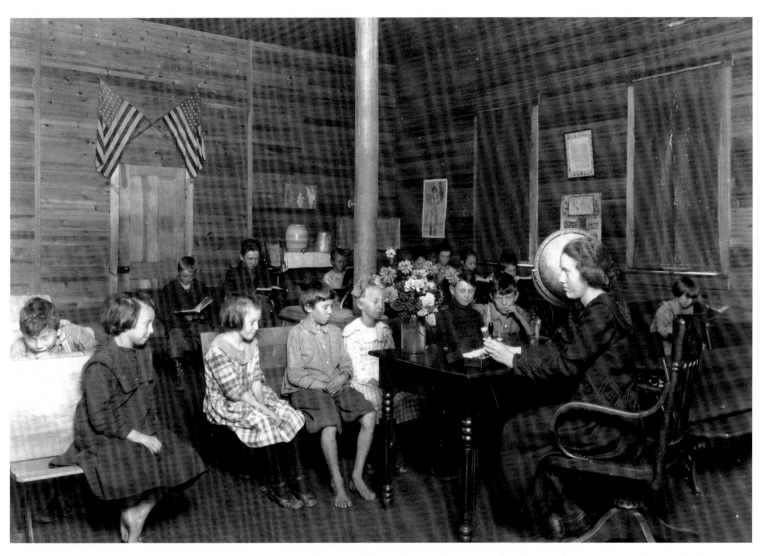

One teacher, one room, multiple grade levels: This 1921 photo taken inside Sunset School in Pocahontas County shows what one-room, rural schools were like. Students in the back read their lesson while the teacher instructs other students in a different subject. Even in town schools, two or more grades were sometimes combined in a single room. One pair of shoes per year, if that, was often the norm, and many children went to school barefoot.

Izetta Jewell Brown of Kingwood ran as a Democrat for the U.S. Senate in 1922 and 1924. She sometimes slogged through ankle-deep mud to ask voters to send a woman to Washington for "housekeeping," to "sweep out" entrenched politicians. She drew large crowds and won praise even from Republican newspapers like the *Telegram* of Clarksburg but lost both elections.

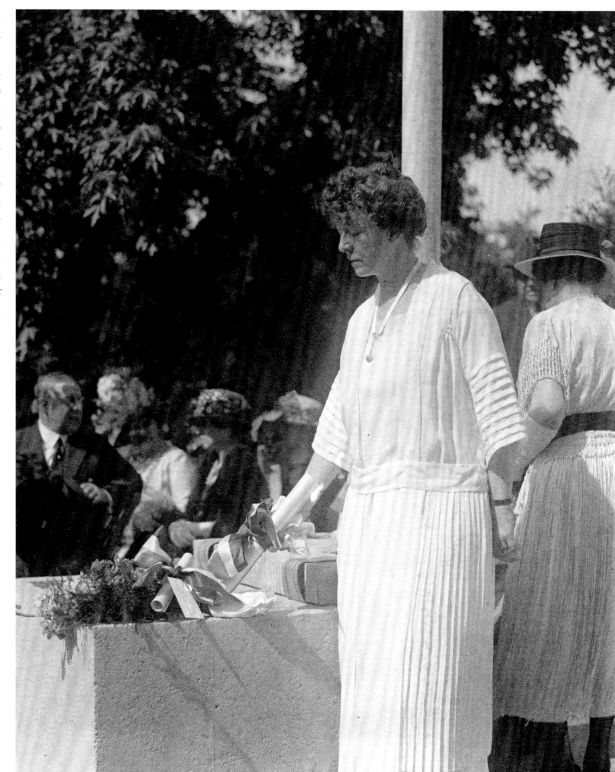

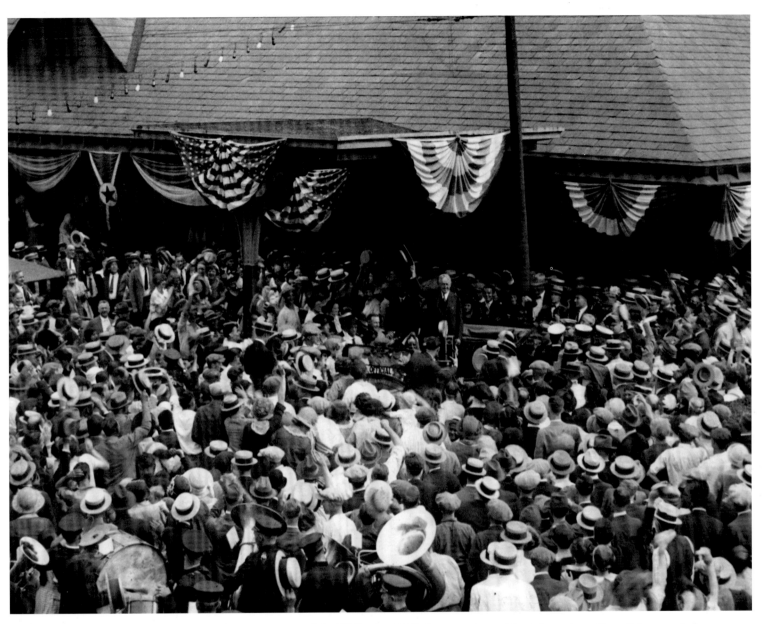

Crowds thronged Clarksburg's depot to welcome native son John W. Davis, 1924's Democratic presidential nominee. One of the twentieth century's most successful attorneys, as U.S. Congressman from West Virginia, Davis helped draft the 1914 Clayton Anti-Trust Act. He was ambassador to England and solicitor (attorney) general. In his lackluster presidential campaign, voters couldn't decide if he was a liberal conservative or a conservative liberal. He failed to carry even his home district.

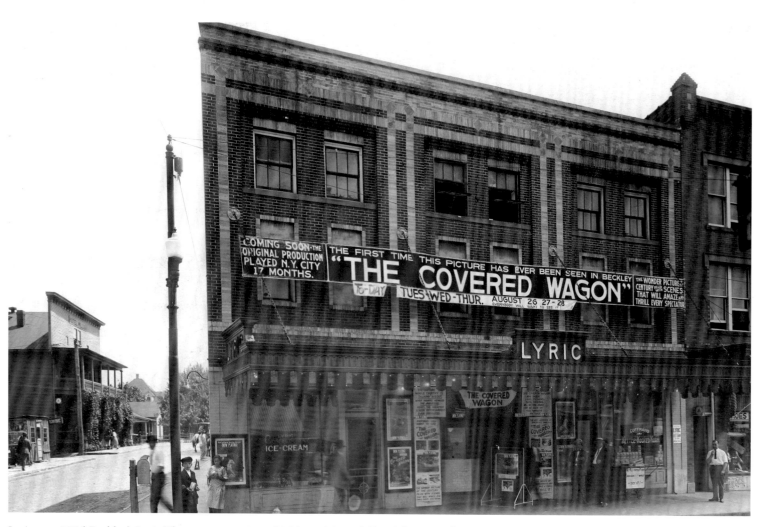

In August 1924 Beckley's Lyric Theatre was touting a highly anticipated film, *The Covered Wagon*, but earlier, on January 4, the Lyric was damaged by fire on a night so cold that water froze on volunteer firefighters' clothes. The nearby Allegheny Theatre was severely damaged and relocated to Mount Hope. Between January and April, the Strand and Palace theaters also burned, leading to public speculation a "religious fanatic" was targeting Beckley's theaters.

Gardens take up virtually every bit of yard beside the homes in Elbert, McDowell County, in July 1926. Most families in the state planted at least a small garden and canned food for the winter. The sugar rationing regulations that would come with World War II a few years later had to be amended to allow a few extra pounds for home canning. Beds of zinnias, spider plants, marigolds, and other flowers were also planted.

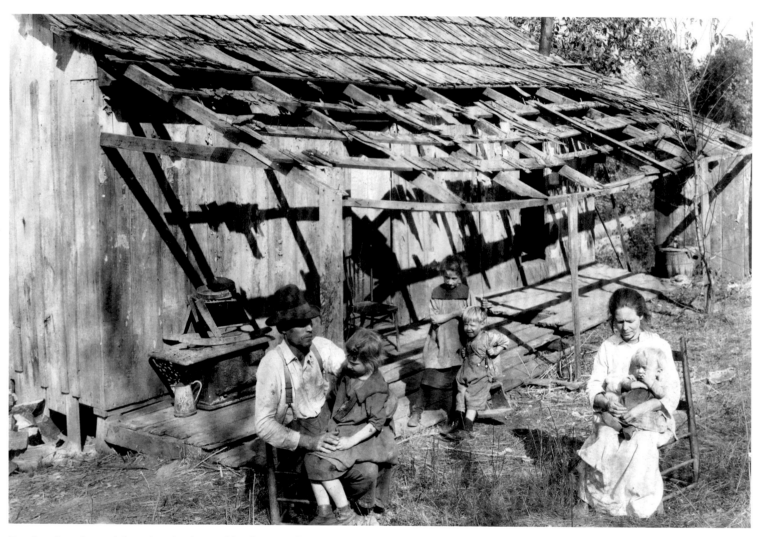

Employed workers might enjoy nice homes like those at Elbert, but there was no safety net for the unemployed. Frank Burditt and his family were photographed outside the dilapidated shack they rented near Sissonville, Kanawha County, where they were trying to eke out a living on meager land.

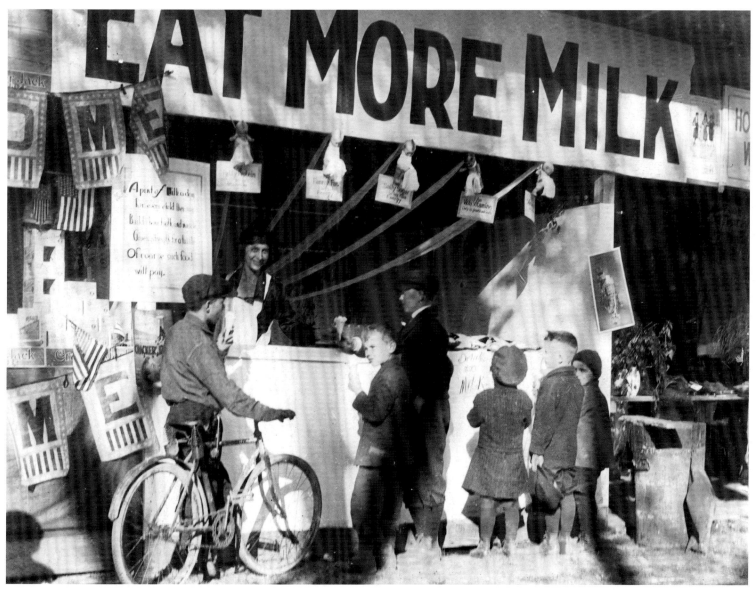

Ice-cream lovers didn't need much persuasion to "Eat More Milk" during a State 4-H Fair in Charleston. Health issues were getting more attention. The first national Child Health Day, later called May Day, was observed on May 1, 1928, with the purpose of "centering the thought and attention of every locality on the health and growth of its children," as the *Grant County Press* explained in its May 3 report.

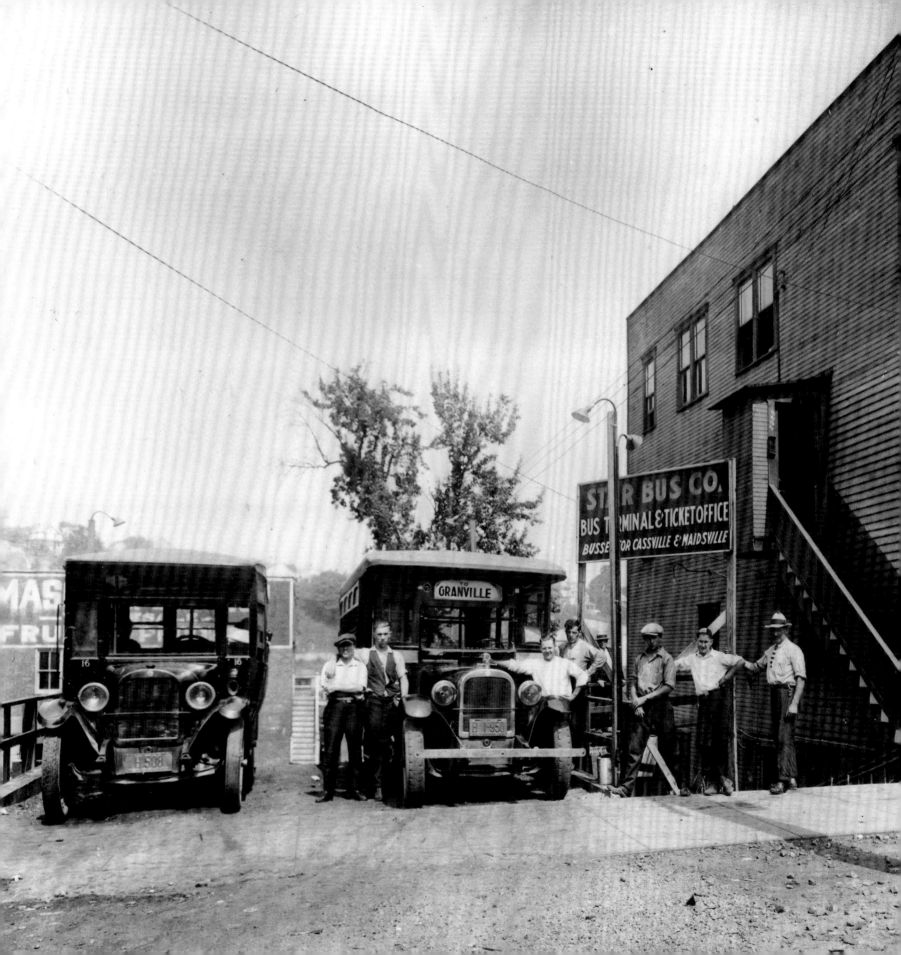

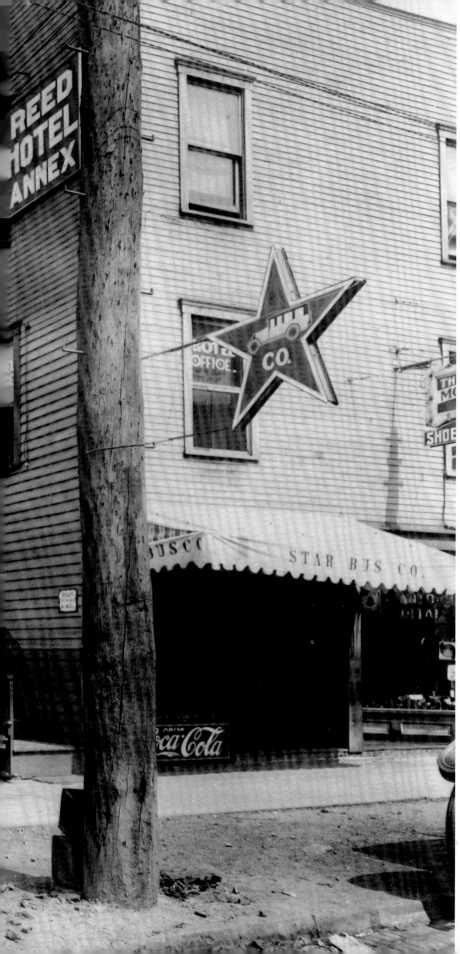

The internal combustion engine was opening up new options for getting around. Not everyone could afford a car, but bus lines arose to serve passengers. Unlike trains or streetcars, they didn't need rails or a network of electric lines. The Star Bus Company of Morgantown offered transport to Granville across the Monongahela or to Cassville in the hills farther west.

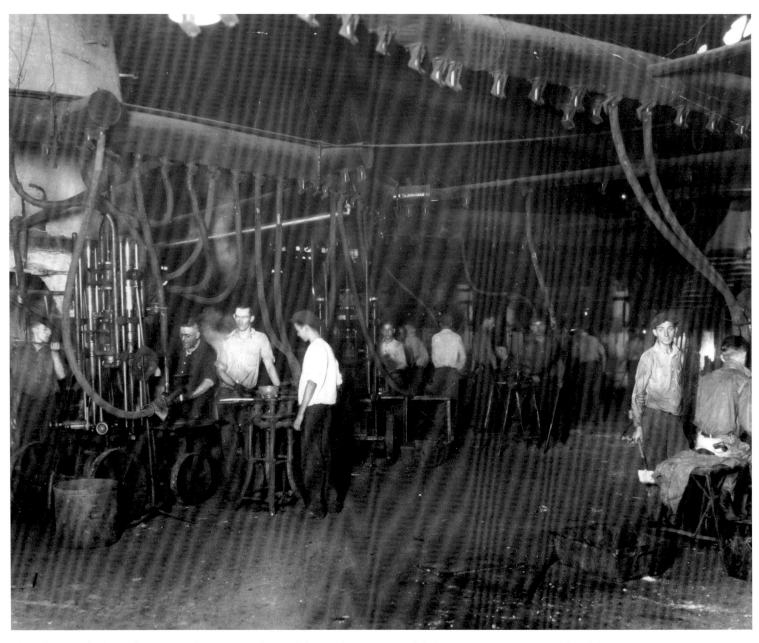

This photograph shows the pressing department of one of the state's most successful glass companies, Fostoria Glass. The company relocated to Moundsville from Fostoria, Ohio, in 1891. During the 1920s its main product line was full dinner service sets done in decorated colored glass, but the company's products always changed along with American tastes. By mid-century it was the nation's leading producer of elegant glass tableware. This plant closed in 1986.

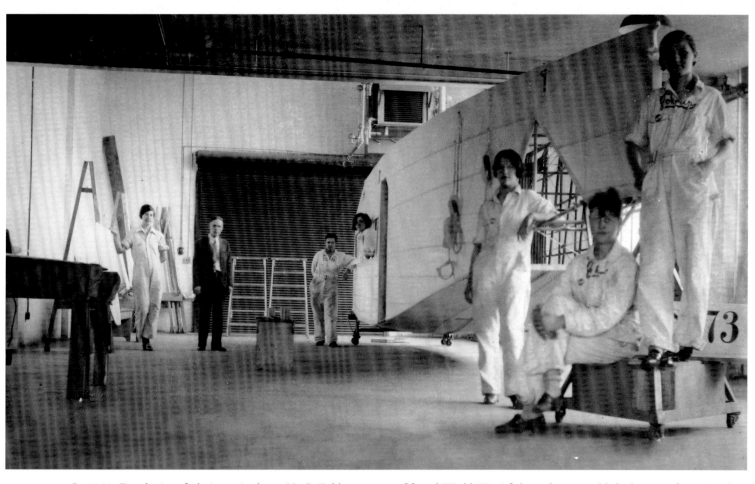

In 1928, Dutch aircraft designer Anthony H. G. Fokker, creator of feared World War I fighter planes, established a manufacturing plant at Glen Dale in the Northern Panhandle to produce passenger airlines, notably the F-10A. It hired area men and women for its assembly lines. In 1934, after Fokker had closed the plant, the Marx Toy Company purchased the factory, and for decades toys made in Glen Dale delighted children worldwide.

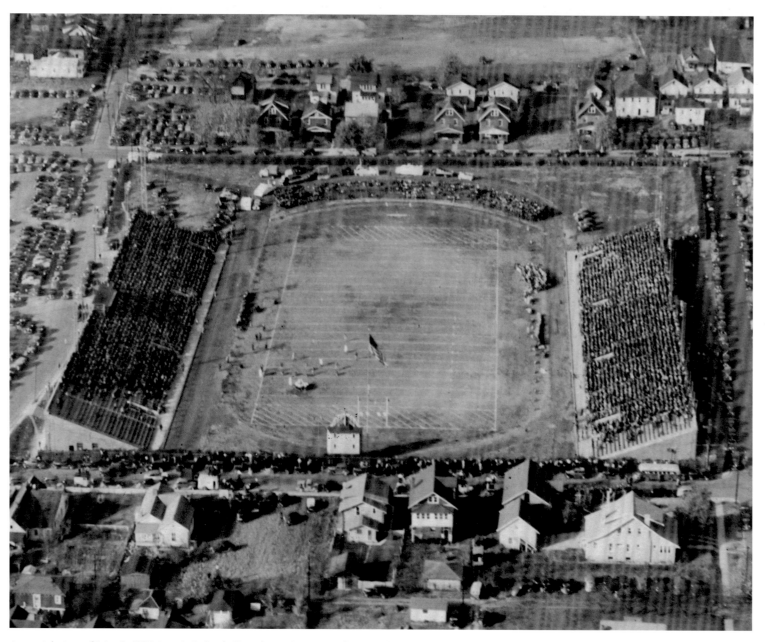

An aerial view of Marshall University's football stadium shows a parking problem on game days. The team was called the Indians in the late 1800s and later Big Green because of their uniforms' colors. In 1925, *Huntington Herald-Dispatch* sportswriter Duke Ridgley applied a name that stuck, The Thundering Herd, lifted from the title of a Zane Gray novel. Other proposed team names have included the Judges, Boogercats, and Green Gobblers.

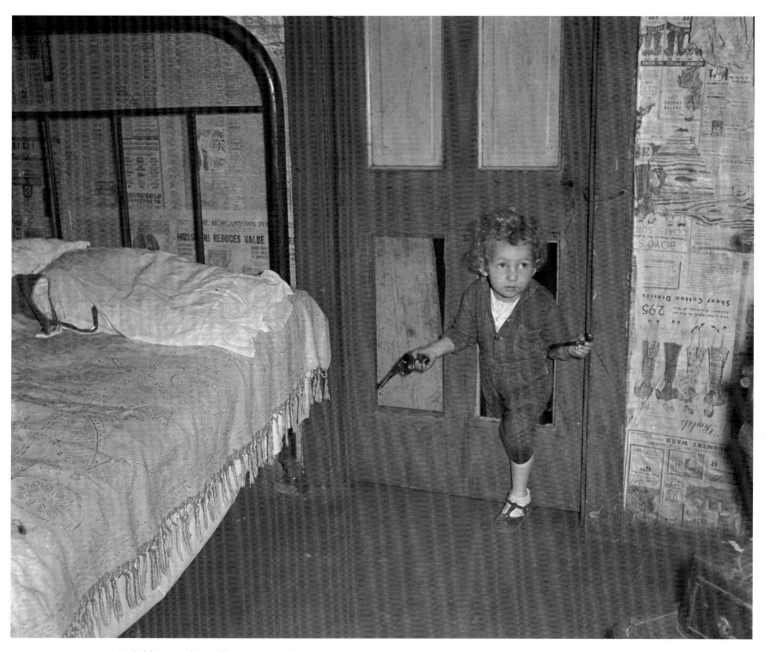

A miner's child at Bertha Hill in Monongalia County plays with a toy gun and Daddy's pipe in a drafty shack. Newspapers pasted to the walls are the only insulation, as was the case in many homes. The proximity of the stove to those newspaper-covered walls and chenille bedspread made fire an ever-present danger. A thick block beneath a bed caster shows the floor's unevenness.

President Franklin D. Roosevelt's administration responded to the Great Depression with public works projects to create jobs. The most popular was the CCC, Civilian Conservation Corps, which had 65 camps in West Virginia. Workers like the men shown here received $30 a month, $25 of which was sent to their families. They built roads and trails, fought forest fires, strung electric and telephone lines, and developed some of West Virginia's first state parks.

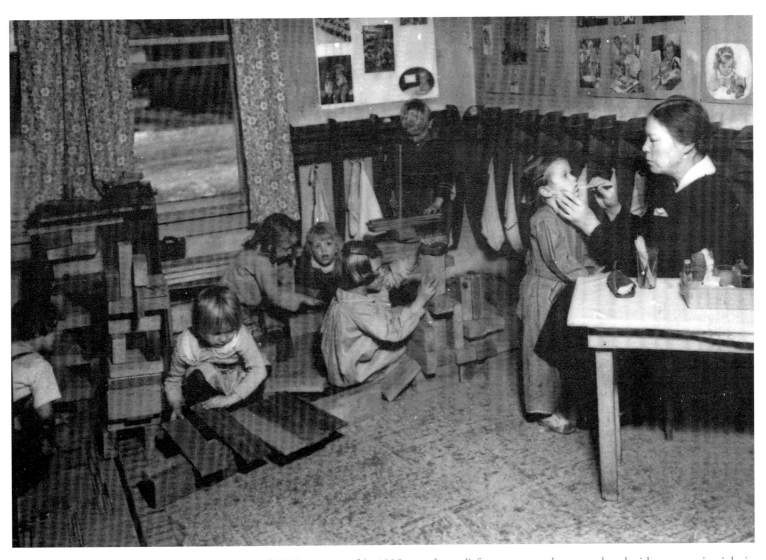

The Works Progress Administration (WPA) was started in 1935 to replace relief payments to the unemployed with wage-paying jobs in areas such as construction, recreation, public health, and the arts. Unproven allegations of political interference arose in the state, but before the program ended in 1942, it created bridges, stadiums, and buildings still in use today. This photo shows a WPA nursery in an abandoned mine fan house at Jere in Monongalia County.

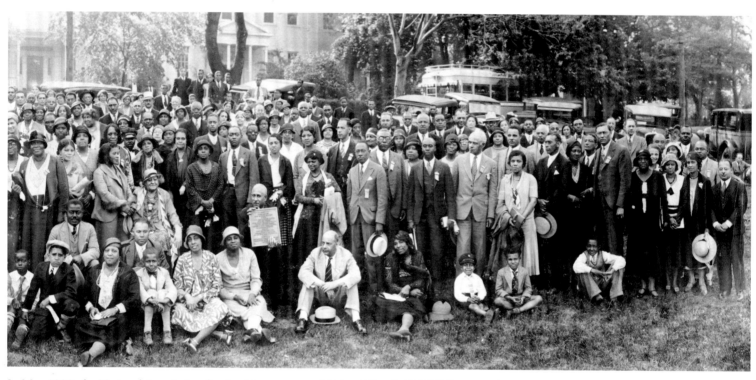

In May 1932, the National Association for the Advancement of Colored People (NAACP) returned to Harpers Ferry, where the roots of the organization were planted. In August 1906, a group known as the Niagara Movement met there to lay a plan for advancing African Americans' civil rights. Harpers Ferry was chosen because it was the site of John Brown's abolitionist raid and home to Storer College. The NAACP was formed a few years later.

Tuberculosis was once virtually a death sentence, claiming 1,000 lives a year in West Virginia. Doctors believed patients should be exposed to fresh air 12 months a year in high, cold places. Accordingly, the legislature authorized construction of Hopemont Sanatorium near Terra Alta in Preston County, with long porches for open-air sleeping. A facility for black patients was located at Denmar in Pocahontas County.

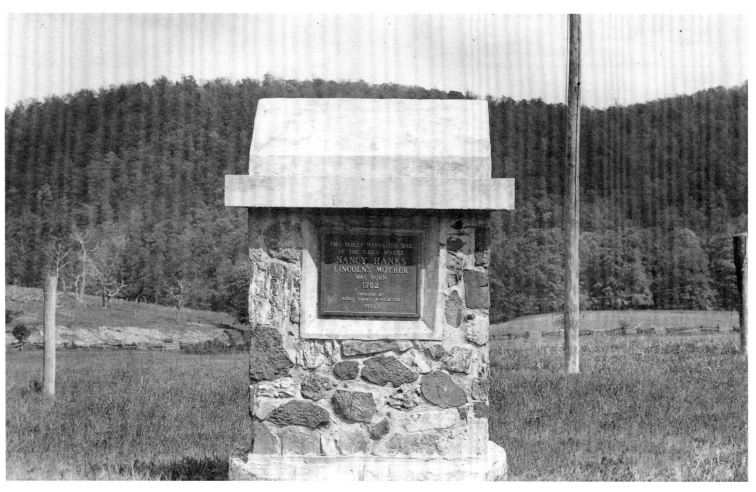

In 1933 the Nancy Hanks Association erected this monument to Abraham Lincoln's mother, Nancy Hanks, at her presumed birthplace, Antioch in Hampshire County. It shows 1782 as her birth year. Current consensus puts her birth in 1783 or 1784, according to *Did Lincoln Own Slaves?* by Gerald J. Prokopowicz, former Lincoln Scholar at the Lincoln Museum, Fort Wayne, Indiana. Her birthplace and paternity are still subjects of debate.

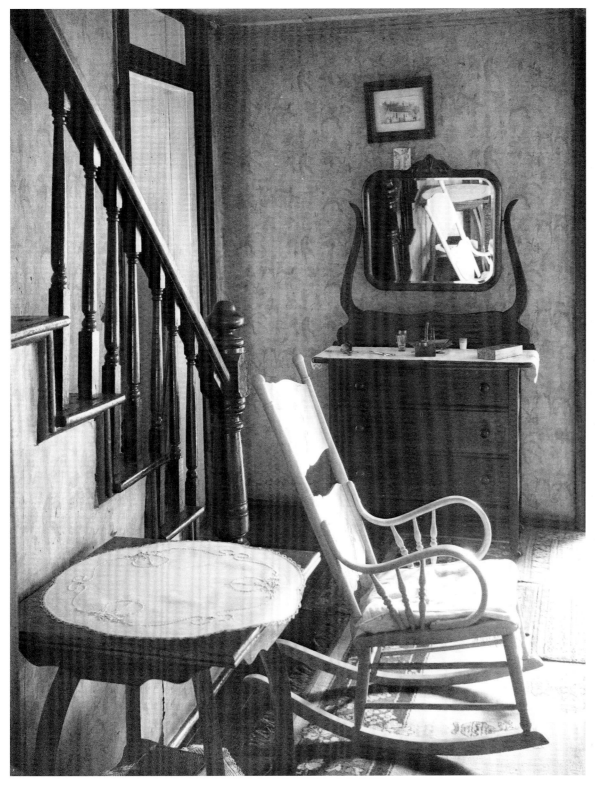

The photographer identified this image from July 1935 as "Interior of an unemployed man's house, Morgantown." If so, the furniture was a vestige of better times. There appears to be a crack below the steps behind the chair, which may be a case of the house sinking or shifting due to proximity to a mineshaft, a not-uncommon problem in the state.

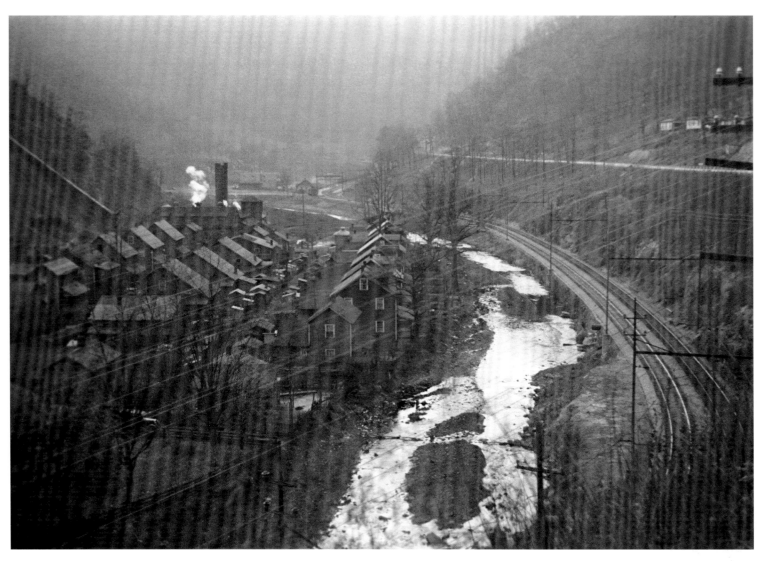

Company towns that sprang up near railroads, mines, or factories needed streams close by to carry off waste from outhouses. Heavy thunderstorms or prolonged rains often sent those streams into the houses. The little town shown here, Kimball, east of Welch, is home to what is believed to be the first war memorial building erected in memory of World War I's African-American veterans.

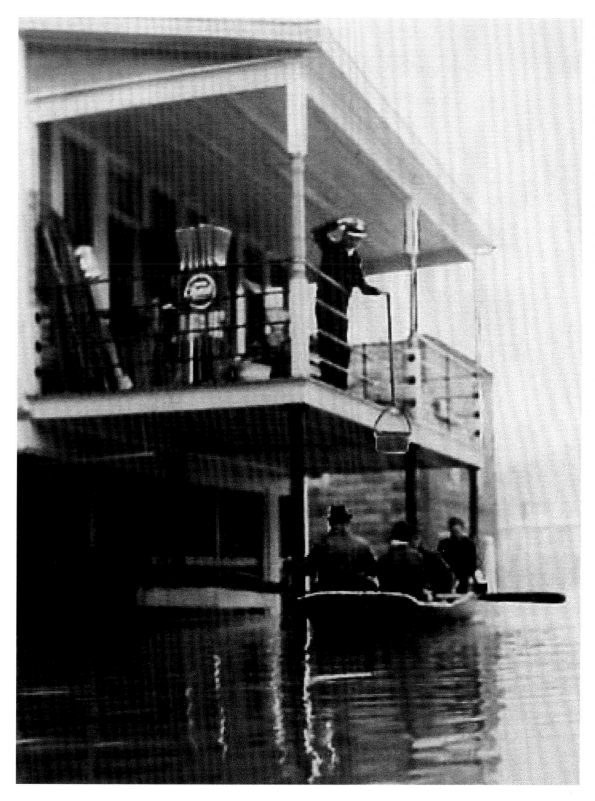

Groceries had to be delivered by boat in New Martinsville during the flood of 1936, although the city had spent three days preparing for the Ohio River's onslaught. At Wheeling, waters crested at 55 feet on March 19. Below-freezing temperatures exacerbated the crisis. From Harpers Ferry to Weston to Parkersburg, from Wheeling to Point Pleasant, 1936 and 1937 saw some of the most destructive flooding in state history.

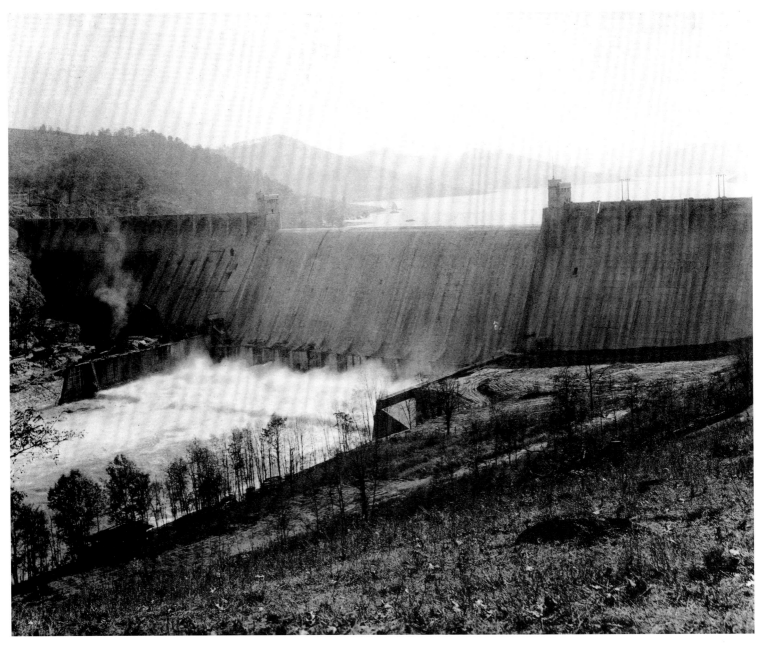

Tygart Valley Dam near Grafton was a flood-control project that, ironically, had been approved because a severe drought at the beginning of the decade nearly shut down navigation on the Monongahela River, which the Tygart flows into. Some 3,000 men worked on the $15 million dam, completed in 1937. At 1,880 feet long and 209 feet high at its spillway, it was the highest dam east of the Mississippi at the time.

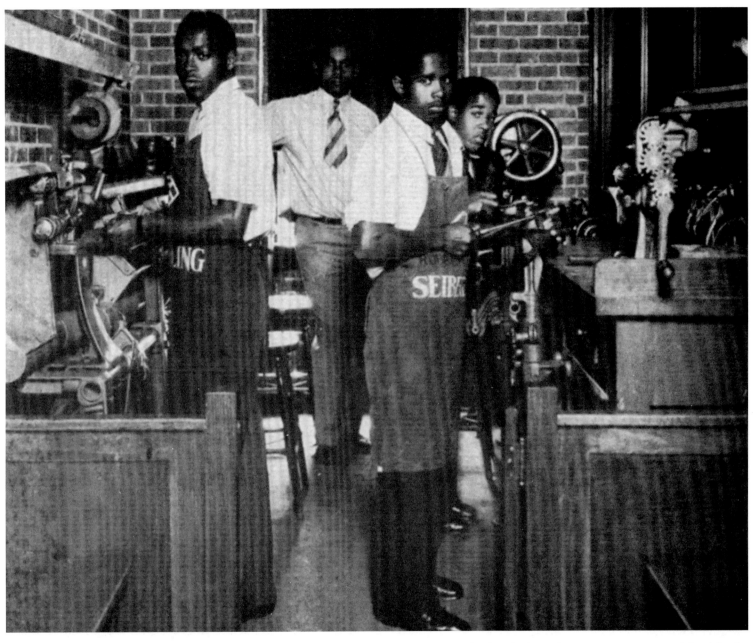

In 1870, the legislature authorized the West Virginia Schools for the Deaf and Blind, to be located in Romney. A separate School for the Colored Deaf and Blind opened at Institute in 1926; the students shown here are working in its shoe shop. The two schools merged at Romney after school segregation was outlawed in the 1950s.

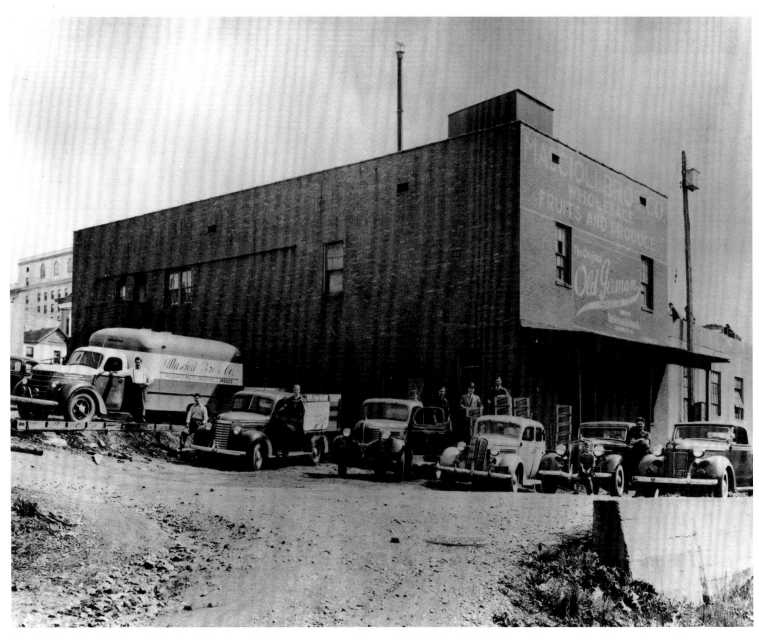

Mascioli Brothers Fruit and Wholesale Produce in Morgantown was doing well in the late 1930s. Often, European immigrants intended to earn some money and go home. Many Italians, in particular, not wanting their families to know they'd left Italy, set up post-office drop boxes so they could send money home while pretending to still be in their homeland. Eventually, most immigrants decided to stay in America. Often they or their children started a family business.

Mine-safety training exercises like this one in Martinsburg drew crowds of onlookers to watch safety teams from different mines compete against each other. Yellow-dog contracts and unfriendly legislation of the 1920s hurt efforts to improve mine safety, but in the 1930s the UWMA began to focus more on health and safety issues and worked to separate safety concerns from production costs.

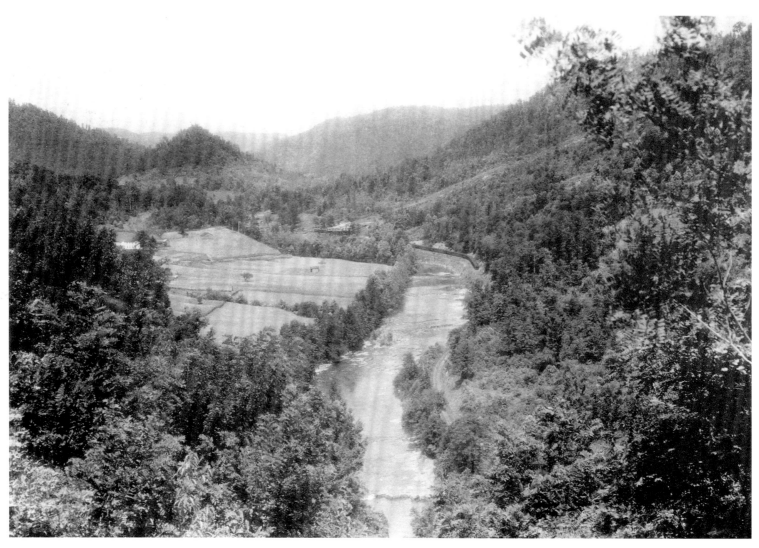

The Elk River glistens in sunlight as it flows through the Monongahela National Forest. During dry conditions, a six-mile stretch of the river disappears below ground in Randolph County. The Monongahela National Forest was created by presidential proclamation in 1920, five years after its first lands were purchased. It owes its existence to the 1911 Weeks Law that sought to protect navigable watersheds.

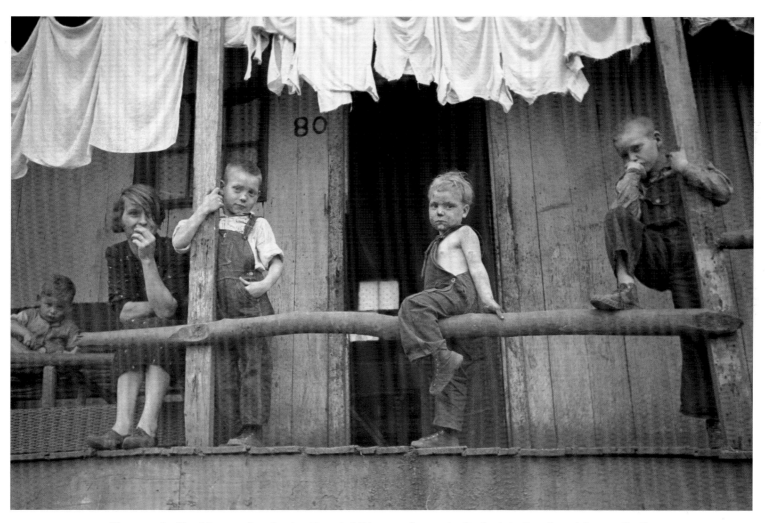

Photographs like this one of a miner's wife and children on the porch of a shack in Pursglove, Monongalia County, were meant to win public support for West Virginians' plight but also cemented a public image of a "hillbilly state." Hillbilly jokes predated this, but entertainment like *Lum and Abner* on the radio and *Li'l Abner* in comic strips were ingraining hillbilly stereotypes in popular culture at the time these photos appeared.

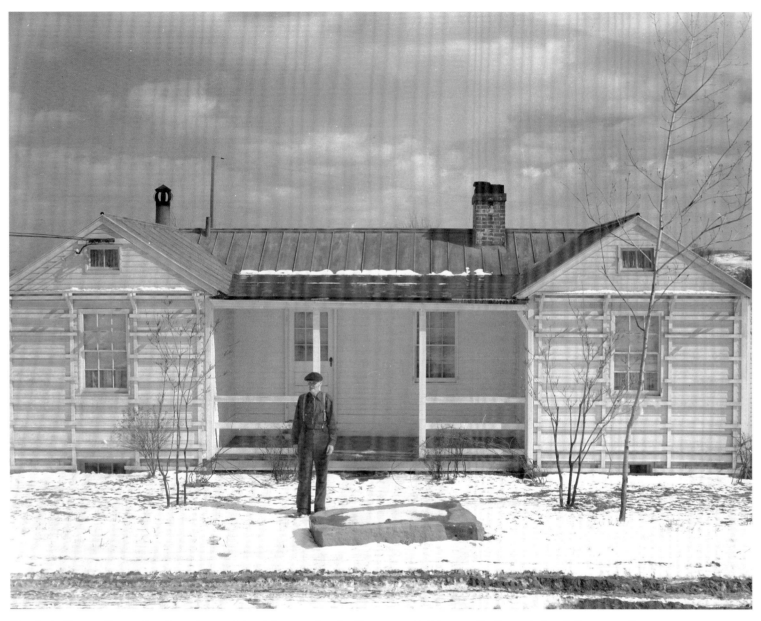

First Lady Eleanor Roosevelt, a long-time social activist, was disturbed by poverty in Monongalia County's Scott's Run area. She convinced her husband to use federal funds to build the nation's first national subsistence homestead community at Arthurdale in Preston County. This photo shows one of the prefabricated houses from The E. F. Hodgson Company that were used to create the town. Similar communities were built at Dailey and Red House, the latter renamed Eleanor.

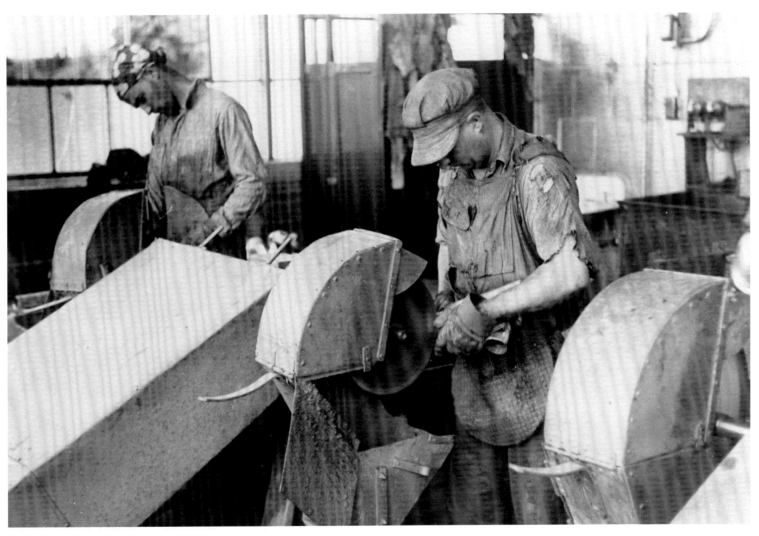

To provide employment for the 165 families at Arthurdale, several cooperative businesses were started, such as the vacuum cleaner factory in this photo. Most foundered within a few years. Every home had indoor plumbing and electricity, things many other Americans lacked, and taxpayers grumbled about the communities. Today, all but one of the original houses still stand, and Arthurdale is a National Historic District.

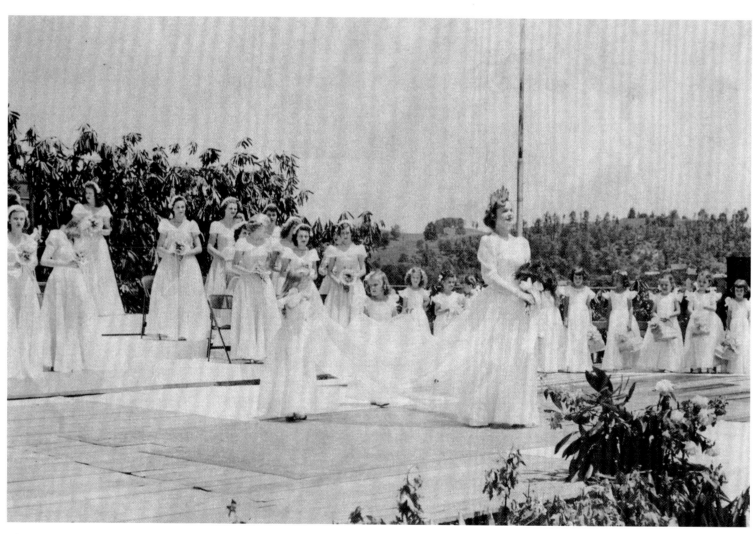

The Depression forced communities to get creative. Some initiated festivals and events to promote products of the local economy; most of these are still annual events. Elkins started the Forest Festival. Mannington established its district fair. Buckhannon's Strawberry Festival originally was intended to promote strawberry growing among local farmers. This photograph shows a Strawberry Festival Queen and her court.

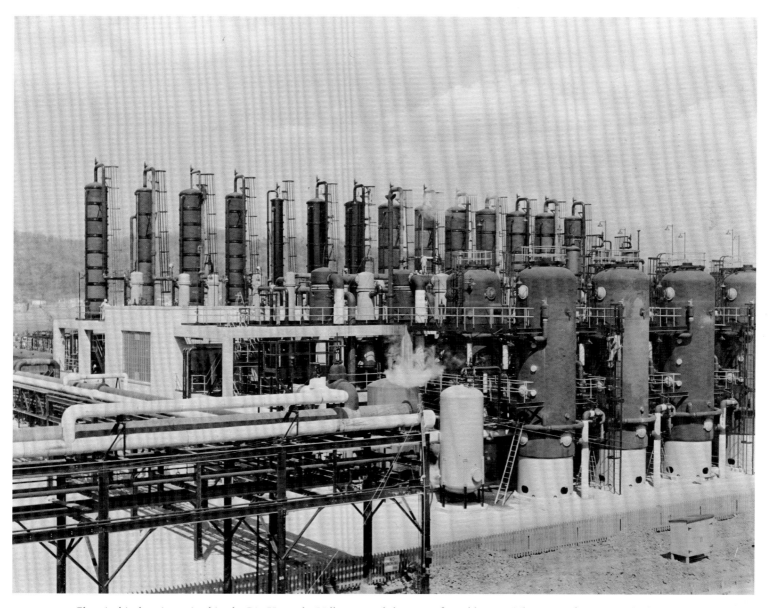

Chemical industries arrived in the Big Kanawha Valley around the time of World War I. The town of Nitro was built to house laborers in a defense industry plant. Carbide and Carbon Chemicals Corporation (CCCC), the chemical division of Union Carbide, arrived in the 1920s; their butadiene storage tanks are shown in this photograph. In 1930, hundreds of men died of silicosis after drilling through silica to construct a CCCC hydroelectric tunnel near Hawk's Nest.

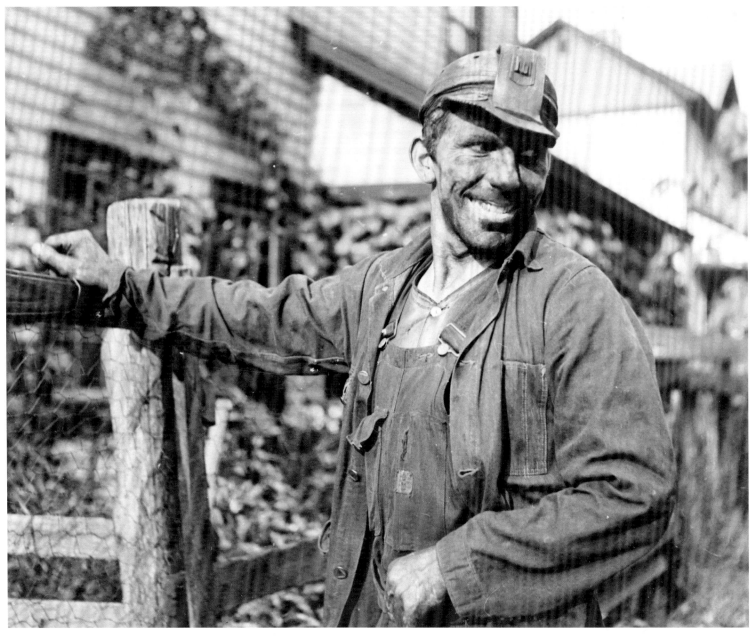

This Polish coal miner was one of thousands of immigrants from many parts of Europe who came to work in mines and factories. They often struggled for acceptance and strove to balance American citizenship with a desire to preserve their traditions. An influx of African Americans fleeing violent racism in the Deep South and seeking better employment also arrived during the Great Migration of 1910–1930.

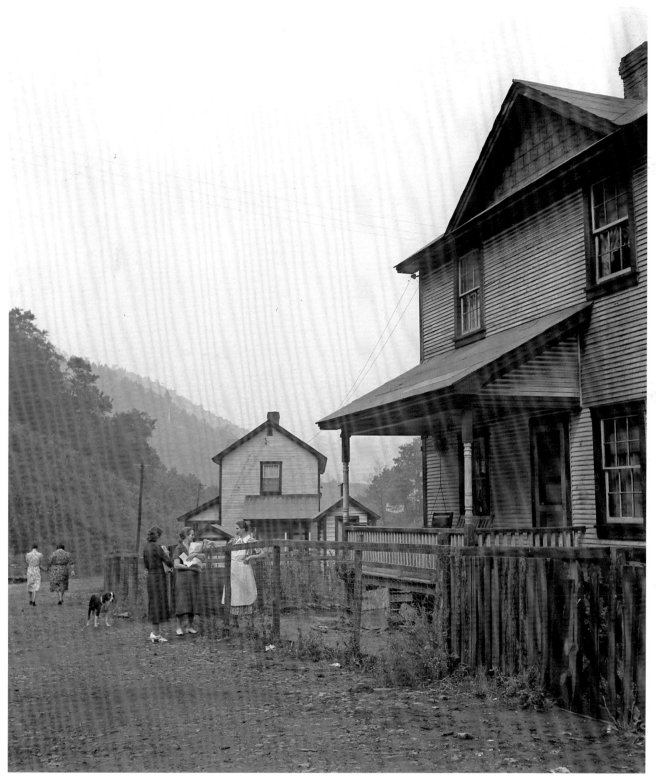

Coal miners' wives chat across a fence in Capels, northeast of Welch. While their husbands, fathers, and sons toiled underground, they fought a never-ending battle to keep coal dust off windows, floors, and furniture. They packed their men's metal lunch pails, raised the children, tended gardens, and generally saw to it that the family attended worship services.

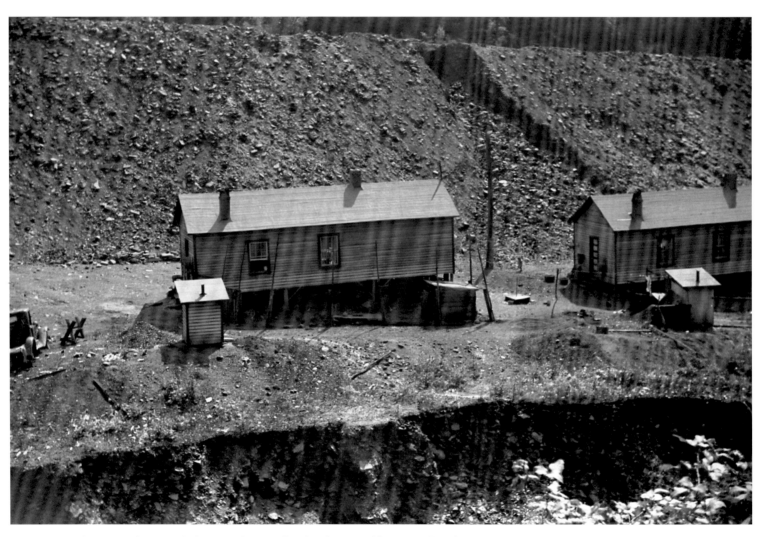

Mining waste known as slag was piled in great heaps taller than houses. If fires started in them, they might burn for years. Children were cautioned not to play on them for fear a soft area would collapse and swallow them. Sulfuric mine drainage made steams flow orange. Slag heaps and orange streams were commonplace until environmental laws forced cleanups late in the twentieth century, but mining provided jobs and fueled the state's economy.

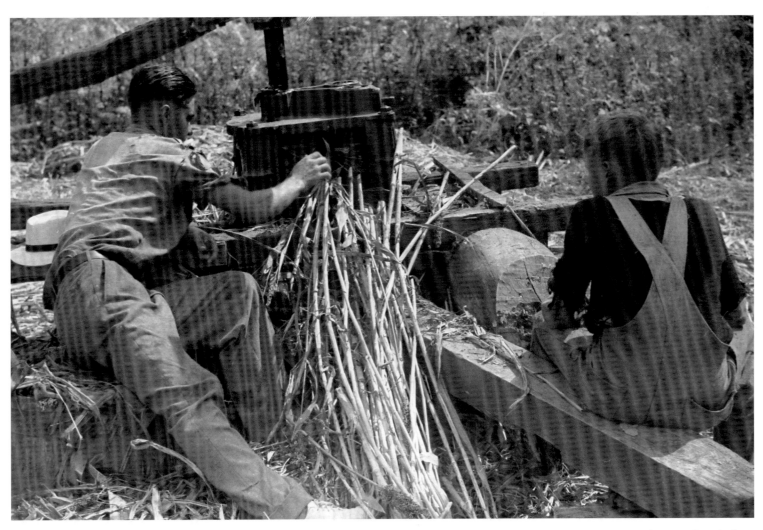

These fellows in Racine are feeding sorghum cane into a press to make thick sorghum molasses. A horse would be harnessed to the long lever shown at upper left, and as it slowly walked in circles, the cane's juice was squeezed out. About 20 gallons of juice would slowly cook down to a couple gallons of molasses. Like apple-butter making, sorghum making was a time-consuming autumn activity.

This statue of "Devil Anse" Hatfield in the cemetery at Sarah Ann, Logan County, commemorates the leader of one side of the Hatfield-McCoy Feud. Randolph (Randall) McCoy led the McCoy faction in Kentucky. The feud's origins are unclear, but between January 1865 and February 1890, the two families inflicted multiple deaths and wounds and strained relations between West Virginia and Kentucky.

No other feud ever captured the nation's imagination like this one did.

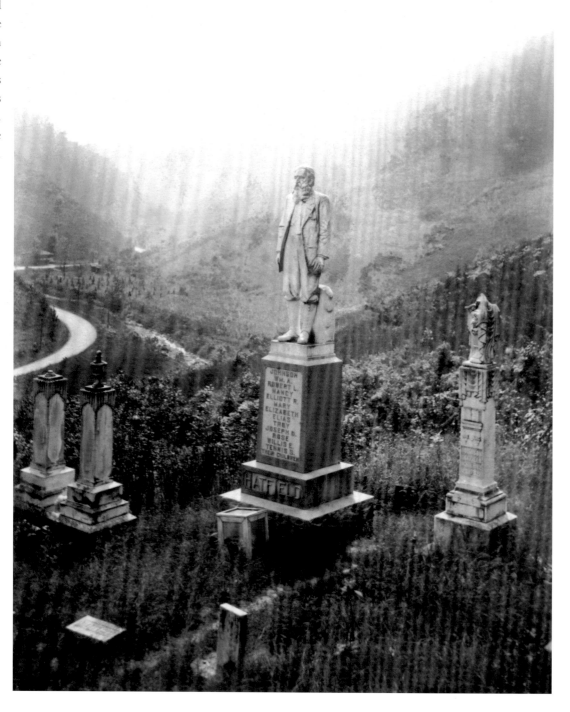

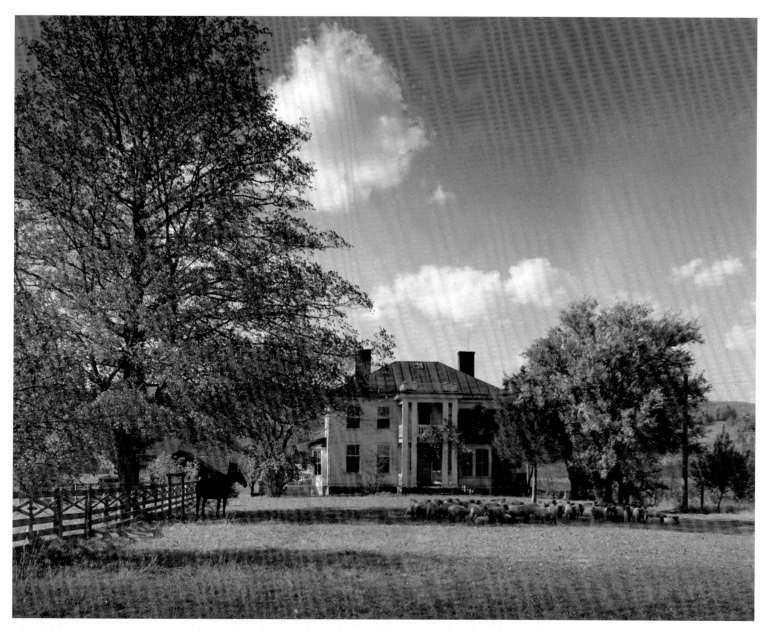

In 1938, Pearl S. Buck, best known for writing *The Good Earth,* became the first American woman to win the Nobel Prize for Literature. She was born in this house, her maternal grandparents' home in Hillsboro, Pocahontas County, now the Pearl S. Buck Museum. The state's many honored writers include Margaret Prescott Montague, the first-ever O. Henry Memorial Award winner, and John Knowles, the first to win the William Faulkner Foundation Award.

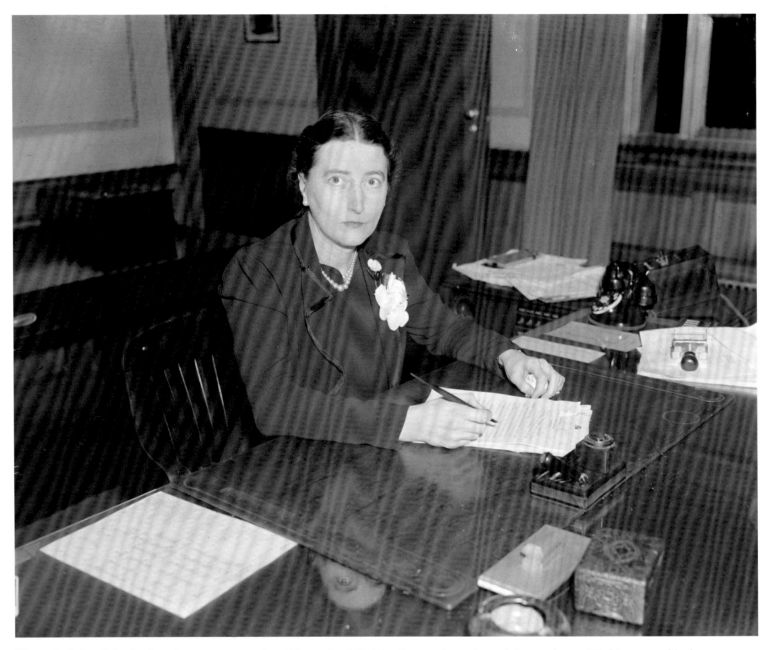

The nation's first federal prison for women opened at Alderson in 1927. The site was chosen because it was close to Washington and had rail transport, good climate, water, and land. Its inmates have included blues singer Billie Holiday; Mildred Gillars ("Axis Sally"); Iva Toguri D'Aquino ("Tokyo Rose"); Lynette "Squeaky" Fromme; and publisher, television host, and home-décor diva Martha Stewart. This photo of Assistant Superintendent Helen Hironimus was taken in her office April 1, 1939.

Exodus and Genesis

(1940–1979)

At Pearl Harbor, Hawaii, on December 7, 1941, USS *West Virginia* was among seven U.S. battleships crippled by Japanese torpedoes and bombs. America was at war.

West Virginia's women had to replace men on jobs, and their workforce numbers leapt from 24 to nearly 35 percent. The Greenbrier luxury hotel housed enemy diplomats until they were exchanged, then became a military hospital. Over 5,800 young men died in strange places like Bastogne and Iwo Jima. One West Virginian helped lead the Tuskegee Airmen to their remarkable war record. Another cracked the sound barrier in an experimental plane shortly after the war.

At home, weather disasters took lives. The state park system swelled, and Green Bank joined the search for extraterrestrial messages. Mechanization in coal mines and increased use of strip mining created the Great Coal Depression of the 1950s. Factories were closing, and West Virginians joked wryly that their schools taught the three r's—reading, 'riting, and the road to Ohio. The Great Exodus had begun.

Morgantown's Don Knotts and Logan County's Virginia Ruth "Dagmar" Egnor entertained audiences through the new medium of television. Teenagers gyrated to a sound that in large measure owed its origins to piano player Johnnie Johnson from Fairmont, "the Father of Rock and Roll," the Johnnie who inspired "Johnnie B. Goode."

In 1960, Democratic presidential hopeful John F. Kennedy had to win the West Virginia primary to prove a Catholic could carry a conservative, Protestant state. Hordes of news media arrived and discovered Coal Depression–poverty in the midst of national prosperity. The term "Appalachia" was born.

West Virginia continued to gain national attention throughout the 1960s. During the Vietnam War era, the state sent a higher portion of its young men to military service than any other state except North Dakota. In the educational realm, Fairmont State founded national drama honorary programs, and its football team won a national championship. Marshall University lost its entire team and coaching staff in an airplane tragedy.

Interstate highways increased mobility and brought shopping malls and chain stores but left bypassed downtowns filled with vacant storefronts. In coming decades, the state would explore new economies from tourism to high-tech industries, often assisted by representatives in Washington who had risen to positions of influence in Congress.

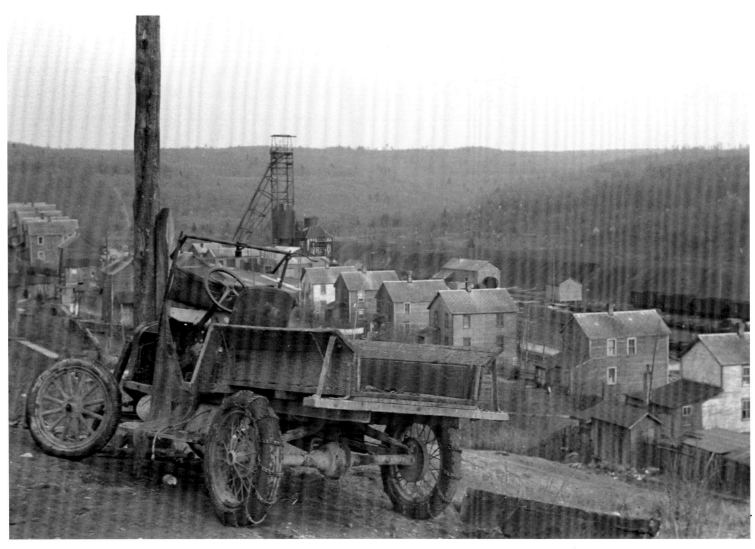

At Kempton, home to the Potomac River's headwaters on the West Virginia–Maryland border in the mountains north of Thomas, vehicles needed chains wrapped around their tires. Driving muddy or snow-covered roads that twisted along steep grades was not a good insurance risk. Even after main roads were paved, all West Virginia drivers kept a set of chains handy; many still do.

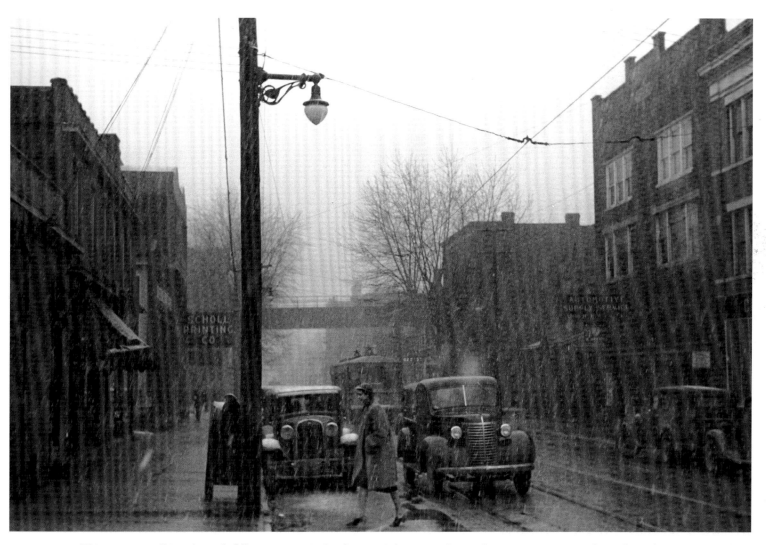

This woman walking through falling snow at Parkersburg in February 1940 may be going to W. C. Lockwood Jewelers, just around the street corner at left. The Scholl Printing Company down the street published such works as Oscar D. Lambert's *Pioneer Leaders of Western Virginia*. Parkersburg at various times has been home to O. Ames Company, world's largest manufacturer of shovels, and DuPont and Marbon chemical plants. Vitrolite glass was made in nearby Vienna.

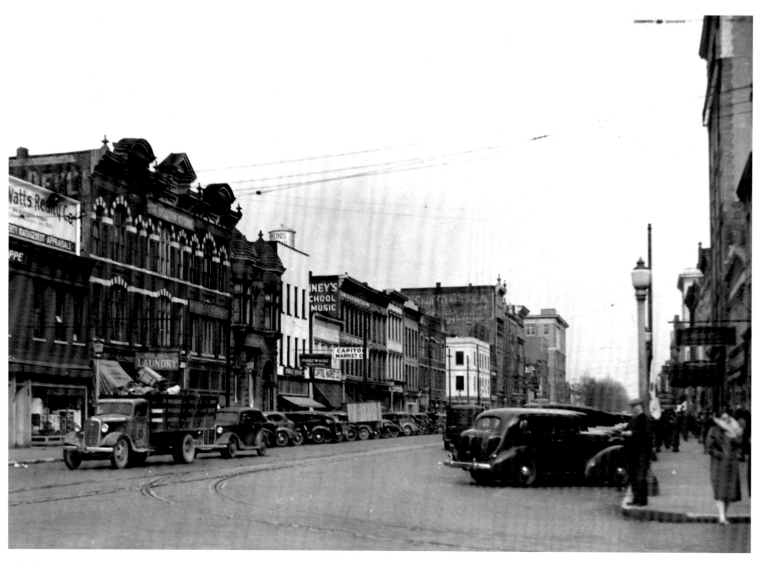

A light snow dusts the streets of Huntington in this photo taken around 1940. The number of businesses shows the city prospering despite the Depression and the floods of 1936 and '37. After the 1937 flood, the U.S. Army Corps of Engineers built a floodwall 11 miles long to protect the city.

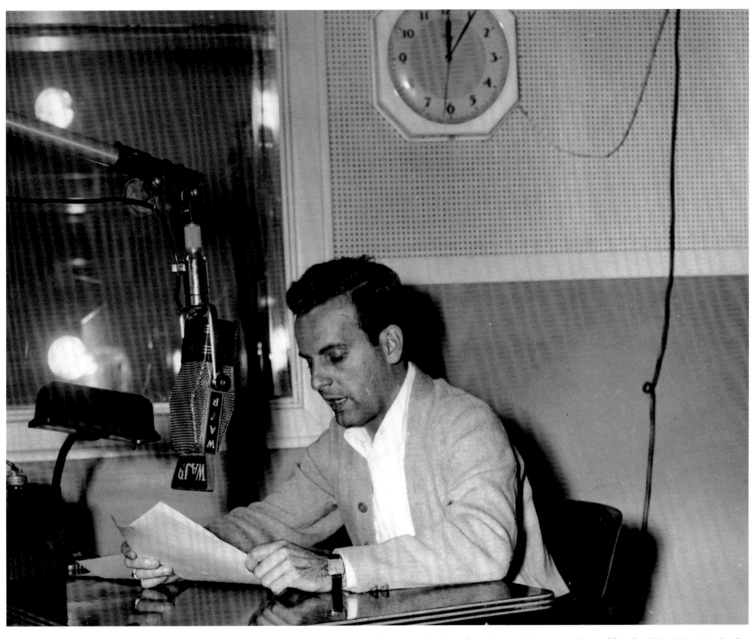

Radio station WAJR went on the air in Morgantown on December 7, 1940, broadcasting at 250 watts. Owned by the West Virginia Radio Corporation, from its inception it worked closely with West Virginia University and became the flagship station for broadcasting the Mountaineer's football and basketball games.

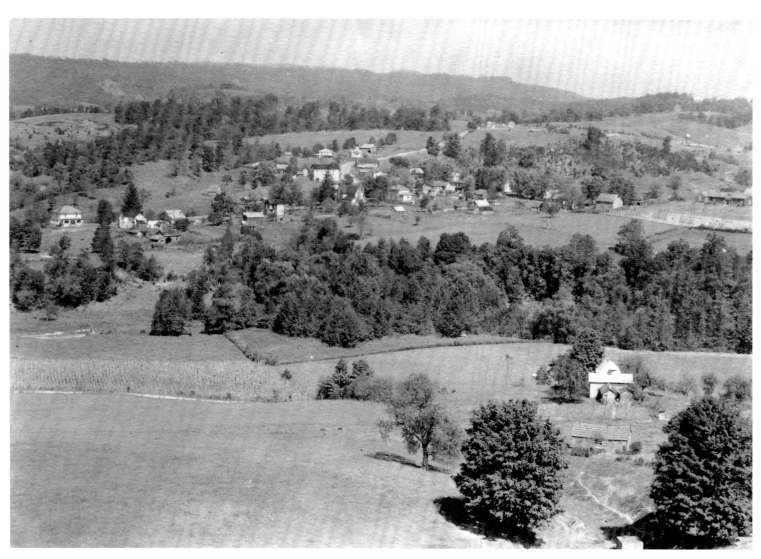

Another tranquil day at Greenville in Monroe County, captured on film around 1940. Still an agricultural area, Monroe County has traditionally had some of the lowest crime rates in the nation. The county was a prominent spa resort destination prior to the Civil War but never regained its status in the antebellum years. It was home to Allen Taylor Caperton, a Confederate senator who was elected to the U.S. Senate after the war.

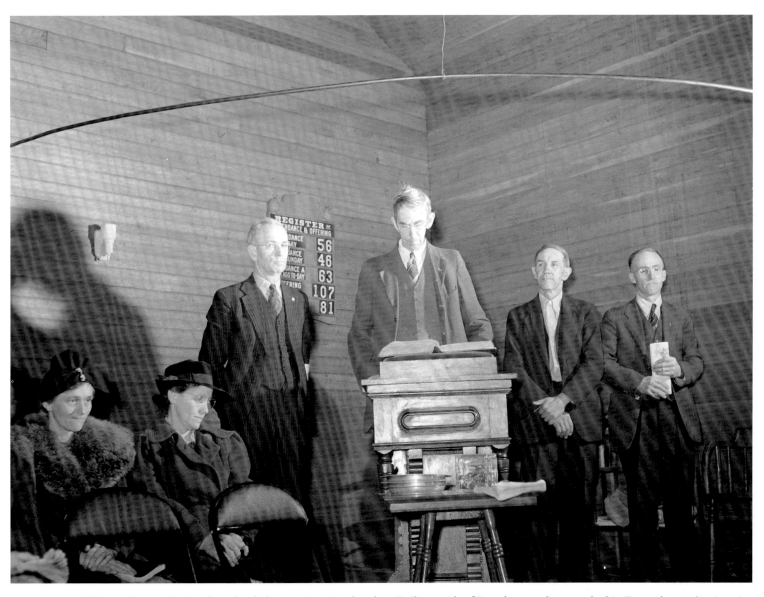

Bible reading at this Sunday school class in a Baptist church at Dailey, south of Beverly, was photographed in December 1941. America was thrust into World War II by the bombing of Pearl Harbor on the first Sunday of that month. Religion has been an important part of life within the state, and small churches like this one still service congregations. Some still use wooden registers like the one on this wall to record attendance.

With America at war, the adults in Dailey prayed, but their children still played. Baseball was a popular game with both genders in every community, and bases were made from whatever was at hand—in this case, a thick rock.

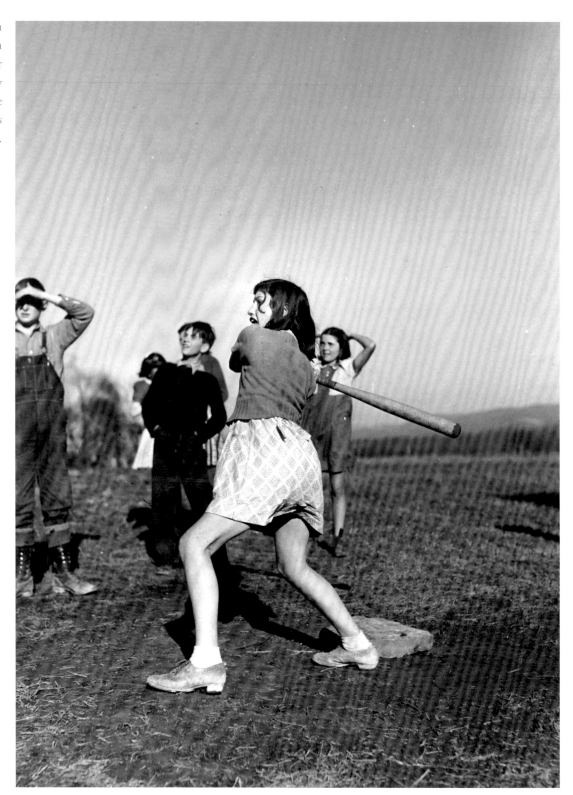

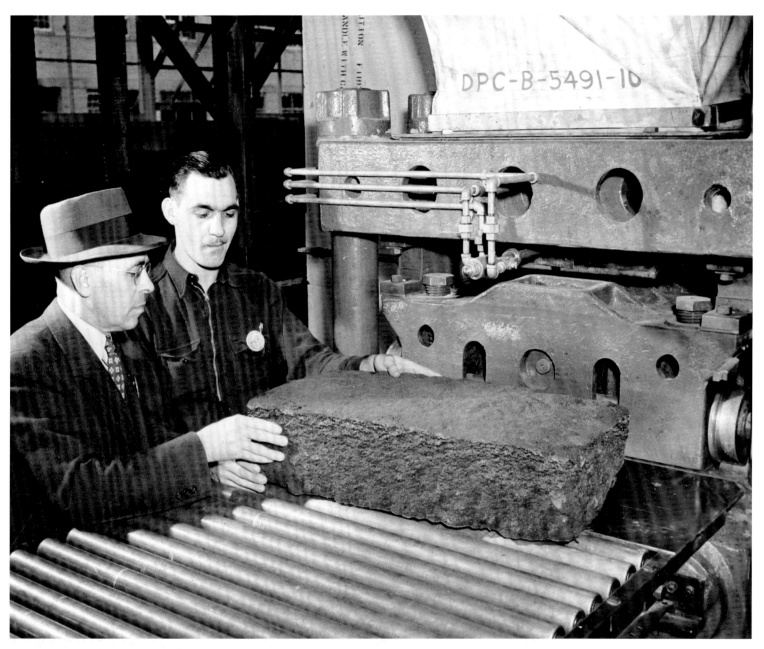

The U.S. Rubber Company at Institute produced thousands of these synthetic rubber loaves every day. Plants like this one, Carbide and Carbon Chemicals Corporation, and others gave rise to the Big Kanawha Valley's nickname, "Chemical Valley." They created good-paying jobs but caused environmental problems. Charleston newspapers began addressing pollution issues as early as 1913; a 1945–1947 study recommended "an overall atmospheric control program."

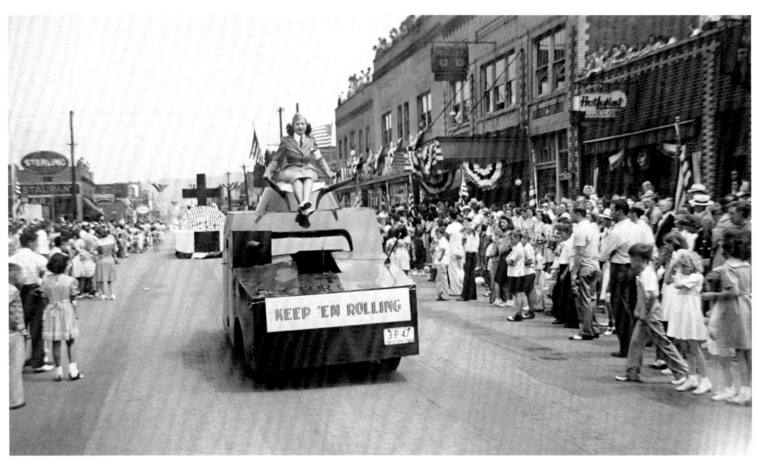

Northern Panhandle steel companies did indeed "Keep 'Em Rolling" during World War II, as this float in a Weirton parade urges. The popular radio variety show, *It's Wheeling Steel,* which may have influenced *The Lawrence Welk Show,* challenged the state's cities to each raise money to buy a bomber. With many men overseas, "Rosie the Riveter" kept assembly lines going strong. In 2009, the Belgian government honored the state's "Rosies" in a ceremony at Shepherdstown.

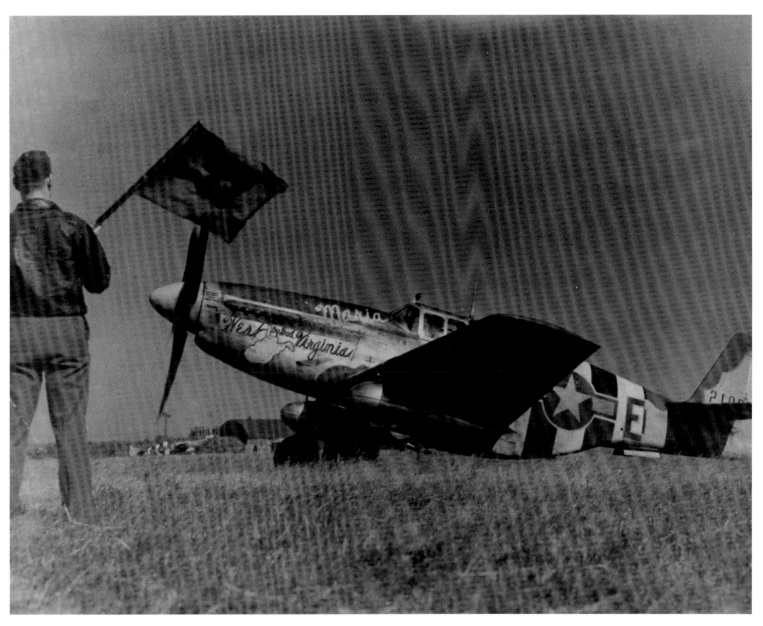

West Virginians get really tired of explaining that their state is not part of Virginia. Dayton Casto had *West By God Virginia* painted on his fighters. Casto's commander, Thomas J. J. Christian, Jr., was Stonewall Jackson's great-grandson. Another plane was *The West By Gawd Virginian* flown by ace Robert "Punchy" Powell from Wilcoe. It has been featured in several aviation-art paintings. The two men were in different squadrons of the Eighth Air Force.

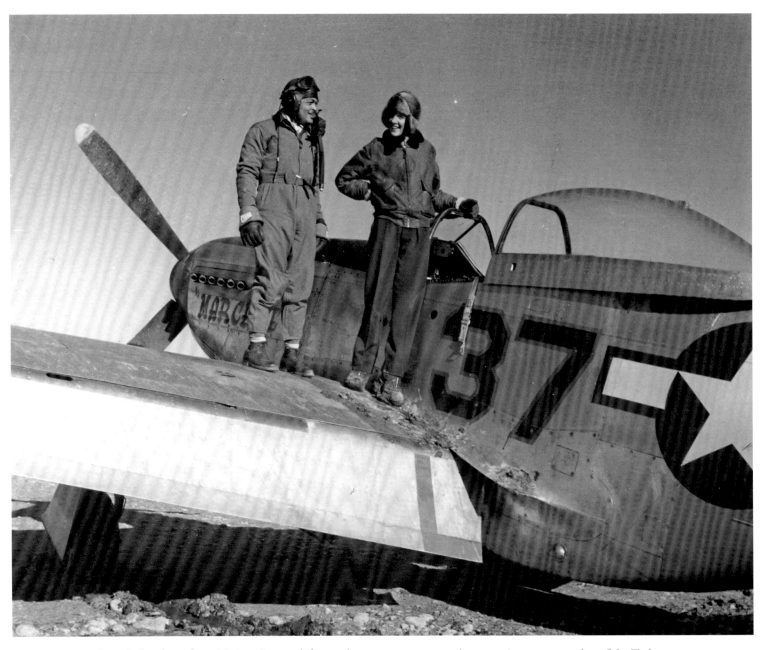

Major George S. "Spanky" Roberts from Marion County, left, was deputy group commander, sometimes commander, of the Tuskegee Airmen, black fighter pilots who racked up an impressive wartime record. This photo was taken at Ramitelli, Italy, March 1945. Roberts entered West Virginia State College at age 15; when older, larger boys teased him, he joked that he'd spank them, and they dubbed him "Spanky." He retired as an Air Force colonel.

Powerful tornadoes are not common in mountainous West Virginia, but around 8:30 P.M., June 23, 1944, the worst in state history roared through Harrison, Marion, Taylor, and Barbour counties before lifting back into the clouds over Randolph County. It took 103 lives and injured 80 others. This picture shows the destruction at Bridgeport, east of Clarksburg.

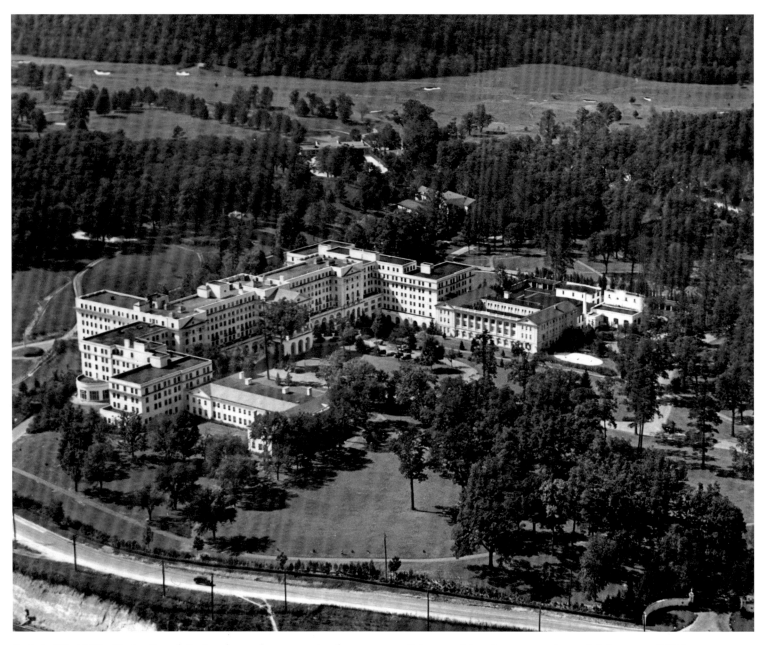

Early in World War II, the Greenbrier hotel complex was used to house enemy diplomats. After they were exchanged, it became a 2,000-bed hospital for American war wounded, nearly 25,000 of whom passed through its doors. By 1948, it had returned to its resort role, but during the Cold War, a 112,000-square-foot bomb shelter was covertly built under a new wing to house the president and Congress in the event of nuclear war.

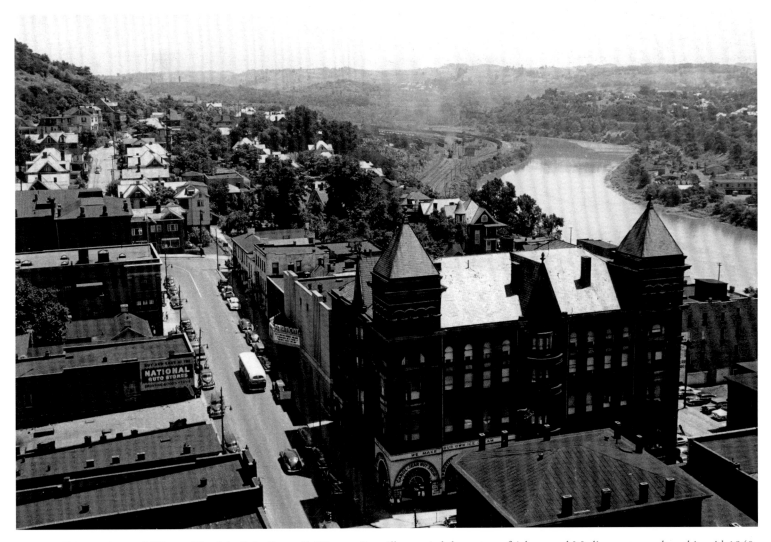

Fairmont's grand Watson Hotel, built by James E. Watson, Sr., still occupied the corner of Adams and Madison streets when this mid-1940s photo was taken. In 1903, the hotel housed an Italian bank and an Italian consulate set up to aid Fairmont's immigrants. Up the street is the marquee of the Fairmont Theater, managed by comic Western actor John Forrest "Fuzzy" Knight. Francis H. Pierpont's house once stood at the top of the street.

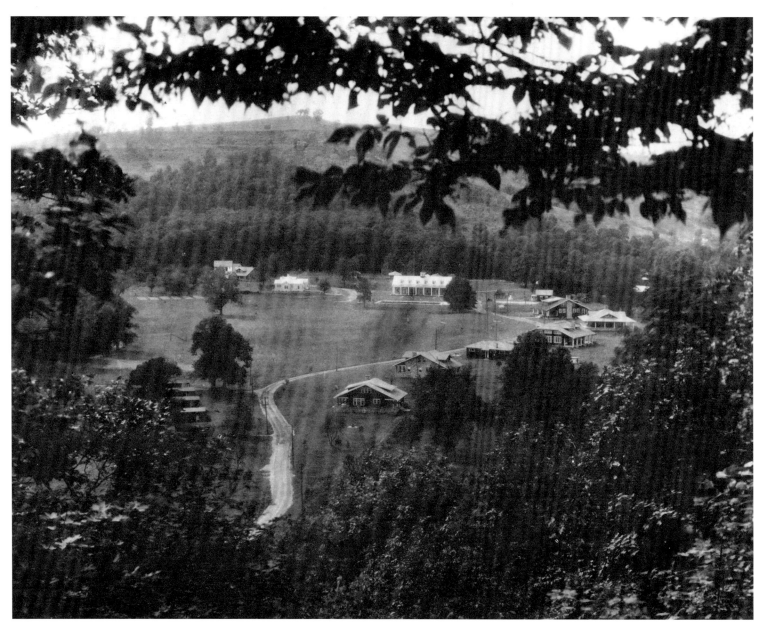

Jackson's Mill, where Stonewall Jackson spent his boyhood, has been a home-away-from-home for thousands of boys and girls since it became the world's first state 4-H camp in the 1920s. The north-facing view in this photo shows several of its cabins, named for the counties that built them. The rectangular building at center is the Mount Vernon dining hall. The old mill is outside the bottom of the photo.

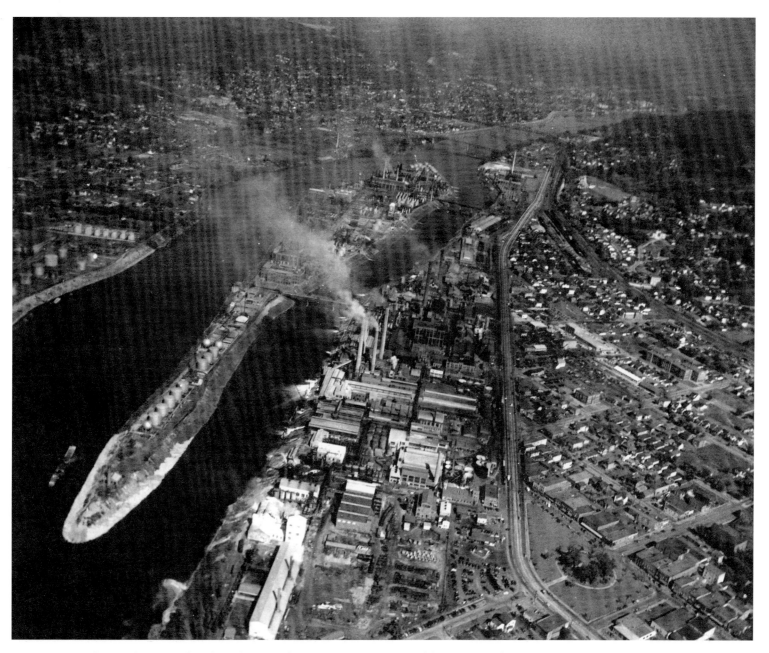

This aerial image, taken from the west, shows postwar industries still booming in Charleston and South Charleston (right). Charleston began as Fort Lee in 1788, but in 1794 was renamed for Charles Clendennin, father of the settlers' leader, George. Daniel Boone lived there for a time, and the home of Confederate colonel George S. Patton, grandfather of the famed World War II general, still stands. Nineteenth-century black leader Booker T. Washington lived in nearby Malden.

The Main Hall at Marshall University holds a special place in the memories of many former students. The school's population swelled after the war, thanks to the G.I. Bill that helped veterans attend college. Marshall, named for U.S. Chief Justice John Marshall, began in 1837 in a log church where this building now stands. It became Marshall University in 1961.

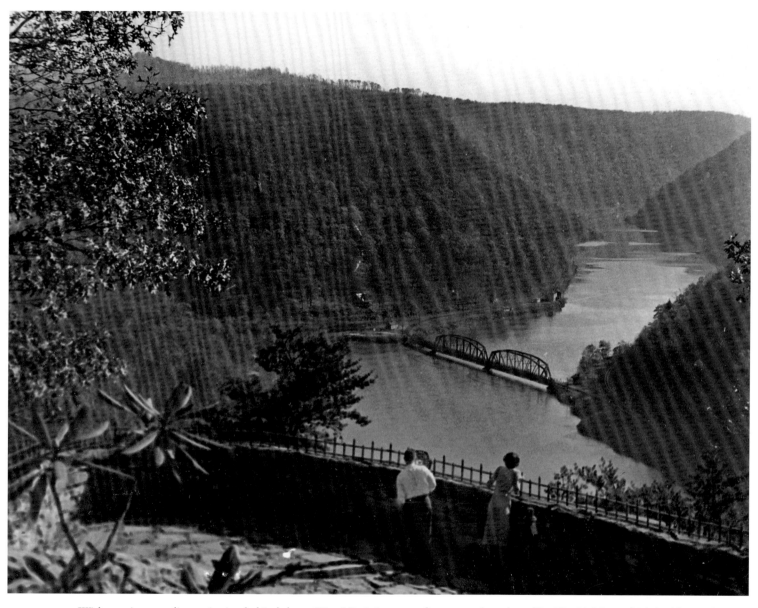

With wartime gasoline rationing behind them, West Virginians were free to travel to places like Hawk's Nest, which had become a state park in 1935 after the New River was dammed the previous year. A tramway was added later. West Virginia's first state park was Watoga, opened in 1934. It had its origins in some 4,500 acres the Game and Fish Commission purchased in Pocahontas County in 1925.

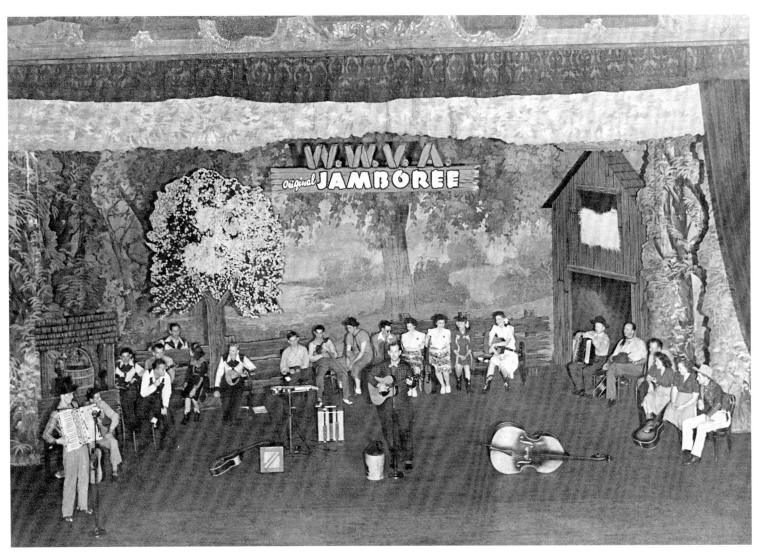

Reed Dunn takes the microphone during a WWVA *Wheeling Jamboree* broadcast in 1946. The *Jamboree* has been delivering live country music to listeners since January 7, 1933. Only Nashville's *Grand Ole Opry* is older among shows of this type. Besides country artists from Little Jimmie Dickens to Brad Paisley, West Virginia can claim rock 'n roll pioneer Johnnie Johnson, renowned opera singer Phyllis Curtin, Grammy-winning pop vocalist Bill Withers, prolific hymn-writer Ida Reed, and others.

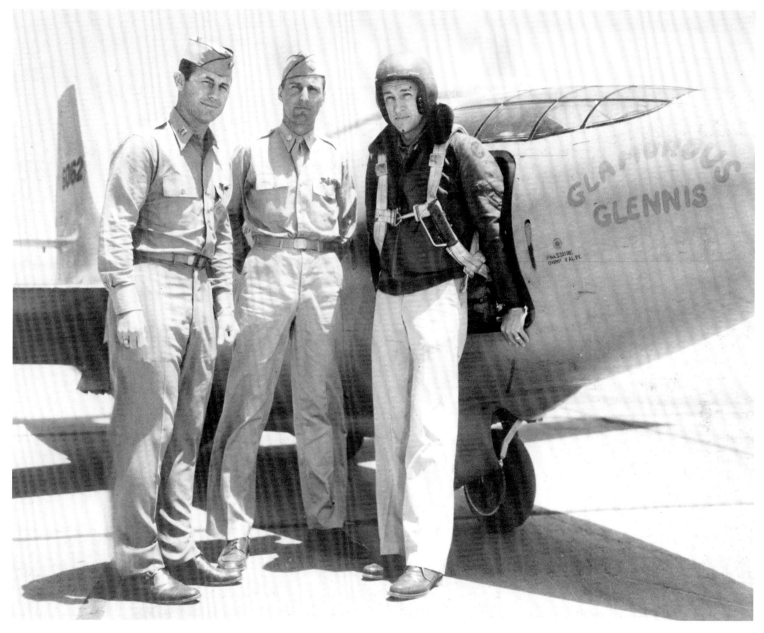

On October 14, 1947, Charles "Chuck" Yeager from Myra in Lincoln County did what had long been believed impossible: Flying an experimental rocket plane, named *Glamorous Glennis* after his wife, he broke the sound barrier. He was a World War II double ace, scoring five of his 13 kills in a single dogfight. Renowned rocket scientist Wernher von Braun sought his assistance for solving missile wobble. Yeager is at left in this photo.

Fairmont State University's drama department established Alpha Psi Omega, the national collegiate dramatics honorary fraternity, to recognize and promote excellence in theater and theater education. The Alpha chapter was formed at the college August 12, 1925. In 1929, Fairmont State helped form both Delta Psi Omega for junior colleges and the high school honorary, the National Thespian Society, which has since gone international. This 1949 photo shows a rehearsal for *Twelfth Night*.

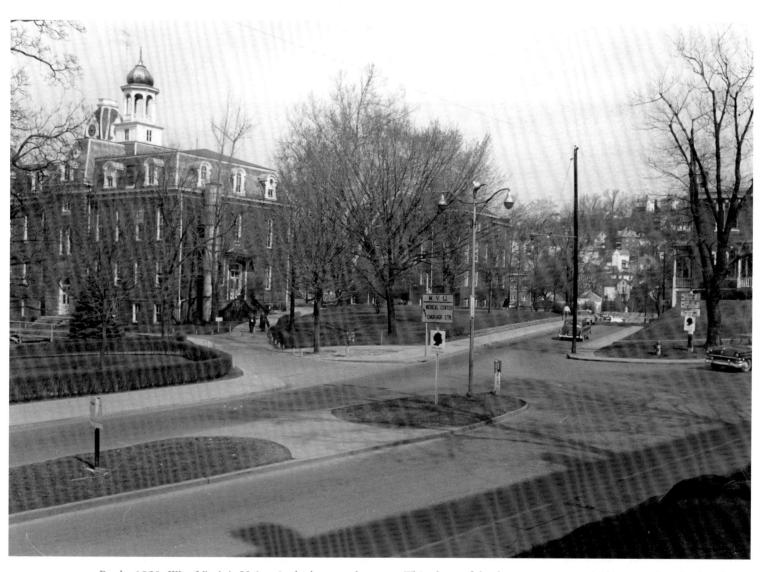

By the 1950s West Virginia University had come a long way. This photo of the downtown campus looks serene, but the decade was one of expansion under President Irvin Stewart. Lands were purchased that would be developed into the WVU Medical Center and the Evansdale Campus.

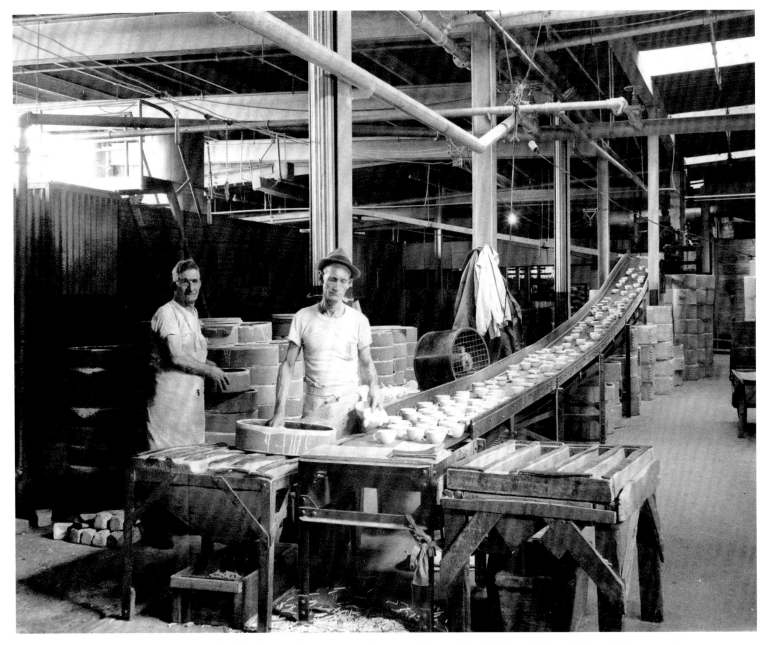

Two workers transfer cups from an assembly line into earthenware containers used for stacking inside McNichol China in Stonewood near Clarksburg. The man at right, Joseph Phillips, was a veteran of the Pancho Villa Expedition and World War I. Factories like this—noisy, hot in summer, drafty in winter—offered lifelong careers with benefits, even to those with limited formal education, but that safety net would soon be cut.

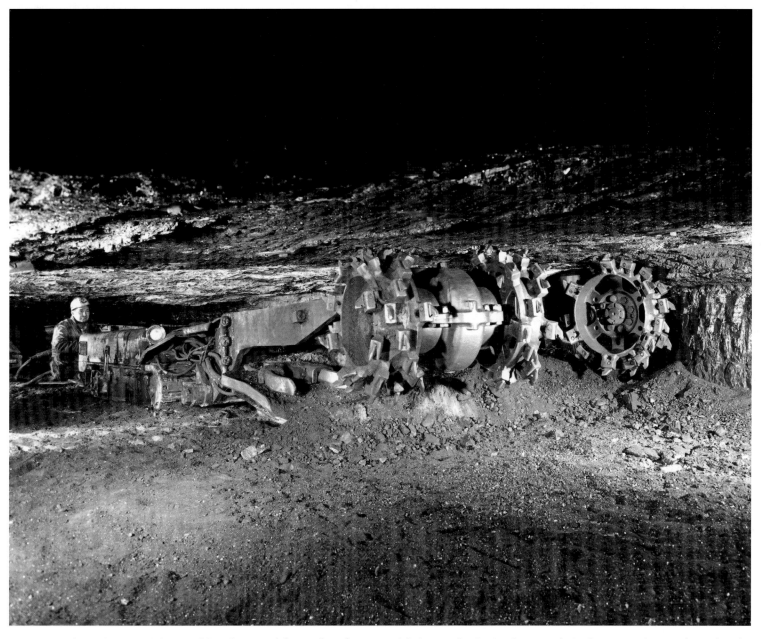

A continuous mining machine chews coal from a four-foot seam. Mining mechanization began early in the century but accelerated in the forties and fifties. The same amount of coal could be produced with a tenth of the employees. That, plus increased strip mining, which required fewer workers, and the railroads' switch from coal to diesel power led to the Great Coal Depression. Between 1949 and 1963, mining employment plunged from 141,000 to 39,800.

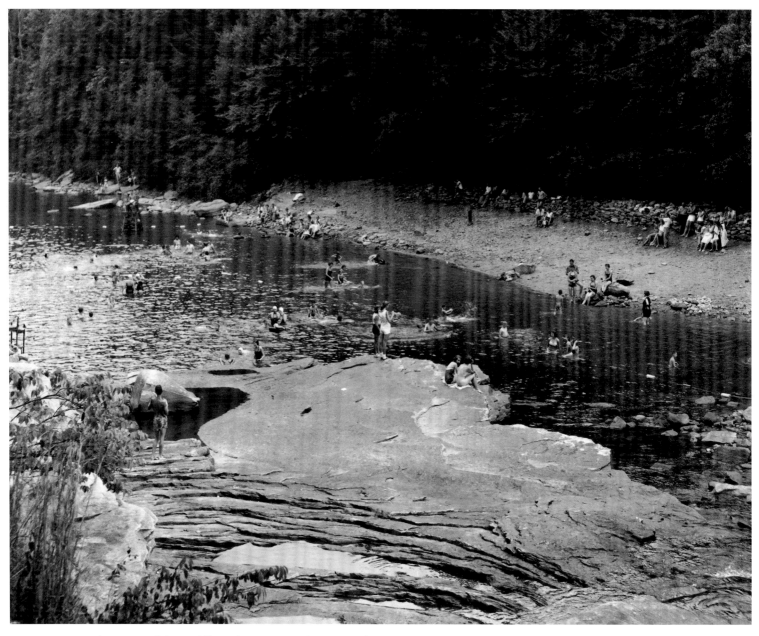

Swimmers enjoy the waters of the Middle Fork River at Audra State Park in Barbour County. The state created the park in 1944. Kermit McKeever, "the father of West Virginia's state park system," increased the number of parks from 14 to 34 during his tenure as director of the park system, 1948 to 1978. Politically astute, he also convinced the legislature to approve money to develop resort parks and winter tourism.

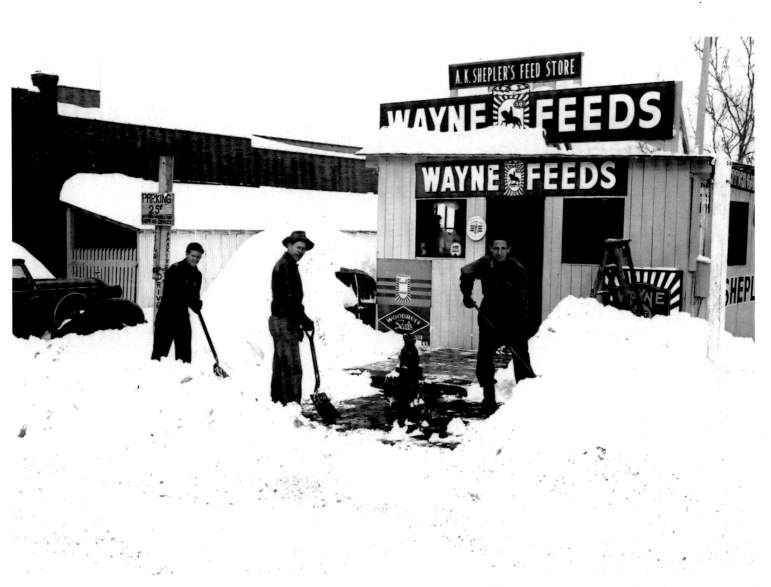

On November 24, the day after Thanksgiving 1950, snow began to fall. And fall. And fall. The state shut down, millions lost electricity, and 160 deaths were reported. The five-day "Thanksgiving blizzard" buried Pickens under 57 inches. These men at A. K. Shepler's Feed Store, 300 Hewes Avenue, are shoveling some of the 38 inches that blanketed Clarksburg. A Canadian upper-atmosphere low-pressure system meeting a secondary surface low over North Carolina caused the freak storm.

The WVU football team runs into the stadium through the legs of a Mountaineer balloon in 1955. That team went 8–2. Among its players was guard Sam Huff, who later went pro. In 1960, CBS increased pro football's credibility and popularity with *The Violent World of Sam Huff,* narrated by Walter Cronkite. Huff was outfitted with a microphone and transmitter to put viewers onto the field of a professional football game.

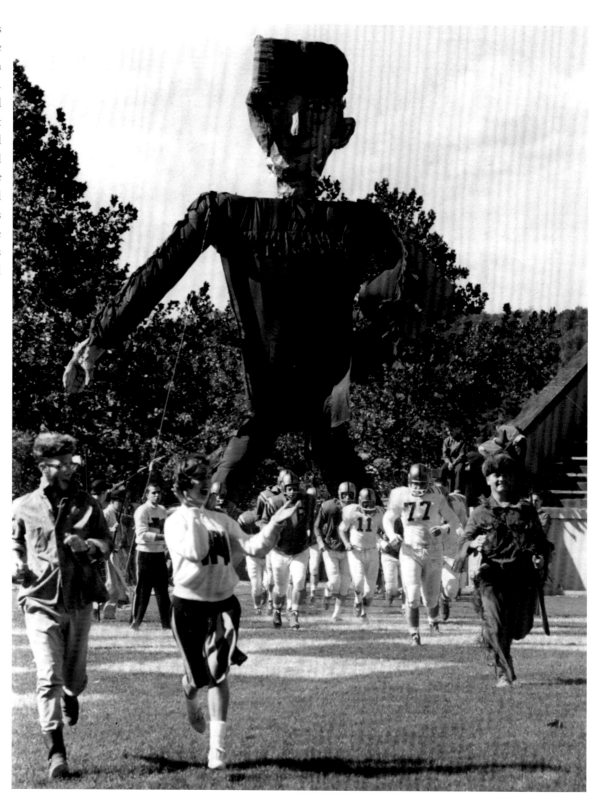

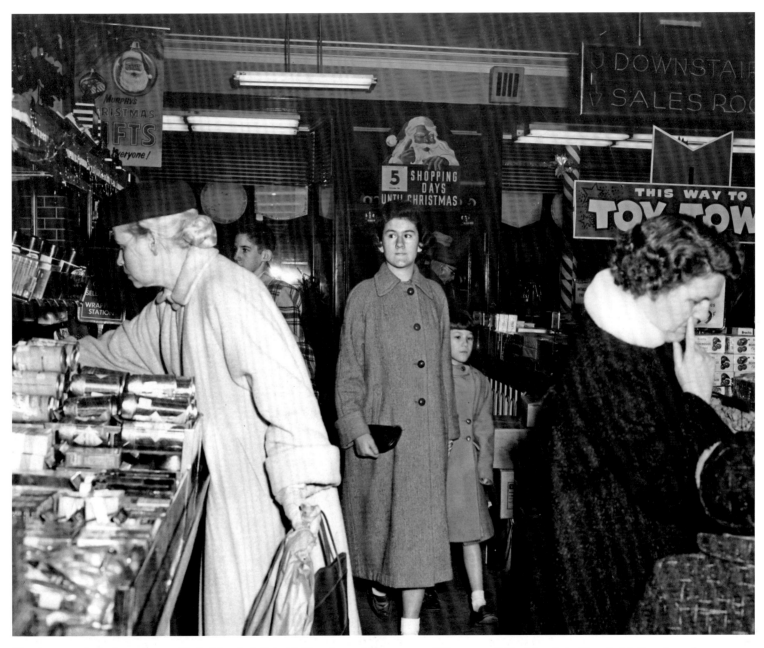

Shoppers search for last-minute gifts in Murphy's 5 & 10 Cent Store, Morgantown. "Dime stores" like Murphy's, Grant's, McCrory's, and F. W. Woolworth carried toys year-round, but at Christmas even auto supply shops and furniture stores got into the act, and kids' eyes sparkled like sunlight on snow. Winter cold reddened cheeks as shoppers walked from store to store, Salvation Army bells rang, and tire chains rattled and crunched on snow-covered streets.

Ernest T. Weir moved Phillips Sheet & Tin Plate from Clarksburg to Hancock County in 1905 after the death of his partner, J. A. Phillips. In 1918, it became Weirton Steel Company. The town of Weirton grew up around it. At one time it was the state's largest employer and largest taxpayer. During World War II, it was involved in the atomic bomb project.

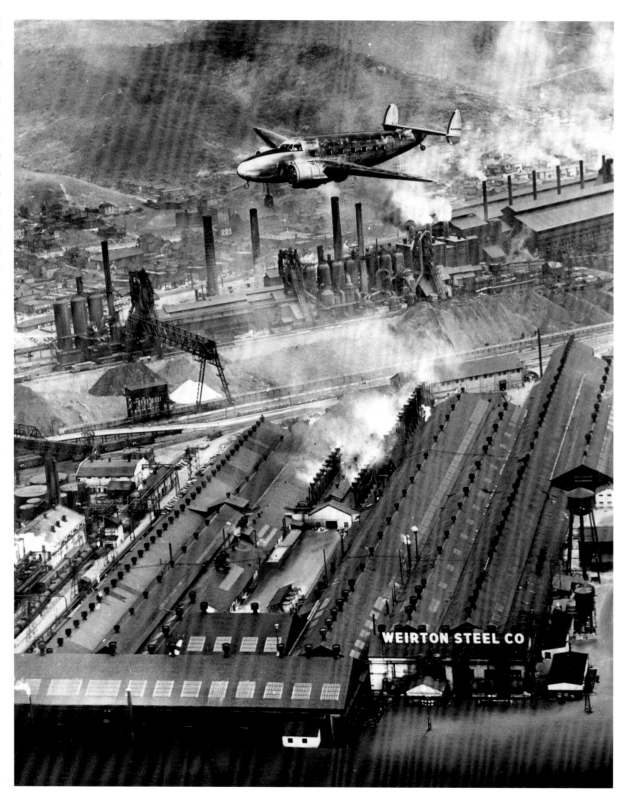

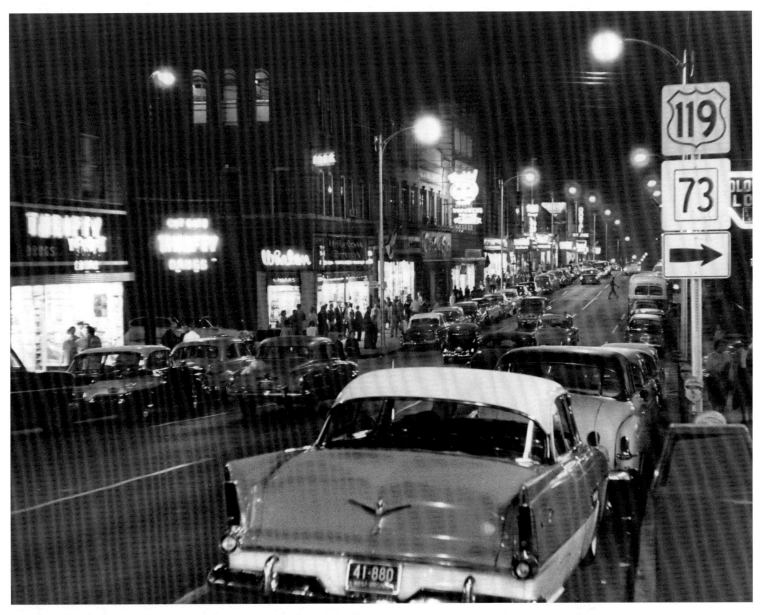

This is the corner of High and Walnut streets in Morgantown, but any town in West Virginia would have looked similar in the 1950s and '60s. Downtown was where all the shops and restaurants were and where teenagers went to meet their friends. The advent of electric lighting in the early twentieth century had transformed downtown nightlife and encouraged shop owners to stay open later.

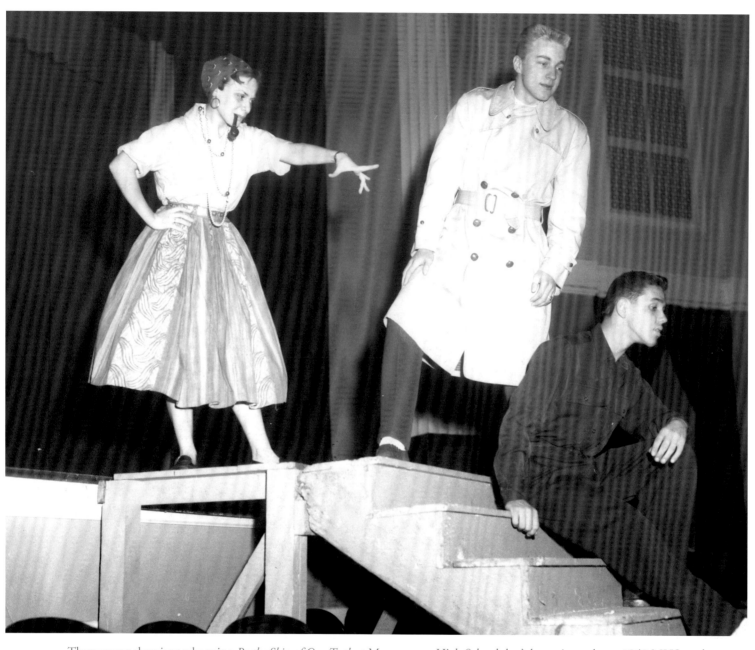

These young thespians rehearsing *By the Skin of Our Teeth* at Morgantown High School don't know it yet, but a 1942 MHS graduate was about to become one of America's favorite actors. In 1960, CBS premiered *The Andy Griffith Show,* with Morgantown's Don Knotts playing hyper, bug-eyed Barney Fife. He won five Emmy Awards for best supporting actor. A street in Morgantown was renamed Don Knotts Boulevard.

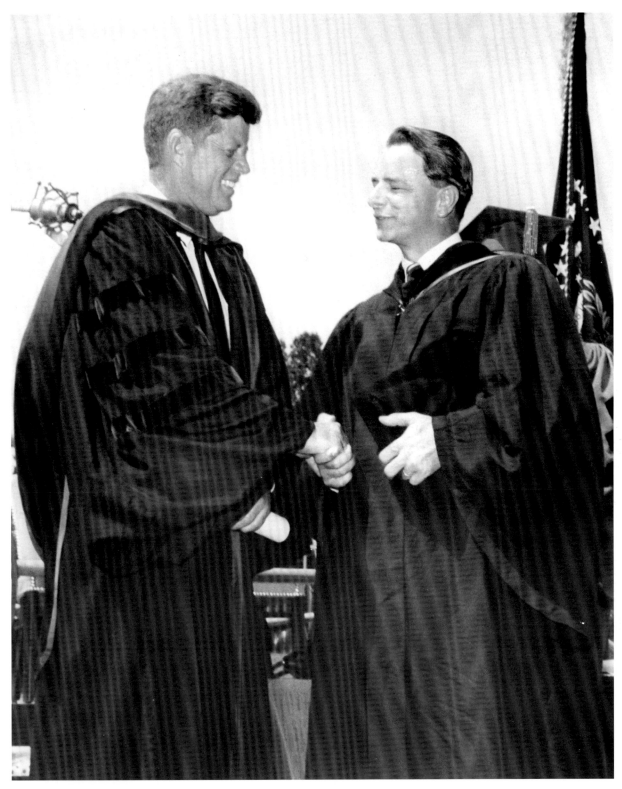

John F. Kennedy's victory in West Virginia's 1960 Democratic presidential primary proved a Catholic could carry a heavily Protestant state and propelled him toward the White House. Here, President Kennedy shakes hands with Senator Robert C. Byrd on the day Byrd received his law degree. Byrd would be Senate majority leader 1977–1981, then minority leader until 1987 and would become the longest-serving senator in America's history. He has secured numerous federal projects for West Virginia.

From 1963 to 1966, Memphis Tennessee Garrison was vice-president of the national board of the NAACP. A Virginia-born schoolteacher, welfare worker, and mediator in Gary, McDowell County, she helped develop NAACP chapters in the southern counties. In the 1920s, she initiated the idea of selling NAACP Christmas seals, which became an important funding source. A relative who had been one of the first black teachers in Memphis, Tennessee, gave her the unusual name.

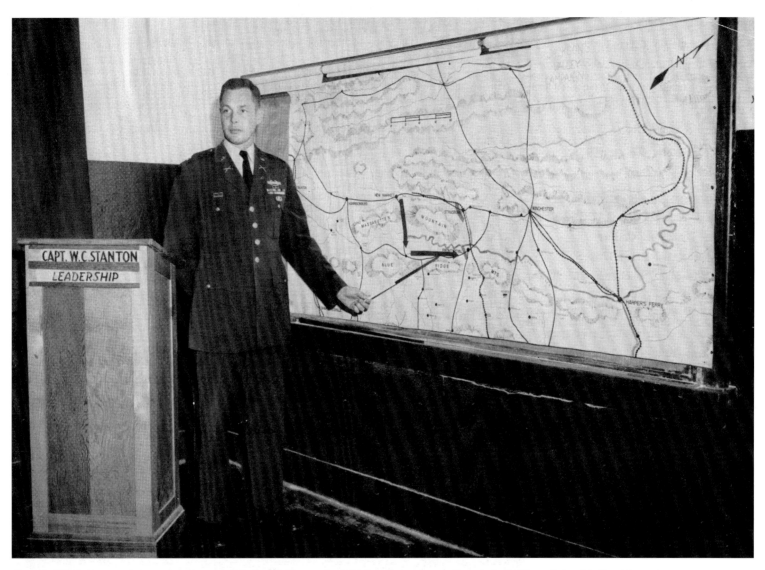

Captain W. C. Stanton lectures on Stonewall Jackson's Shenandoah Valley Campaign at Greenbrier Military School in Lewisburg. Begun in 1890 on the site of a much older school, the academy changed its name and academic focus several times before H. B. Moore, who had been headmaster since 1906, purchased the academy with two of his brothers in the 1920s and renamed it Greenbrier Military School. It closed in 1972.

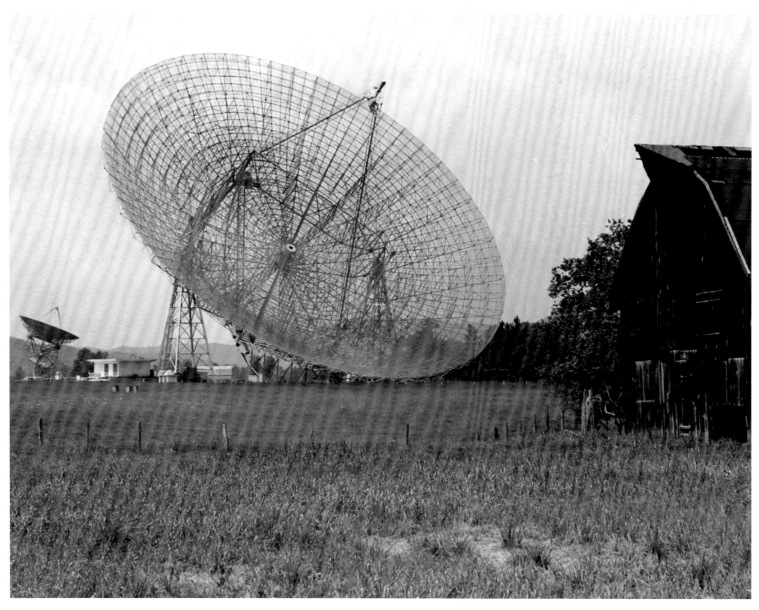

I think I'm picking up extraterrestrial messages—oh, wait, it's just a cow. Green Bank, Pocahontas County, became home to the National Radio Astronomy Observatory because the hills block radio interference, and the absence of industry allows for clearer signals. Completed in 1959, the NRAO searches the cosmos for radio signals, naturally occurring or otherwise. Today it is home to the 16-million-pound Robert C. Byrd Green Bank Telescope, the world's largest fully steerable radio telescope.

Jerry West from Cabin Creek takes a jump shot for WVU against Tennessee. In 1959, he led the Mountaineers to within two points of the national championship and was Most Valuable Player of the NCAA tournament that year. He co-captained the undefeated 1960 U.S. Olympic team and had a 14-year career with the Los Angeles Lakers. Named Most Valuable Player in 1972, "Mr. Clutch" was inducted into the Pro Basketball Hall of Fame in 1980.

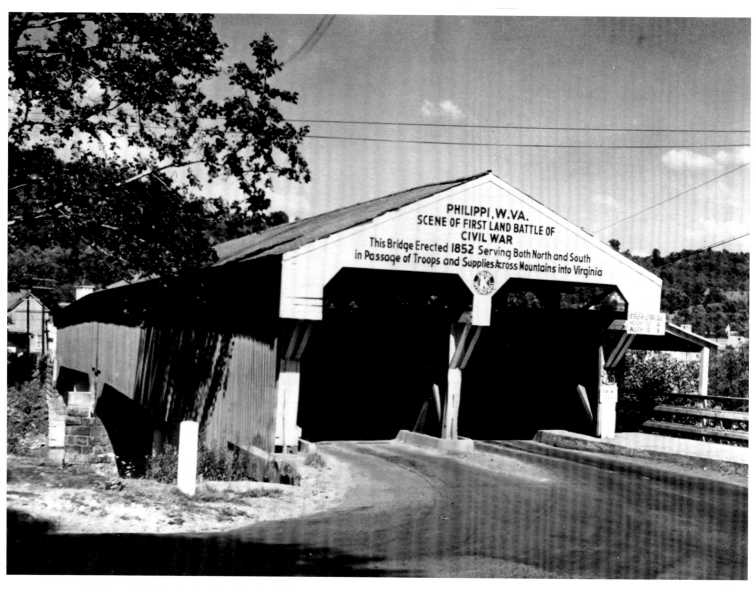

On June 3, 1861, the first land battle of the Civil War was fought at Philippi in Barbour County, a Union victory with no fatalities on either side. This covered bridge witnessed the battle and was a featured site in the 1960s when the state celebrated both the Civil War centennial and 100 years of statehood. Following a truck explosion in 1989, everything but the original beams had to be replaced.

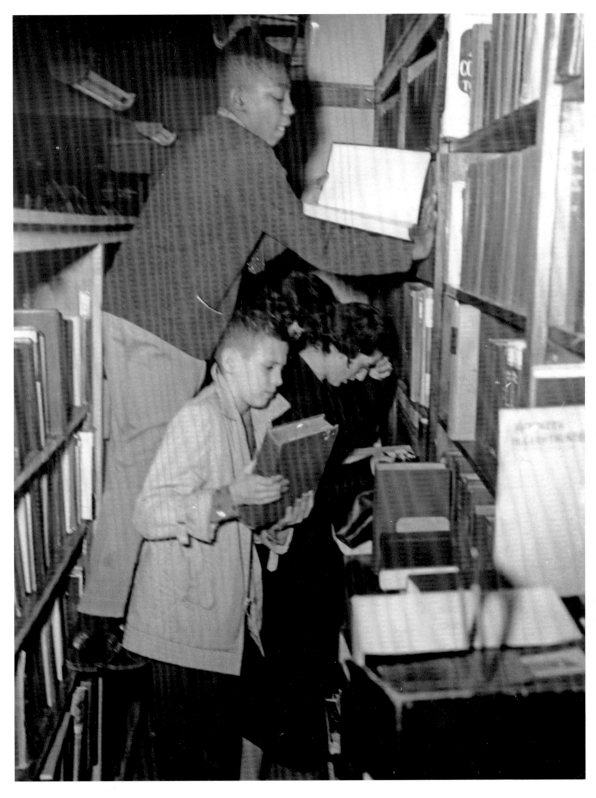

Black and white children look for books together in Morgantown's Waitman Barbe Public Library in 1961. In 1954, *Brown vs. Board of Education* banned segregated schools. Legendary lawyer John W. Davis, former presidential candidate from Clarksburg, was the losing attorney in *Brown,* arguing that states' rights permitted separate-but-equal laws. West Virginia was not one of the states involved in the suit. Closing the state's "colored schools" eliminated jobs for black principals, coaches, and bandleaders, however.

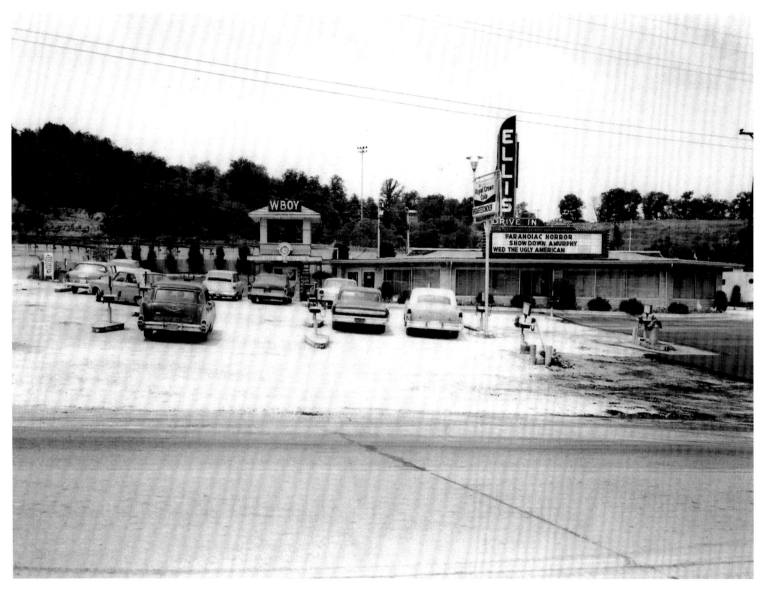

Stewart's Drive-In in the Big Kanawha Valley was selling Stewart's root beer, popcorn, and hot dogs in the 1930s. Shoney's founder, Alex Shoenbaum, opened the Parkette in Charleston in 1947. But drive-ins blossomed in the fifties and sixties. At Ellis Drive-In near Clarksburg, patrons could even watch live radio broadcasts made from the Sky Castle that sat atop WBOY. A drive-in movie classic, *Attack of the 50-Foot Woman,* starred Charleston-born actress Allison Hayes.

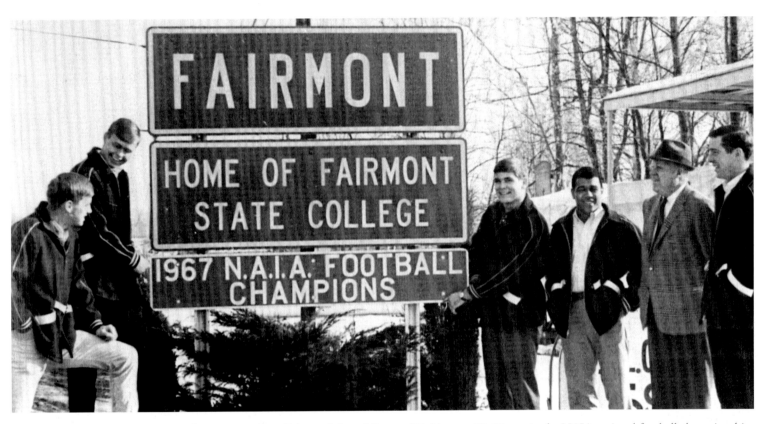

On December 9, 1967, the Fairmont State Falcons defeated Eastern Washington 28–21 to win the NAIA national football championship; Deacon Duvall was named NAIA Coach of the Year. Other national titles for state schools include two NCAA I-AA national football championships for Marshall University. Davis & Elkins College won national NAIA soccer championships in 1968 and 1970. Bill Nuttall, D&E's goalkeeper, became general manager of the U.S. Soccer Federation teams, 1991–1994.

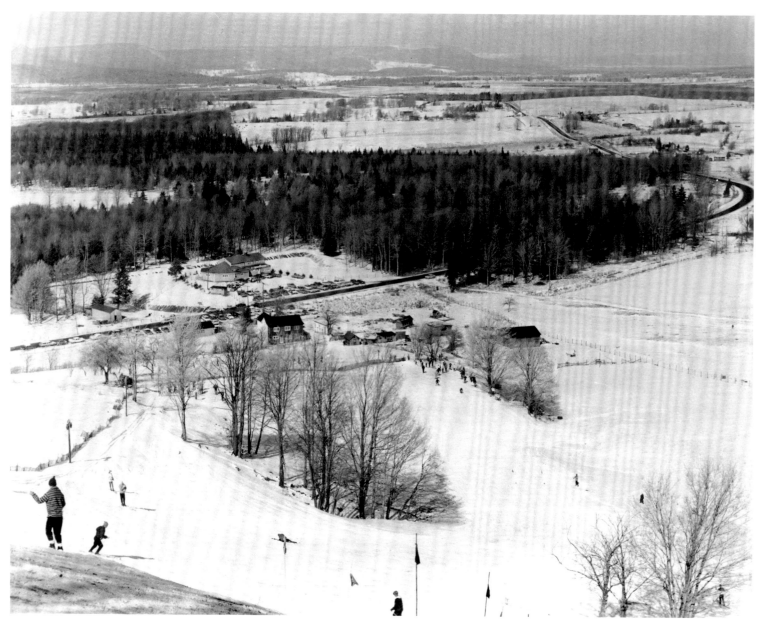

Skiers take to the slopes near Cabin Mountain in Tucker County around 1963. The Washington (D.C.) Ski Club discovered in 1950 that a protected slope of Cabin Mountain retained enough snow for skiing even in April. Ski slopes were developed there and on Weiss Knob. State parks director Kermit McKeever oversaw the establishment of a ski resort at Canaan Valley State Park to increase winter tourism.

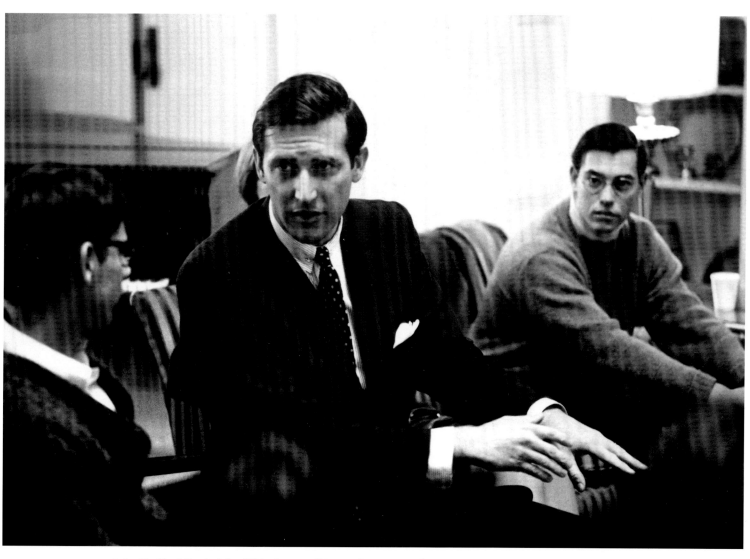

John D. "Jay" Rockefeller IV is shown talking with WVU students in 1967 as Kanawha County's delegate in the state House of Representatives. Since 1984, Rockefeller has been one of West Virginia's U.S. senators, serving on the intelligence and veteran affairs committees and chairing the finance committee and the Committee on Commerce, Science and Transportation. He was also West Virginia's secretary of state, twice governor, and president of West Virginia Wesleyan College in Buckhannon.

After rail transport declined in importance, unused tracks lay rusting. Some former rail lines found new life as tourist attractions. Cass Scenic Railroad, shown here, began hauling tourists on the 11-mile trip to Bald Knob in Pocahontas County June 15, 1963, as part of the state's centennial celebration. Scenic rail companies in the state include the Potomac Eagle, the Durbin & Greenbrier Valley Railroad, New River Train, and the New Tygart Flyer.

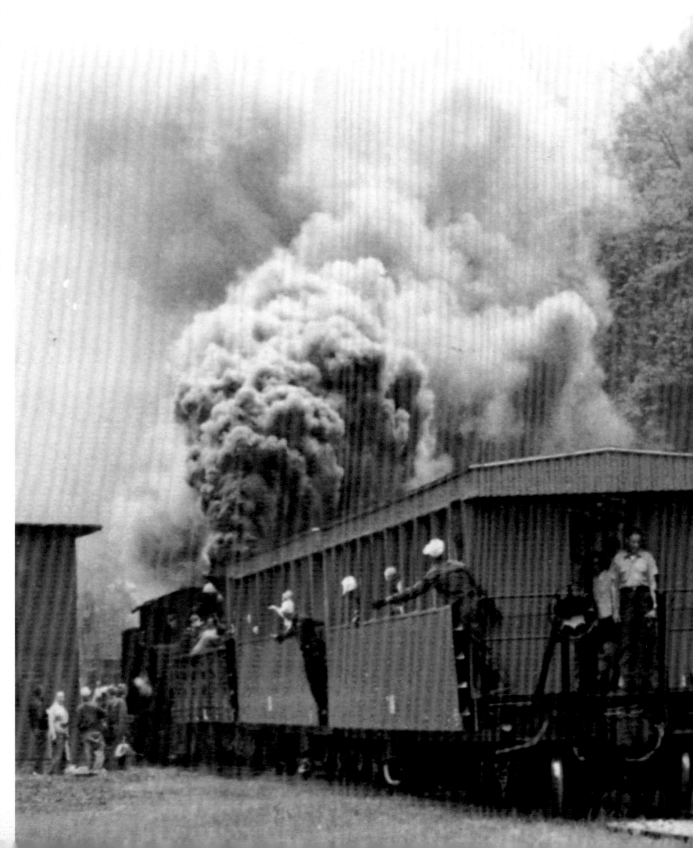

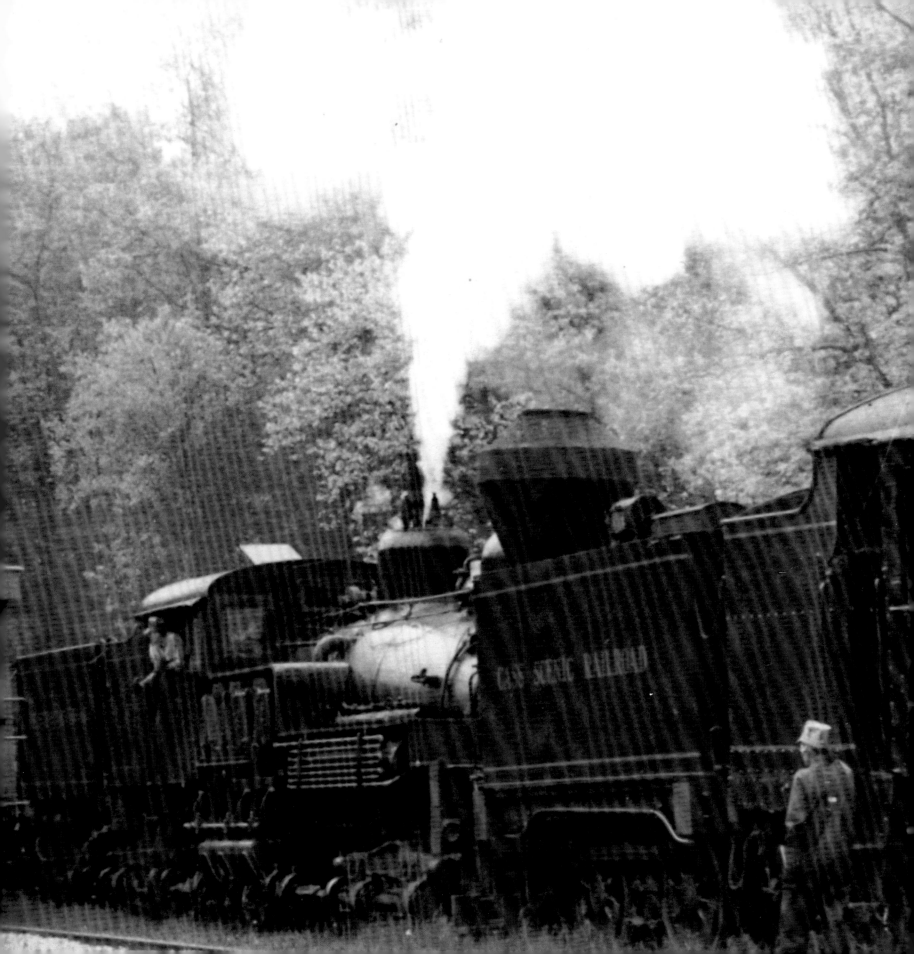

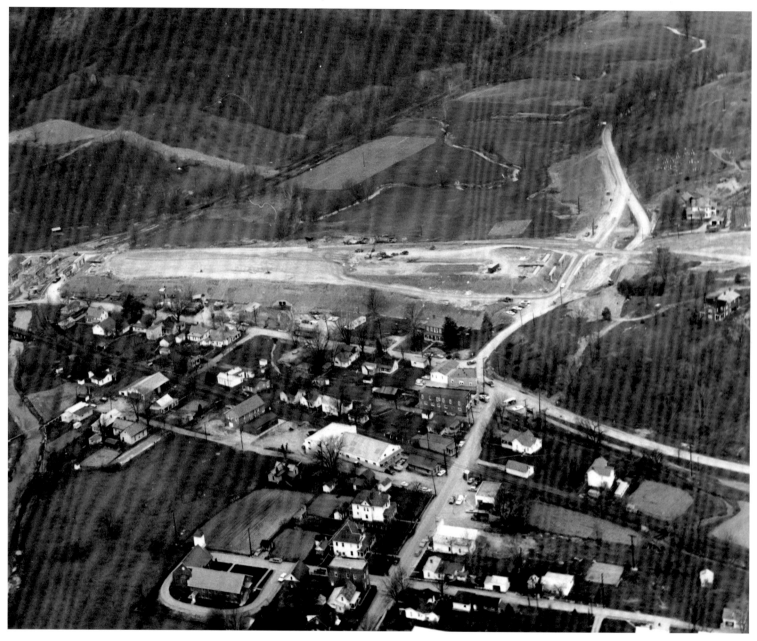

Few innovations have changed West Virginia as much as Interstate highways have. Between 1957 and 1988, at a cost of nearly 3 billion dollars, 515 miles of high-speed roadways were cut through the state's hills and farmlands; more were added later. Residents of small towns like Jane Lew in Lewis County, shown here, can now be in Charleston or Parkersburg or Wheeling in a couple of hours. New businesses clustered around exits, but bypassed downtowns withered.

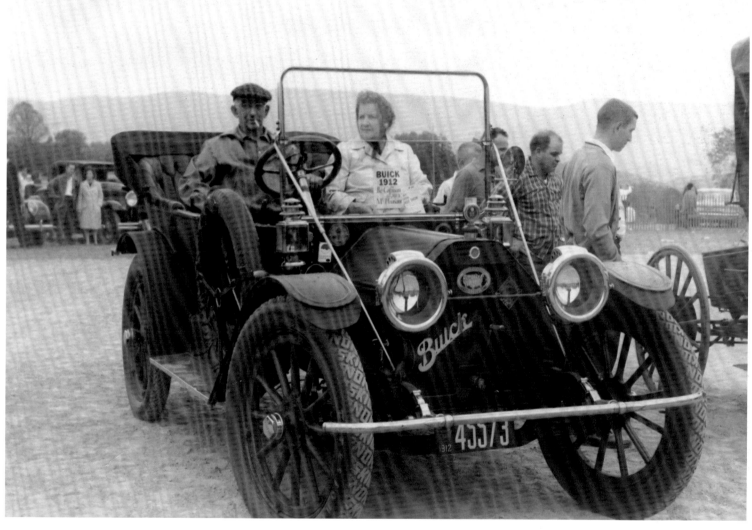

The success of festivals that began in the Great Depression led other areas to develop their own: Bluefield's Lemonade Days; the Italian Heritage Festival and the Black Heritage Festival, both in Clarksburg; Bridge Day at New River Gorge; Apple Harvest Festival in Martinsburg, and many more. Kingwood held its first Buckwheat Festival in the autumn of 1938 and later added a classic car show. This 1912 Buick was photographed there in 1976.

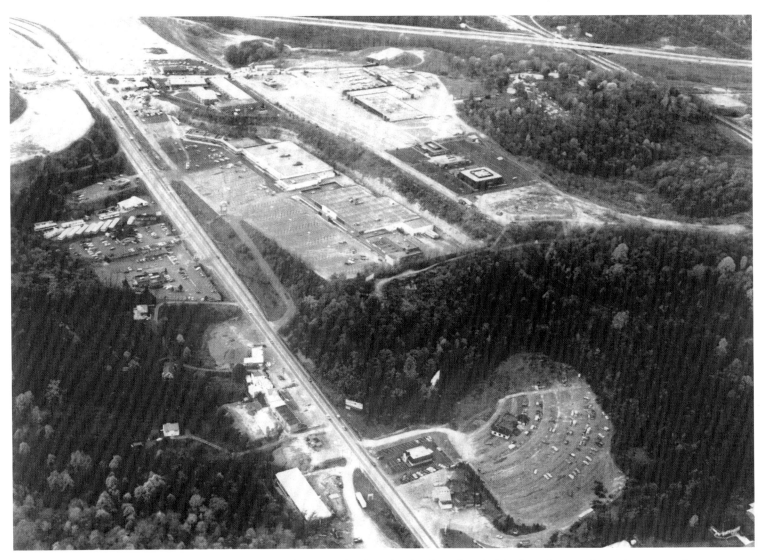

With the mobility the new Interstates provided, plazas like those of Hills and Gabriel Brothers in Harrison County, shown here, opened to offer wider, often less expensive selections and convenient parking. Malls soon followed, bringing chain stores and "big box" retailers that local merchants couldn't compete with.

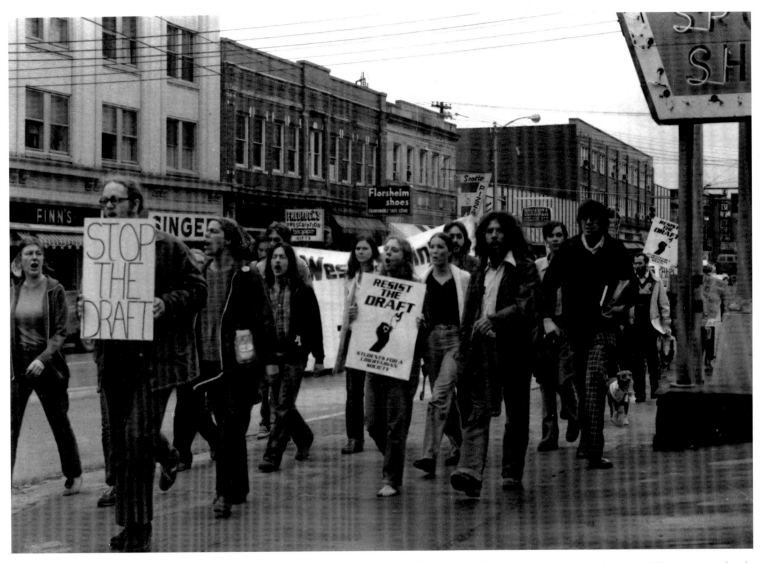

West Virginia sent 20.3 percent of its male population age 16 and over into military service during the Vietnam War era, second only to North Dakota; 581 died from hostile action. This reflected the state's history of military service, deep sense of patriotism, lack of employment opportunities—and the draft this group is protesting in Morgantown. Five West Virginians were awarded the Medal of Honor, including Morgantown's Thomas Bennett, a conscientious objector and Army corpsman.

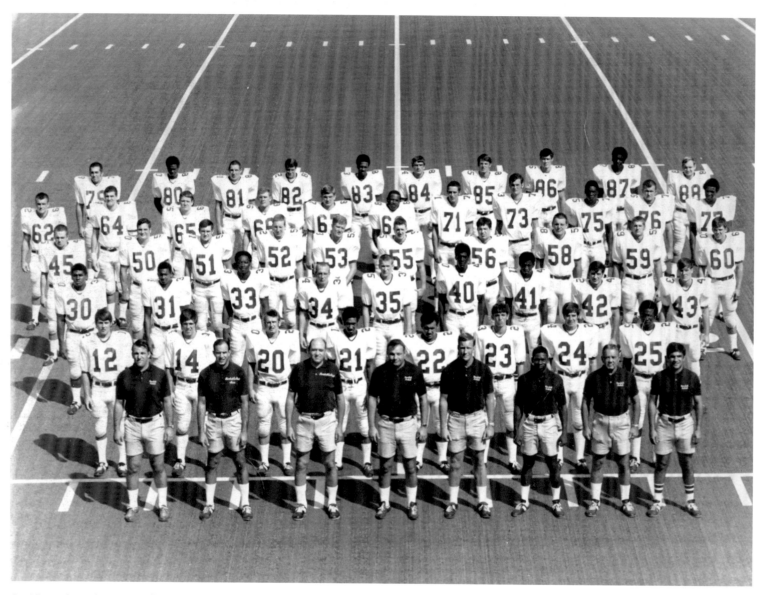

On November 14, 1970, a plane carrying the Marshall University football team, coaches, and boosters home from a 17–14 loss to East Carolina University crashed into a hillside near Kenova. There were no survivors. This team photo was taken at the beginning of the season. A movie about the incident, *We Are Marshall*, premiered in 2006. The school rebuilt its football program and has since won two NCAA I-AA national championships.

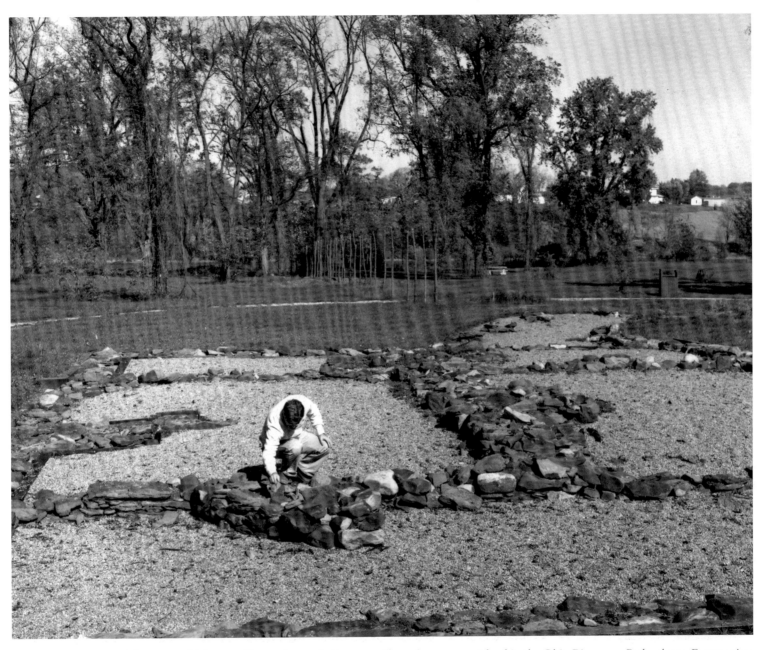

In 1798, Harman and Margaret Blennerhassett built a magnificent home on an island in the Ohio River near Parkersburg. Former vice-president Aaron Burr used it in 1805 to 1806 as his headquarters for planning a military expedition to seize land from Mexico. Burr was tried for treason and acquitted, but the Blennerhassetts had to flee. In the 1970s, their mansion's foundation was discovered, and the building was re-created as part of Blennerhassett Island State Historical Park.

The sun sets, a mist rises, and lights come on along Cheat River. West Virginia, like a mother waiting patiently, whispers to its scattered children, "Come home when you can."

NOTES ON THE PHOTOGRAPHS

These notes, listed by page number, attempt to include all aspects known of the photographs. Each of the photographs is identified by the page number, photograph's title or description, photographer and collection, archive, and call or box number when applicable. Although every attempt was made to collect all data, in some cases complete data may have been unavailable due to the age and condition of some of the photographs and records.

II BIRD'S-EYE OF HARPERS FERRY
Library of Congress
LC-DIG-cwpb-03871

VI CANNELTON
Library of Congress
LC-DIG-ppmsca-10502

X TAM O'SHANTER
Library of Congress
LC-DIG-ppmsca-10500

2 JOHN BROWN'S FORT
Library of Congress
LC-DIG-stereo-1s01836

3 HARPERS FERRY
Library of Congress
LC-DIG-stereo-1s01839

4 VOLUNTEERS AT MORGANTOWN
West Virginia and Regional Collection
West Virginia University Libraries
000852

5 TENTS AT HARPERS FERRY
Library of Congress
LC-DIG-stereo-1s01838

6 DINNER AT CALDWELL'S
Library of Congress
LC-DIG-ppmsca-05401

7 WHITE SULPHUR SPRINGS
Library of Congress
LC-DIG-ppmsca-05402

8 WHEELING SUSPENSION BRIDGE
West Virginia State Archives
CL18-0195; collection
001801

9 1876 FAIRMONT FIRE
West Virginia and Regional Collection
West Virginia University Libraries
005727

10 WESTON MENTAL HOSPITAL
West Virginia and Regional Collection
West Virginia University Libraries
028224

11 BIRTH OF DAVIS
Library of Congress
LC-D4-14137

12 SHEPHERDSTOWN
West Virginia and Regional Collection
West Virginia University Libraries
013142

13 MONTANA MINES
West Virginia and Regional Collection
West Virginia University Libraries
002092

14 BAPTISM
West Virginia and Regional Collection
West Virginia University Libraries
013154

15 STORER COLLEGE
West Virginia and Regional Collection
West Virginia University Libraries
022457

16 PALATINE POTTERY
West Virginia and Regional Collection
West Virginia University Libraries
029455

17 WVU FACULTY
West Virginia and Regional Collection
West Virginia University Libraries
021716

18 1884 FLOOD
West Virginia and Regional Collection
West Virginia University Libraries
007178

19 FRANCIS H. PIERPONT
West Virginia and Regional Collection
West Virginia University Libraries
017159

20 RAILROAD CREW NEAR GRAFTON
West Virginia and Regional Collection
West Virginia University Libraries
014943

21 JACKSON'S MILLS
West Virginia State Archives
221214

119 FOKKER AIRCRAFT FACTORY
West Virginia and Regional Collection
West Virginia University Libraries
013463

120 MARSHALL UNIVERSITY FOOTBALL STADIUM
West Virginia and Regional Collection
West Virginia University Libraries
026581

121 MINER'S CHILD AT BERTHA HILL
Library of Congress
LC-DIG-fsa-8c29892

122 CIVILIAN CONSERVATION CORPS
West Virginia and Regional Collection
West Virginia University Libraries
031659

123 WPA NURSERY
West Virginia and Regional Collection
West Virginia University Libraries
002834

124 NAACP PILGRIMAGE
Library of Congress
LC-USZ62-111528

125 CHILDREN AT HOPEMONT SANATORIUM
West Virginia and Regional Collection
West Virginia University Libraries
015591

126 BIRTHPLACE OF LINCOLN'S MOTHER
West Virginia and Regional Collection
West Virginia University Libraries
012639

127 INTERIOR, MORGANTOWN HOME
Library of Congress
LC-USF342-T01-000889-A

128 BIRD'S-EYE OF KIMBALL
Library of Congress
LC-DIG-fsa-8a16972

129 GROCERY DELIVERY DURING FLOOD
West Virginia and Regional Collection
West Virginia University Libraries
007704

130 TYGART VALLEY DAM
West Virginia and Regional Collection
West Virginia University Libraries
006499

131 COLORED DEAF & BLIND SCHOOL
West Virginia and Regional Collection
West Virginia University Libraries
026228

132 MASCIOLI BROTHERS
West Virginia and Regional Collection
West Virginia University Libraries
011825

133 MINE SAFETY TRAINING
West Virginia and Regional Collection
West Virginia University Libraries
007381

134 MONONGAHELA NATIONAL FOREST
Library of Congress
LC-USF344-003192-ZB

135 MINER'S CHILDREN, PURSGLOVE
Library of Congress
LC-DIG-fsa-8a39466

136 HOMESTEADER, ARTHURDALE
Library of Congress
LC-USF34-013087-D

137 VACUUM CLEANER FACTORY, ARTHURDALE
Library of Congress
LC-USF33-006352-M5

138 STRAWBERRY FESTIVAL
West Virginia and Regional Collection
West Virginia University Libraries
014220

139 CARBIDE & CARBON CHEMICALS CORP.
Library of Congress
LC-USW33-028393-C

140 POLISH MINER
Library of Congress
LC-USF34-050258-E

141 COAL MINERS' WIVES, CAPELS
Library of Congress
LC-USF34-050260-E

142 SLAG HEAPS
Library of Congress
LC-USF33-030100-M3

143 MAKING SORGHUM
Library of Congress
LC-USF33-030261-M5

144 "DEVIL ANSE" HATFIELD STATUE
West Virginia State Archives
pn1134

145 PEARL S. BUCK HOME
West Virginia and Regional Collection
West Virginia University Libraries
015878

146 FEDERAL PRISON FOR WOMEN
Library of Congress
LC-DIG-hec-27817

148 OLD TRUCK AT KEMPTON
Library of Congress
LC-DIG-fsa-8a04079

149 SNOWSTORM, PARKERSBURG
Library of Congress
LC-DIG-fsa-8a12888

150 HUNTINGTON STREET SCENE
West Virginia and Regional Collection
West Virginia University Libraries
007226

151 WAJR
West Virginia and Regional Collection
West Virginia University Libraries
020763

181 CAPT. W. C. STANTON
West Virginia and Regional
Collection
West Virginia University
Libraries
000827

182 GREEN BANK
OBSERVATORY
West Virginia and Regional
Collection
West Virginia University
Libraries
015975

183 JERRY WEST
West Virginia and Regional
Collection
West Virginia University
Libraries
018068

184 PHILIPPI BRIDGE
West Virginia and Regional
Collection
West Virginia University
Libraries
001275

185 CHILDREN IN WAITMAN
BARBE LIBRARY
West Virginia and Regional
Collection
West Virginia University
Libraries
008178

186 ELLIS RESTAURANT AND
DRIVE-IN
West Virginia and Regional
Collection
West Virginia University
Libraries
030494

187 NAIA FOOTBALL
CHAMPIONS
Fairmont State University
Photo Archives

188 SKI SLOPES NEAR
CABIN MOUNTAIN
West Virginia and Regional
Collection
West Virginia University
Libraries
002056

189 JOHN D. "JAY"
ROCKEFELLER IV
West Virginia and Regional
Collection
West Virginia University
Libraries
023874

190 CASS SCENIC RAILROAD
West Virginia and Regional
Collection
West Virginia University
Libraries
000060

192 INTERSTATE
CONSTRUCTION
West Virginia and Regional
Collection
West Virginia University
Libraries
013357

193 1912 BUICK AT
BUCKWHEAT FESTIVAL
West Virginia and Regional
Collection
West Virginia University
Libraries
015663

194 HILLS AND GABRIEL
BROTHERS PLAZAS
West Virginia and Regional
Collection
West Virginia University
Libraries
031260

195 ANTI-DRAFT PROTEST
West Virginia and Regional
Collection
West Virginia University
Libraries
024428

196 1970 MARSHALL
FOOTBALL TEAM
Marshall University

197 BLENNERHASSETT
ISLAND, LAYING
FOUNDATION
West Virginia and Regional
Collection
West Virginia University
Libraries
015071

198 CHEAT RIVER
West Virginia and Regional
Collection
West Virginia University
Libraries
020206